Dear Cynthia

Memories are made
of this!
Thank you for your
support —

Reinhardt

Sept 2015

what if textiles:
the art of
GERHARDT
KNODEL

**Contributions by Janet Koplos,
Shelley Selim, Douglas Dawson,
Rebecca A. T. Stevens, and
Gerhardt Knodel**

4880 Lower Valley Road • Atglen, PA 19310

Other Schiffer Books on Related Subjects:

Esherick, Maloof, and Nakashima: Homes of the Master Wood Artisans, Steven Paul Whitsitt and Tina Skinner, ISBN 978-0-7643-3202-9

Southeast Asian Textiles, Claire & Steve Wilbur, ISBN 978-0-7643-1810-8

Chinese Artists: New Media, 1990–2010, Xhingyu Chen, ISBN 978-0-7643-3675-1

Designed by Elliott Earls
Type set in the Corundum Family
ISBN: 978-0-7643-4994-2

Printed in China

Published by Schiffer Publishing, Ltd.
4880 Lower Valley Road
Atglen, PA 19310
Phone: (610) 593-1777; Fax: (610) 593-2002
E-mail: Info@schifferbooks.com

For our complete selection of fine books on this and related subjects,
please visit our website at www.schifferbooks.com. You may also write for a free catalog.

This book may be purchased from the publisher. Please try your bookstore first.

We are always looking for people to write books on new and related subjects. If you have an idea for a book, please contact us at proposals@schifferbooks.com.

Schiffer Publishing's titles are available at special discounts for bulk purchases for sales promotions or premiums. Special editions, including personalized covers, corporate imprints, and excerpts can be created in large quantities for special needs. For more information, contact the publisher.

Knodel established a practice that he refers to as "evolving strategies," in which he works speculatively, always asking himself "what if?" The question can be addressed to a material or technique but also to the art world, the design world, or the world at large. It is his way of looking for "breathing space" in which to find his own way.

—Janet Koplos

Contents

Introduction

Gerhardt Knodel is uninhibited about declaring his devotion to the language of textiles and the significance of materials, processes, and expressive potential in contemporary life. He weaves, he cuts, he sews, he draws, he writes, he photographs. He also collects eloquent and ingenious textiles of the past, and eagerly shares insights and enthusiasm for them with others.

A focus throughout Knodel's career has been inquiry about viewer involvement in the experience of art, specifically the need for the viewer to become aware of the degree to which audience interaction complements the work of the artist. For many years, he realized this interest through major architectural installations and gallery projects that invited audiences to explore their associations with the textile medium in new ways.

From the mid-1970s Knodel's art stood at the forefront of evolving possibilities for textiles, joining the work of other young artists whose interests emerged out of a field previously connected with functional design and craft. Working in conjunction with more than two hundred graduate students over a twenty-five year period, he contributed to the viability of the textile medium that exists in today's art world.

Since 2008 Knodel has concentrated on building work that encourages the art viewer to share his insatiable appetite for invention within the context of textiles. Along with mapping the flow of his career through more than four decades, *What If Textiles* reflects his interest in conceptually stretching the potential of the medium and its history.

A fine point of departure for considering his work exists in "Snapping at the Fly," an address he presented on the occasion of his 2014 exhibition *Let the Games Begin!* In it his passion for search and discovery is revealed, as is his insistence on patience in pursuit of art that works.

Janet Koplos discusses experiences that shaped Knodel's appetite for art in the context of mid-century modernism in Southern California, an environment that inspired his interest in discovering new approaches to using textiles in relationship to architecture, and supported his commitment to sharing his insights with others. She follows his move on to extraordinary opportunities in the community of Cranbrook Academy of Art.

Shelley Selim leads the reader through the changes that characterize Knodel's work since 2008. She describes how the work emerging after Knodel's departure from his directorship of Cranbrook Academy of Art reveals the significant benefits that come with a commitment to pursuing art making as the dominant focus of attention through extended periods of studio time. As the works evolve, one from the other, she traces the web of relationships that connect them within the radically changing conditions of the early twenty-first century.

Throughout Knodel's career, an undercurrent of interest in the rich language of historic textiles of other cultures has driven his imagination. Douglas Dawson sets the stage for better appreciating the legacy of narrative textiles that absorb and communicate essential concepts at the foundation of diverse cultures of the world.

Rebecca A. T. Stevens presents provocative reflections on the use of historic resources in contemporary art as generated in conversation with Knodel about his own collecting interests.

Knodel's interpretation of textiles in his collection follows. His insights are rooted not only in the beauty, craft, and meaning residing in textiles that have captured his attention, but also in their ability to inspire response in tandem with conditions of our own time. These personal responses are contained in twenty short essays on pieces that have affected his own work, and they offer the reader avenues of approach to considering textiles as a primary form of art.

A biography portrays the evolution of Knodel's work with an annotated survey of significant circumstances relating to the development of his work, and observations on situations that impacted his career as well as the general field of contemporary work in the fiber medium.

An illustrated chronology that charts the evolution of Knodel's work from 1969 to 2014 contributes insight into the work as a progression of interrelated experiences in time, providing opportunity to discover relationships at a distance from the moments of their making.

Snapping at the Fly

Gerhardt Knodel

The moment we pay attention to something, we are part of it.

Fascination happens in a special moment of contact, generating a richness of potential with which you want to travel. You sense opportunity for discovery in that new connection, and over time a stream of relationships with past experiences is formed.

A piano offers eighty-eight keys to be played. Which ones to choose? Endless combinations have been explored, reams of melodies and harmonies and rhythms have been uncovered in that field of eighty-eight keys, but the appetite for pursuing the potential is not spoiled by what has been done before.

One special day, you discover a subject with characteristics that ask to be acted upon. At first, you flirt with the subject like a dog playing with an irritating and insistent fly. But then, in one aggressive moment, the dog snaps at the fly, and the fly is caught. Is this an ending, or a beginning?

Real adventure begins at that moment of capture. The idea: to snap at the air with determination to capture something elusive. The question: how to capture but not stifle. After snapping it up, how to hold something in one's grasp, marvel at its existence, then make it the subject of attention for hours, days, and months, then ultimately release it and give it the freedom it requires.

New adventures begin as one pays attention to them as fields of opportunity. A new body of work comes from trusting that lifelong experiences will not inhibit attention to a new set of strategies. Experience will quietly reside at the periphery of the table. However, once into the adventure, you often discover how very persistent those past accomplishments are. They sit on your creative shoulders, sometimes like gargoyles perched on the cathedral walls, waiting to assert themselves as channels of energy through which new possibilities must flow.

Freedom is discovered by allowing accidents to happen, by swallowing the fly, rather than playing with it. Sometimes freedom happens in a flash as new subjects reveal unexpected relationships. Once opened, as a crack in the wall, all that had been held back, unseen on the opposite side, seems to rush forward in an avalanche of "what ifs."

Much of my past work was inspired by architectural space. Open physical spaces, like the vast interior spaces found at entrances or atria of corporate offices, hotels, or other public facilities, offered the opportunity for the creation of three-dimensional textile constructions/sculptures that activated space, essentially revealing aspects of light or energy that existed, but were not seen.

Returning to the studio after years in the director's seat at Cranbrook, I decided that my large studio would become the new arena for the work and that once completed, the work would live with me in the studio until the studio was so full that I would have to let go. In years past, I had worked on projects for a year or more, installed them in spaces for which they were commissioned, and then rarely revisited them.

The process of living with finished work further enriched my relationship with it. Whereas formerly I regularly faced deadlines contractually established by client or gallery, my new approach allowed for new levels of discovery through reaction, even after I thought a work was complete. This slower process also enriched the dialog with the work, allowing the work to dictate what it needed to fulfill its potential. I became the user, the audience.

Commissioned work requires careful deliberation and planning, just as architecture does. I have always been proud of my ability to imagine real space and project actual scale in my architectural models produced for the client. The challenge of envisioning the successful completion of the work while being only indirectly involved with it in drawings or models is a very different process than that of being intimately involved with it, with touching every aspect of it, experiencing continuity in the flow of construction, and having immediate experience with resistance or mistakes. Helen Frankenthaler once described her woven tapestries as the result of "happy hands" responding to the dictates of a cartoon/painting she had created in watercolor on paper. She did not weave, did not touch the construction of her tapestries, but instead trusted her assistants and their "happy hands" to faithfully reproduce her painting in woven thread. Today, "outsourcing" has become a major means of art production used by most artists with international attention. Although I have had that experience of working with many assistants in the production of my architectural work, I have chosen instead to be directly connected to every move in my current work, and ultimately to take on a different association with the word "authorship."

Textiles have always offered inspiration for my work. I respect the history of the medium for all it has contributed throughout human history, including the extraordinary relationships existing between people and cloth generated in all aspects of individual and commercial production. How can we make those traditions relevant in a changing world? I stubbornly believe that my love for the medium and for all the back alleyways of inspiration offered to me through the medium are worthy subjects to explore. And just as sensitivity to textiles in the contemporary world has changed as the medium comes into play with our lives differently than it has in the past, so has the potential of new ideas morphing with the old. In contrast to the world of abstract imagery that dominated my interests as subject matter in the past, my work is now motivated by ideas rooted in the world of contemporary experience, the world of problems, challenges, opportunities, and failures that characterize this moment in time. What better way to examine some of those conditions than in the context of textiles, a medium that conjures positive expectations and associations?

In the 1980s, I began to incorporate images of people into my woven wall textiles as a means to revive interest in figurative work in weaving. My goal was to discover a new potential for the figure to inhabit the space and structure of woven cloth. I aligned the expressive dimension of

those figures with human images in sixteenth-century tapestries that expressed poetic ideas and states of being beyond the limitations of the physical.

The incorporation of human images as subjects "in" textiles took a turn in 2007 when the representation was substituted by the physical presence and interaction with members of the audience. Beginning in 2007, game playing, as a new focus of the work, involved the game (the object) interacting with the players (the subjects), a field of rich potential. The fact that game playing is always subject to uncertain conclusions seemed logically tied to the uncertainty in the experience of twenty-first-century living. Thoughts of "loss" or "gain" came to motivate every action in the studio and to generate a new, subtle undercurrent in all of the work.

The audience will certainly take notice that new work incorporates many new materials not usually associated with work in the textile medium. In fact, those materials drifted into my vocabulary according to ideas that required their use. In some cases the questions or concepts that generated new work were derived from ideas rooted in the broad scope of textiles, but expression of those ideas required the incorporation of other materials. It has been exhilarating to experience the freedom that comes from understanding textiles' continuity in the work over time.

In a wonderful story, architect and writer Italo Calvino describes an abrupt moment of conscious decision by a young boy to contradict tradition demanded by his father, and escape physically and mentally into a new realm of existence. In a bold act of response to criticism, the boy climbs the branches of a tree and announces that he will "never come down," and subsequently, he lives out all the days of his life in the branches of trees that cover the village adjacent to his home. His decision perfectly reflects my notion of "snapping at the fly," the moment that we seize new opportunities created by our own actions.

The path ahead divides, and if we are lucky, intuition directs us to new adventures, with no regret.

June 2014

I.
Scene Design

Gerhardt Knodel's Theatrical Magic

Janet Koplos

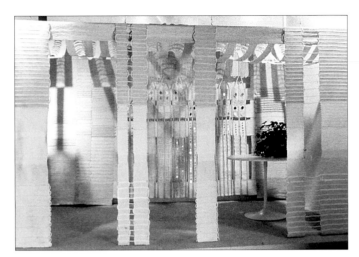

1.1 *DINING ENVIRONMENT,* 1970 (CHRONOLOGY 009)

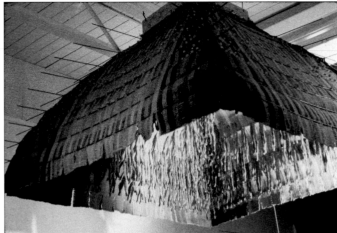

1.2 *WOVEN CANOPY,* 1969 (C. 003)

Gerhardt Knodel likes to tell the story of designing scenery for a play when he was in high school.[1] He diligently painted his design on the expanse of drop curtain but felt that it was not working. Then, when he saw it under theatrical lighting for the first time, it was dazzling.

This anecdote is as illuminating as the experience was, for scene design in the largest sense has been the heart of Knodel's exceptional body of work, and his career might be said to have originated in that memorable moment. He made his reputation by creating textiles of very large scale that dramatically shaped and activated space. His signature work had more to do with architectural context than with the weave structure or tactility that often attracts makers and viewers to the medium. From high school on, Knodel was concerned with creating an environment.

The excitement of stage presentation had touched him even earlier. He recalls, as a boy soprano, singing in the chorus of *Carmen* and *La Bohème* and loving being backstage in the dark.[2] He plays with light and shadow in many of his works. A feeling for the link between light and color also came early, in a balsa-stick structure he made in junior high school and filled with Japanese tissue, which glowed like stained glass when struck by light. No one could have predicted where he would go with these early influences.

All Roads Taken

Knodel was born in 1940 in Milwaukee to German immigrants who had met in Los Angeles and who returned there to rejoin other family members when he was four. Los Angeles had a thriving émigré culture. In the 1930s and 1940s, such noted German artists and intellectuals as Thomas Mann, Theodore W. Adorno, Bertolt Brecht, Fritz Lang, and Arnold Schoenberg lived in Los Angeles.[3] In the craft milieu a number of important California-based figures came from Germany or the countries first affected by the rise of the Nazis, such as the Austrian ceramists Gertrud and Otto Natzler and Susi Singer. The German-born textile designer Maria Kipp was active in Los Angeles in the 1940s. Although he was given a very Germanic first name, Knodel was called, in a gesture of assimilation, Gery. (It was not until years later that he began to use Gerhardt, after Roy Slade, then director of the Cranbrook Academy of Art, discovered and delighted in the name.)

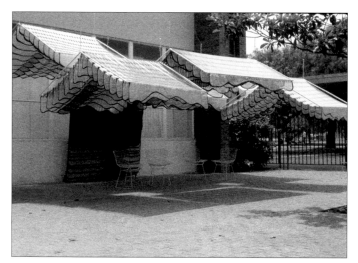

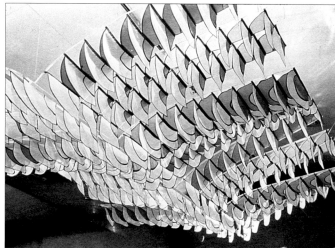

1.3 *Sunshades*, 1970 (C. 008)

1.4 *Flying Canopy*, 1971 (C. 011)

Knodel studied art, music, and theater at UCLA (1957–1961). Under the influence of Bernard Kester, a ceramist who also taught weaving, he delved into textiles. He also took three-dimensional design classes, which connected him to geometry, the International Style, and the notion of going from increments to larger structure—which may have contributed to the clarity of his later work. A holistic idea was characteristic of the time, one thing relating to the next.

Knodel's time at UCLA overlaps the beginning of important ceramic activity in Southern California with the arrival of Peter Voulkos at Otis Art Institute in 1954. Voulkos developed a coterie of students—close to his own age—who were together to foment what is now referred to as a clay revolution before he relocated to Berkeley in 1959. At the same time, an assemblage tradition was developing in California, and Edward Kienholz was creating chaotic yet socially trenchant tableaux. In addition, Ferus Gallery, established by Walter Hopps and Kienholz in 1957, developed a stable of artists who would become major figures of international renown—including Ed Ruscha, Robert Irwin, and Ken Price. From 1964 to 1967, *Artforum* magazine was headquartered in Los Angeles. In other words, Southern California was then defining the environment of creativity and lifestyle that has recently been much celebrated, with artists of the era featured in many museum shows.[4] The California tumult was matched by national upheaval: a string of assassinations, war in Asia, student protests, race riots, etc.

Knodel was aware of the art ferment. While at UCLA he represented the school in the All University Arts Festival at Berkeley. He saw ceramics students throwing irregular pieces and reported back to his home base about "those wild people up there." As he puts it, he "didn't grow up in the messy school." A contributing factor is that he studied piano for twelve years and was a music minor at UCLA. That order and discipline, plus training in musical analysis, helped him to under-stand structure in the textile medium.

After graduation he focused on a different context: for six years he was a high-school art teacher and continued to create sets for school plays. But change was afoot, as during his second year of teaching he bought a Gilmore loom and made a piece that was accepted for exhibition by the Southern California Designer Craftsmen. At the same time, he moved into a bland and relentlessly

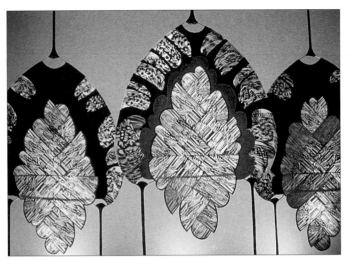

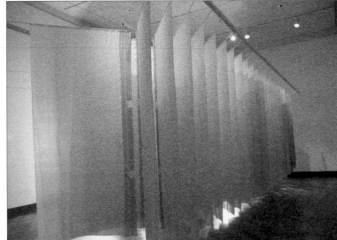

1.5 *Something to Do with Trees*, 1970 (C. 010) 1.6 *44 Panel Channel*, 1973 (C. 012)

rectilinear apartment and a light bulb went on in his head: he could reshape the space with fabric, as he did on stage.

Evolving Strategies

Knodel decided he should go to graduate school in textiles. He enrolled at California State University Long Beach to study with Mary Jane Leland. Textiles, like everything in the baby-boom, counterculture, anti-war decade, was changing. A major source of excitement came from Eastern Europe, where artists were creating huge works in rough or highly tactile materials, most famously Magdalena Abakanowicz and Jagoda Buic. An international tapestry biennial was established in Lausanne, Switzerland, in 1962. But its requirement that all submissions measure ten square meters in fact encouraged the development of new forms of textile expression. In New York City in 1963, the Museum of Contemporary Crafts (now the Museum of Arts and Design) presented six artists in a show called *Woven Forms*. The title, adopting a term from the leading figure, Lenore Tawney, sounded like an oxymoron, since weaving was by its nature planar—shapes, not forms. Tawney compressed and expanded the warp threads, used fringes to release the tension of lines and folds, and made strikingly tall works, an emblem of the growing ambition of the fiber field. In 1969, fiber works were shown at the Museum of Modern Art in an exhibition inadequately titled *Wall Hangings.*[5]

In this period of ferment, Knodel's graduate thesis work occupied a distinctive position between design, sculpture, painting, and architecture. He took "changing spaces in which we live" as a project. He made a "tailored environment, designed to create a formal, defined dining area. Woven of cotton, linen, and nylon, it incorporated mirror glass intended to reflect the lighting within the space." This *Dining Environment* (1970) pulled out from the wall and opened up to make an enclosed space. He was thinking of the environment under a lace-tablecloth-covered dining table.[6] This work was seen by Eudorah Moore and selected by her for the eleventh iteration of the prestigious *California Design* exhibition at the Pasadena Art Museum. Moore had taken over the show in 1962 and led it from a 1950s focus on well-behaved crafts for interior-design purposes toward one-of-a-kind and expressive works. (A number of fiber works were shown in *CD11*, representing

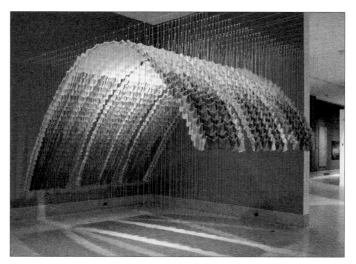

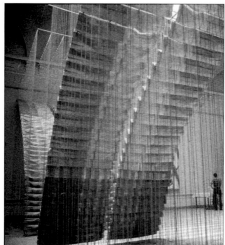

1.7 *Act 8*, 1974 (C. 025) 1.8 *Parhelic Path*, 1975 (C. 026)

such established interests as organic forms, textural emphasis, and ethnic textiles.) Knodel's *CD11*
appearance followed his selection for the prestigious *Young Americans* show at the Museum of
Contemporary Crafts and acquisition of his work by the important collector Robert Pfannebecker
of Pennsylvania.

Knodel's attraction to theatrical scale allowed him to think about fabric defining space (taking off
from theater's drop curtains and the tall stretched canvases called flats that illusionistically mark the
edges of stage spaces). That architectural capacity naturally brought tents to mind. Tents became an
ongoing interest, one that he began to research in his travels and that became part of a significant
collection of ethnographic textiles; travel, collecting and thus-inspired new works are inextricably
mixed in Knodel's life. Tents may be purely utilitarian, but examples from other cultures are also
highly decorative. It is interesting to compare such forms to art, architecture, and design of the 1960s
and 1970s—from the ropy entanglements of Eva Hesse and the draped felt masses of Robert Morris
to the parabolic curves in contemporary architecture and various chairs emphasizing containment
(egg or womb chairs). Knodel's free thinking about space came from a new direction. His idea
carries on in later works taking various approaches to cover, including his Canopies (*Woven Canopy,
Sunshades, Flying Canopy*, 1969, 1970, and 1971) and *Parhelic Path* and *Schoenbrunn Suite* (dis-
cussed below). The first historical textile in Knodel's collection was an Indian fabric with mirrors:
"You see yourself in the textile and the reflections appear to emanate light," he notes. The influence
on his later work is unmistakable. He has written of the fascination of collecting "the material
wealth of faraway places, distanced by time, yet accessible through tangible 'shadows' of people I
would never meet."[7] He felt that he could create such magic.

He observes that the spirit of that time in textiles was discovery—uncovering the secrets of the
past as fuel for the present (macramé for Claire Zeisler, tie-dye and other resist dye methods for
Marian Clayden). Increased air travel made it easier to go to exotic places and encounter their
textiles firsthand. Knodel traveled extensively in the 1970s and was able to see Afghanistan and Iran
and such places that political upheavals have rendered inhospitable today, as well as Turkey, India,
Indonesia, and elsewhere. Through his own experience and through ethnographic photographs of

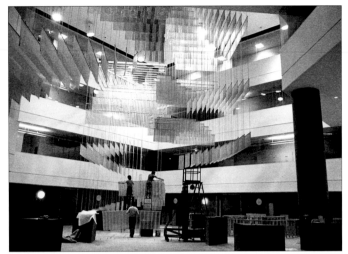

1.9 *FREE FALL*, 1977 (C. 029) 1.10 *GRAND EXCHANGE* (INSTALLATION), 1981 (C. 067)

things like wedding yurts of white felt, he saw what he calls "the wow! history of the decorative" that had fresh potential. Pop culture and alternative culture gave permission, but the only familiar examples of drawing inspiration from ethnic textiles were commercial fabrics by Jack Lenor Larsen, Alexander Girard, and others.

Knodel established a practice that he refers to as "evolving strategies," in which he works speculatively, always asking himself "what if?" The question can be addressed to a material or technique but also to the art world, the design world, or the world at large. It is his way of looking for "breathing space" in which to find his own way. He regards this as expressing the modernist ideal of progress. The process leaves plenty of room for intuition, for an image or solution to come to him indirectly and unexpectedly, "quite magically," he says.

As he completed his graduate work and it was chosen for *CD11*, Leland and Kester told him that a position was opening up at the Cranbrook Academy of Art—artist in residence, head of textiles— and he should apply. To his surprise, he was hired, straight out of graduate school. The selection committee told him they liked what he was doing. He arrived in Michigan in August 1970 and prepared new work to join his graduate school pieces for a Cranbrook Art Museum show that introduced him to the community. His first experience of colorful fall foliage inspired a piece called *Something to Do with Trees*. It consisted of four abstract shield shapes, each loosely suggesting a tree canopy and made of layers of wool, china silk, nylon, and polyester plus opaque screen printing and flocking. The compositions seemed to shift as the light source changed.

Textile Environments

A textile need not be applied to a wall. Knodel found a way to make it a physical experience by embedding the viewer in the work. This approach related to happenings, performance, and contemporary dance and yet was true to the nature of textiles. A significant work from his early years at Cranbrook was *44 Panel Channel* (1973), an ethereal corridor of china-silk panels through which viewers could walk. China silk offered color and flexibility, and it could move in space without a rigid armature, contradicting the hard surfaces of rooms, he noted. In this work color

 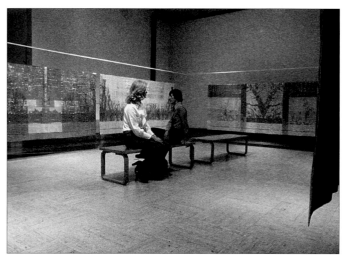

1.11 *Grand Exchange*, 1981 (C. 067) 1.12 *Schoenbrunn Suite*, 1979 (C. 046)

changed at the periphery of vision, and walking became an extension of breathing, in Knodel's view. This piece, like the *Dining Environment*, made a place, but this one was experienced fleetingly, kinaesthetically.

This work, while sensual, had a quality of precision and reserve; it contrasted to the "free" messiness of the concurrent counterculture. Consider, for example, the work of Barbara Shawcroft. Her *Arizona Inner Space*, an enterable environment of knotless netting measuring 17 by 6 feet, was also included in *CD11*. Although certainly highly structured, hers was a place of sensation and withdrawal in a hotter, rougher way.

Knodel's exploration of china silk in space lead to investigation of new ways that the fabric could become both sculptural form and an inhabitable and changeable construction. His *Act 8* could be compressed against a wall, or be expanded into a flexible environment offering numerous possibilities for configuration. When fully opened it became a gentle fabric shelter responsive to illusive qualities of air movement, changing light, and the physical presence of inhabitants.

In 1975 Knodel submitted to the Lausanne Biennial *Parhelic Path*, a "conversation with architecture" that respected tapestry but left the wall. The piece was woven in his studio, with his assistants "chained to the loom," he jokes. It consisted of two pairs of suspended arcs of fabric, sweeping gestures that come close together near the floor, but far enough apart that a viewer could walk between them. That year he also went to the Basel (Switzerland) art fair, which was dominated by grids and systems, such as the work of Hanne Darboven, Sol LeWitt, and artists using language. As he saw it, textiles were the place where structure and the decorative came together. He envisioned combining Mies van der Rohe's International Style architecture with the sensibilities of an Afghan tent. After making a few generous-sized pieces for corporate offices, he had his first chance to play out this notion in monumental scale with an atrium piece for the Plaza Hotel in Detroit's Renaissance Center in 1977.

Free Fall, 70 feet tall and 15 feet wide, was a balletic configuration of swan-diving lengths of fabric. Viewable from afar as an overall composition, the piece also offered intimate views from each atrium balcony in its segmented descent from a skylight to a reflecting pool at ground level.

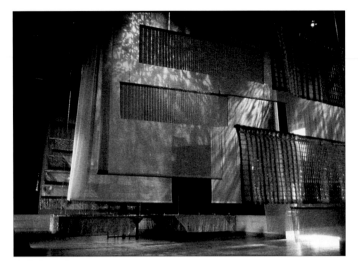

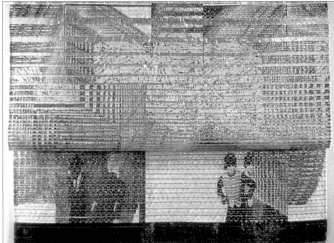

1.13 *ENTR'ACTE,* 1983 (C. 102) 1.14 *SOUVENIR,* 1982 (C. 084)

Corporate commissions led him away from china silk, which was impractical in terms of mainte-
nance and durability, he says. In this work he used wool weft that transmitted light and metallic
Mylar in the warp that caught and reflected light, or sometimes was transparent.

This and several subsequent commissions were unique in public art of this scale because they
came from the perspective and practices of a maker. Whether the fabric was woven in Knodel's
studio or by the Churchill Weavers of Berea, Kentucky, it was hand-woven, and the projects
challenged preconceptions from both the craft side and the design side. Knodel was the first to see
how panels of fabric cutting through space could relate to and expand upon architectural structure.

Another notable piece, *Grand Exchange for Cincinnati Bell* (1981), was like a deck of cards flying
sequentially between the hands of a magician. Repeated flat planes make a three-dimensional space
in what Knodel calls slices of reality. He was again thinking back to illusions in theater. The differ-
ence was the clarity of his complex compositions, absence of imagery, and the conciseness of the
elements. These large-scale designs relied on model-making as well as the ability to envision both
planes and color in space. The stair-stepped hanging pieces were conceived to show their origin in
textiles in that they draped, their textures changed appearance with changes in light, and there could
be a degree of movement. He was thinking, he explained in another context, of the objectness of
fabric, which has a front and a back. People seemed to grasp that the softly cascading planes were
just what the buildings needed.

He explored space in other ways in personal works. *Schoenbrunn Suite* (1979) consisted of six
abstract woven panels that framed a 14-by-20-foot space. Two benches within invited viewers to
study the nonspecific but suggestive tapestries, which were inspired by the Gardens of Schoenbrunn
near Vienna. Knodel notes that the panels are not narrative or sequential, yet each enriches the
others by its presence. And then there is *Entre'acte,* his piece for the 1983 Lausanne Biennial, in
which a person sits on a chair in a framed space enclosed by layers of varying draped fabrics, like
translucent "stage flats."

Corporate commissions continued into the 1980s, the "money" decade when crafts—particularly
glass—became high-priced, when post-modernism dominated architecture, when "over-the-top" was

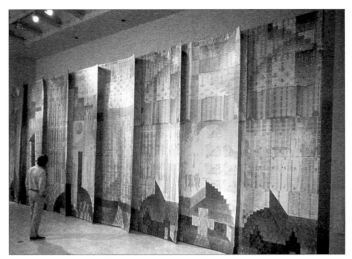

1.15 THE *PONTIAC CURTAIN,* 1982 (C. 100)

1.16 THE *PONTIAC CURTAIN* IN PROCESS, 1982 (C. 100)

the word in painting and sculpture by practitioners such as Julian Schnabel, David Salle, and Jeff Koons. Knodel made a policy of accepting only offers that allowed him to discover something new and refusing to simply repeat. Corporate commissions gradually diminished but public works did not cease. (Recent examples include two large-scale works for the William Beaumont Hospital, Royal Oak, Michigan, in 1996 and 2005.)

As early as 1979 Knodel began to explore photographic imagery. He wanted to reflect the real world (a recurring urge), and the tapestry method would have been terribly time-consuming. He screen-printed photographic images on cotton twill tape which was then used as a weft element to construct an abstracted picture that, as he has put it, "inhabits" the textile. Here Knodel deals with explicable content, in addition to the dazzling formalism of colored planes moving in space that had been his signature up until that time. His shift subtly echoes the movement of the art world toward sociopolitical and analytical expression in those days. But that may be simply coincidental, and the change the consequence of his personal experiences. He believes that in such works the structure of the textile must be as strong as the image it carries, and the structure of repetition is about what he is.[8]

Souvenir (1982) was the first work to use figures, but *Pontiac Curtain,* created that same year, was perhaps his most powerful early expression. *Pontiac Curtain* is a reflection of his studio environment in the town of Pontiac, where he bought an old building in 1980, renting out the upper floors and making the storefront his studio. (Five years later he bought a smaller and more derelict building next door; opened to the rafters and with the rotted floor removed, it became an open three-story space that allowed him to see his large works in full.) The shadowy images on the curtain are derived from his posed photos of customers at a nearby diner, so it is a portrait of a community at a certain time. He presented the figures and streetscape on a heroic-scale tapestry (eight panels adding up to roughly 14 by 36 feet); at the same time it is impossible not to think of the economic tragedy of Pontiac and the American automotive industry (although the city today is on the upswing). But more, it is another example of Knodel striving not just to be personal but to find larger implications, whether space, time, memory, or hope. A number of 1980s pieces involved architectural or human

1.17 JACQUARD LOOM AT RHODE ISLAND SCHOOL OF DESIGN, 1982

1.18 *JACQUARD SUITE #8,* 1982
(C. 095)

imagery, abstracted to varying degrees. Around the same time he was able to experiment with imagery on the Jacquard loom at the Rhode Island School of Design.

Other Engagements

As Knodel was creating colorful, responsive environments in the sky, so to speak, "installations"—temporary arrangements of multiple elements—were becoming increasingly common in the art world. Given textile's flexibility and adaptiveness, the very idea of a tent as an enclosure for events, and the fact that he had already made *Dining Environment* and *44 Panel Channel*, it was inevitable that Knodel would expand that vein. His interest in the textile division of space (for that matter, he has regarded all textile forms, including garments, as defining space[9]) was carried out in installations in a variety of venues. At ground level he could further develop notions of layering and veiling, so that viewers' visual experiences changed as they moved through the space.

One of his most admired installations was mounted in Seattle in conjunction with a meeting of the Surface Design Association in 1991. Titled simply *Walls*, it involved layers of nearly invisible black netting within a dark gallery, interspersed with screen-printed images on cotton cloth backed with colorful silks that were cut into strips and laced through the netting. Motifs included large heads in profile, empty picture frames, and abstracted birds in flight. The dominant color progression moved from darkness to heat, passion to light.

Relatively Yours, installed at a Michigan community college in 1997, included panels perforated with the names of unrelated famous people who share a last name; projected light cast the names from opposite directions (and thus irreconcilably) upon viewers wearing provided white T-shirts. This perforation grew out of his conception that drilling a sheet of polycarbonate plastic was parallel to the needle of an embroiderer penetrating fabric—but in this case material was removed instead of added. Then he passed light through the "fabric" rather than thread. The projection of light necessarily creates shadows as well, which he can manipulate dramatically or subtly. Knodel created a different configuration of words and shadows as a permanent work for a Michigan public library in 1998, with a congeries of letters seeming to hover at the ceiling and cascade downward on barely

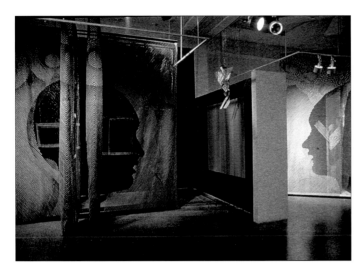

1.19 *WALLS,* 1991 (C. 162)

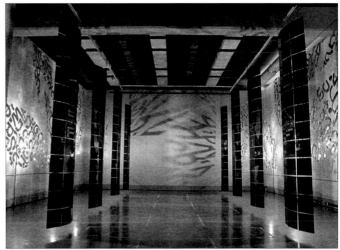

1.20 *RELATIVELY YOURS,* 1997 (C. 199)

visible netting. In *Skydance at the Western Gate* he made shadows a positive rather than negative element, in an example of his characteristic layering that is both tangible and intangible.

Skydance was in some sense an exception, for in the next phase of Knodel's career, his decade as the director of Cranbrook, he was able to do almost no studio work. When he returned to the studio full time on his retirement, he began afresh. He was working in a new way, usually alone, whereas he had previously always had at least one assistant and, on the big projects, as many as fifteen. In retirement, he notes, he was working for no purpose except satisfying himself. Unlike today's students, he comes from a place of distance between art and craft. Still concerned with bridging, with remembering where he has come from, he devised a game theme that may have larger applications to the art world or even to the more general conditions of life. He is trying to open up things so that our history comes back and we respond in a new way. But it is hard to avoid thinking that he also explicitly marks his return to the game of art, recognizing that rules and conditions have changed.

Reconsidering the more abstract works, it can be seen that Knodel was often looking at interval, the space "between"—what the Japanese call *ma.* He placed a viewer between projections, worked with shadows, used thin cords like a veil to separate inside from outside, or otherwise sought to define a space and make it alive. It is possible to look at this approach and assume that when he used images he was doing something else entirely, but that is not quite right. He is always concerned with relationships, with the meaning of structure within and between cloth, with metaphors, with context, with the literal and direct, but also a larger picture. "[T]he pliability, vulnerability, and responsiveness of fabrics allow them to be a perfect metaphor for humanness," he once wrote,[10] and that sensibility is rarely absent from his work; he expresses it through abstraction or representation. As an educator, Knodel can spell things out, naming a reason for everything; nothing happens by chance, whether the work is purely formal or narrative. His creativity has been constant, as he chooses to activate space, to create an illusion, to evoke memory, to manipulate metaphor, to charge life with color, to transfer the magic of theater from a dark box to the illuminated realm of the everyday.

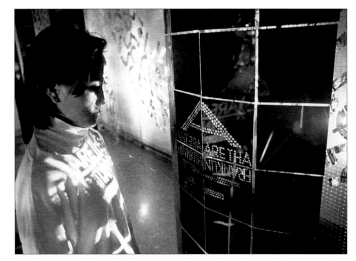

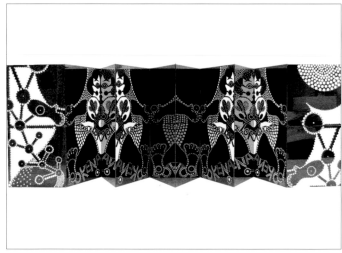

1.21 *Relatively Yours*, 1997 (C. 199)

1.22 *The Lorena Twins and Their Offspring #2*, 1998 (C. 203)

Notes

1. Knodel, who both speaks and writes very articulately, leaves little for a critic to invent. Quotations and paraphrasing without attribution in this essay are based on interviews with the artist, June 17–19, 2014.

2. These were productions of the Los Angeles Conservatory Opera Company, which performed at various locations throughout Southern California.

3. See, for example, Erhard Bahr, *Weimar on the Pacific: German Exile Culture in Los Angeles and the Crisis of Modernism* (Berkeley: University of California Press, 2007).

4. Most notable, perhaps, were the multiple exhibitions in 2010 funded by the Getty Foundation under the rubric "Pacific Standard Time." In addition to the numerous "Pacific Standard Time" catalogs, see Peter Plagens, *Sunshine Muse: Art on the West Coast, 1945–1970* (Berkeley: University of California Press, 1974, 1999).

5. The exhibition was curated by Mildred Constantine and Jack Lenor Larsen, who went on to produce two important books on the new textiles: *Beyond Craft: The Art Fabric* (New York: Van Nostrand Reinhold, 1973) and *The Art Fabric: Mainstream* (New York: Van Nostrand Reinhold, 1981).

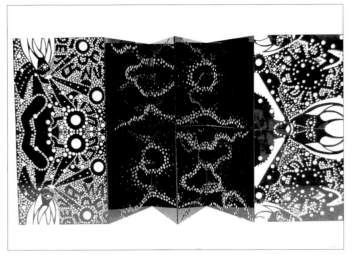

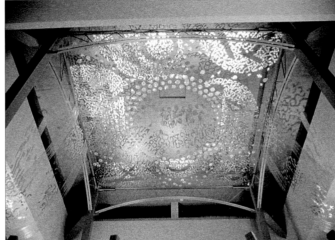

1.23 *DEVIL MUSIC,* 1998 (C. 207–210)

1.24 *SKYDANCE AT THE WESTERN GATE,* 1998 (C. 215)

6. Jo Lauria and Sue Baizerman,
 California Design: The Legacy of West Coast Craft and Style
 (San Francisco: Chronicle Books, 2005), 7.
7. From the leaflet for *Southeast Asian Textiles: Selections from the Gerhardt Knodel Collection*
 (SUNY Cortland, Dowd Fine Arts Gallery, 1994); it includes a wonderful account of his collecting
 experience in Indonesia.
8. Repetition "is fundamental to all existence" he wrote in gallery information
 for *Gerhardt Knodel: Skywalking* (Royal Oak, MI: Sybaris Gallery, 1998).
9. Leaflet for *Mysterious Voids at the Heart of Historic Textiles:*
 A Search for Meaning (Washington, DC: The Textile Museum, 1995).
10. Proposal to US/Japan Exchange Fellowship Program, 1985.

2.
Portfolio: A Gallery of Images, 2005–2014

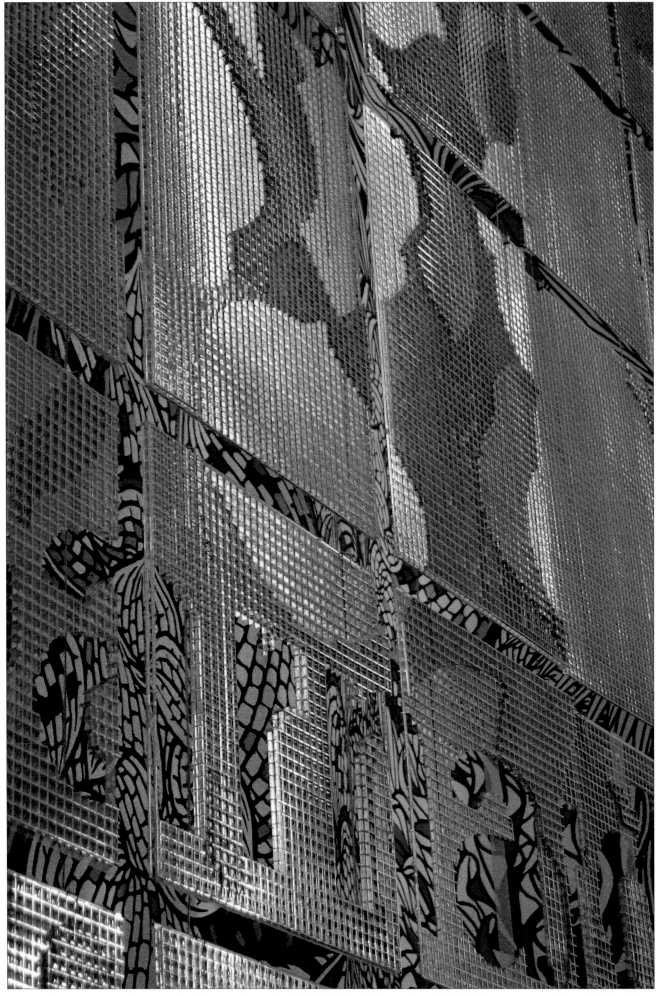

THE ECHO OF FLORA EXOTICA, 2005 (CHRONOLOGY 216, 217, 218)

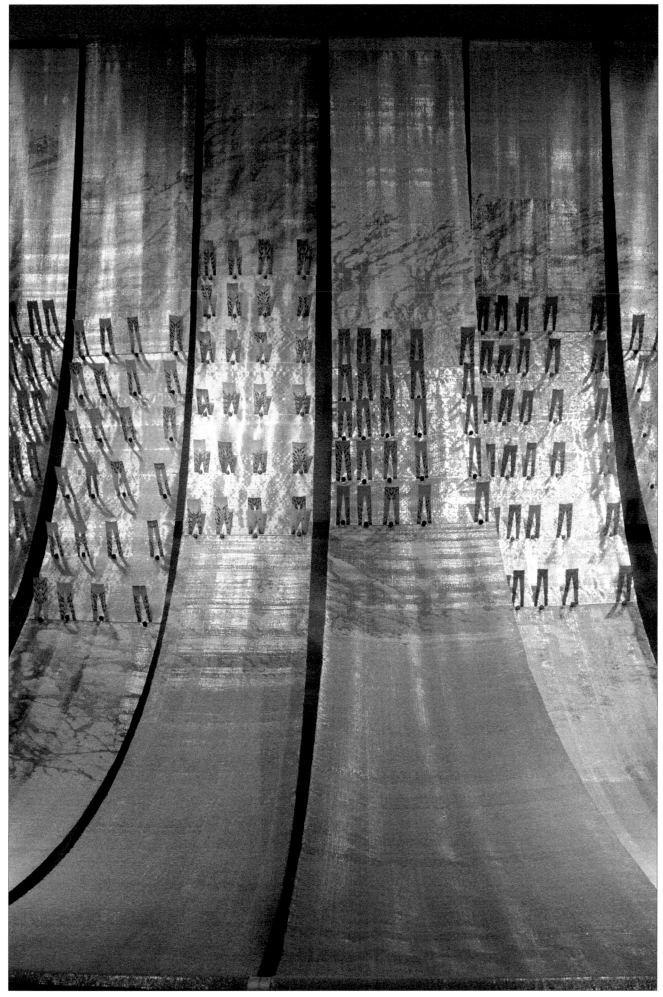

RECOVERY GAMES: AT THE READY, 2008 (C. 224)

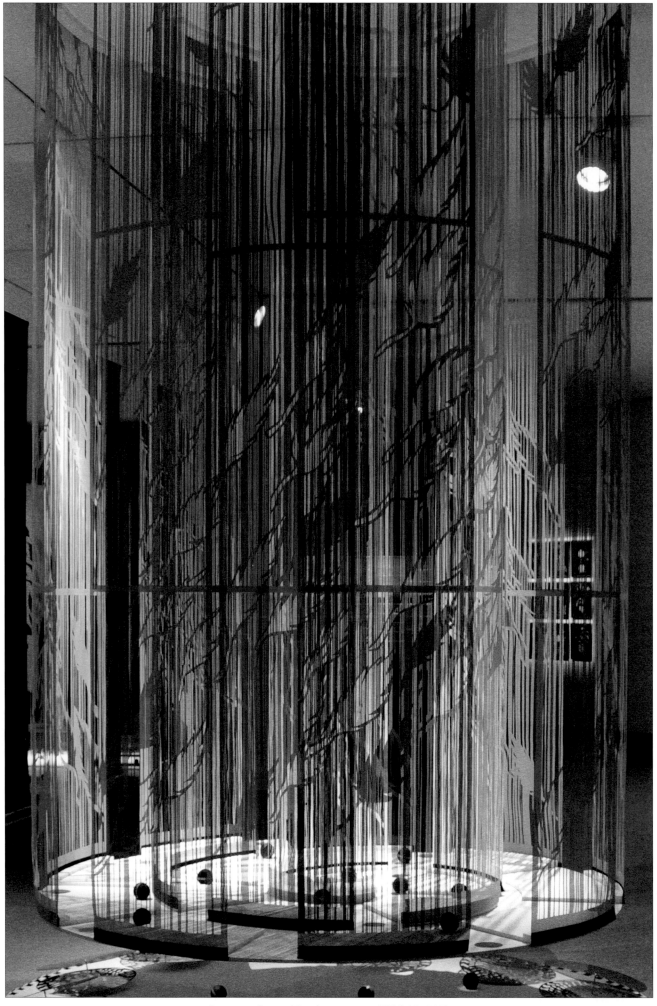

RECOVERY GAMES: THE ACCELERATOR, 2008 (C. 219)

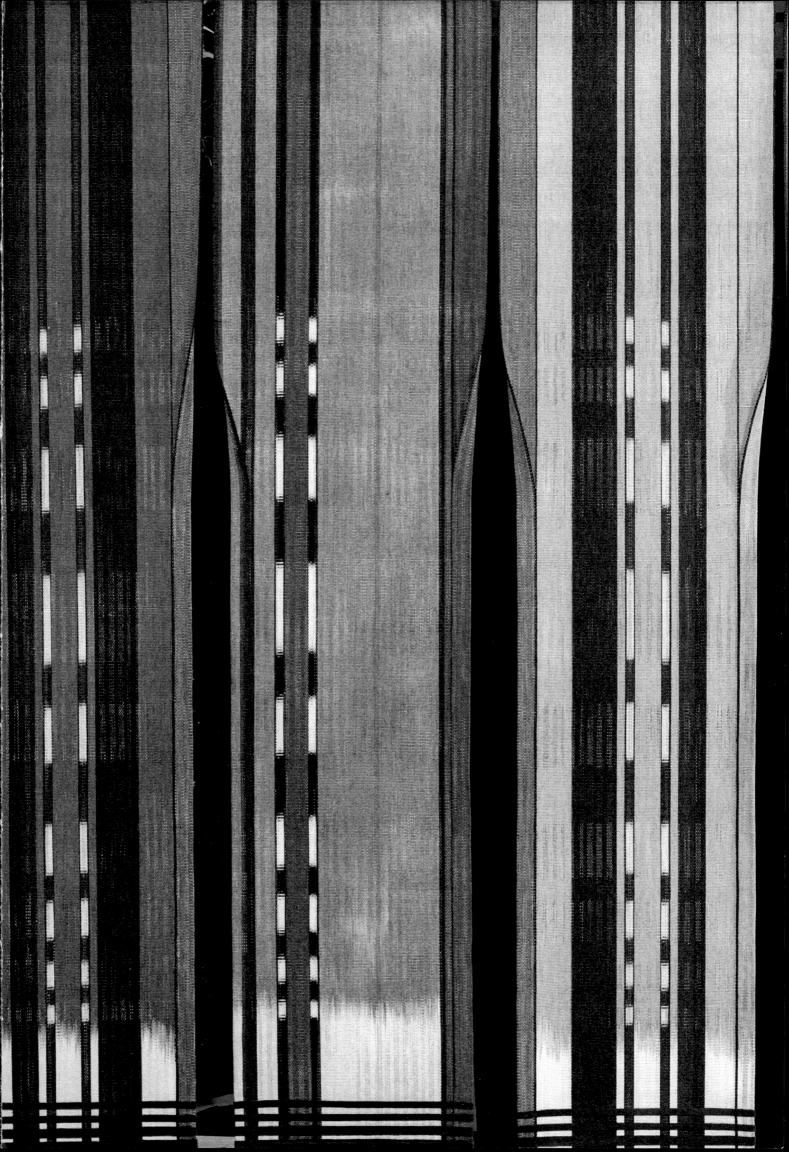

Calvino's Curtain: Invitation to a Future (in open position), 2014 (C. 267)

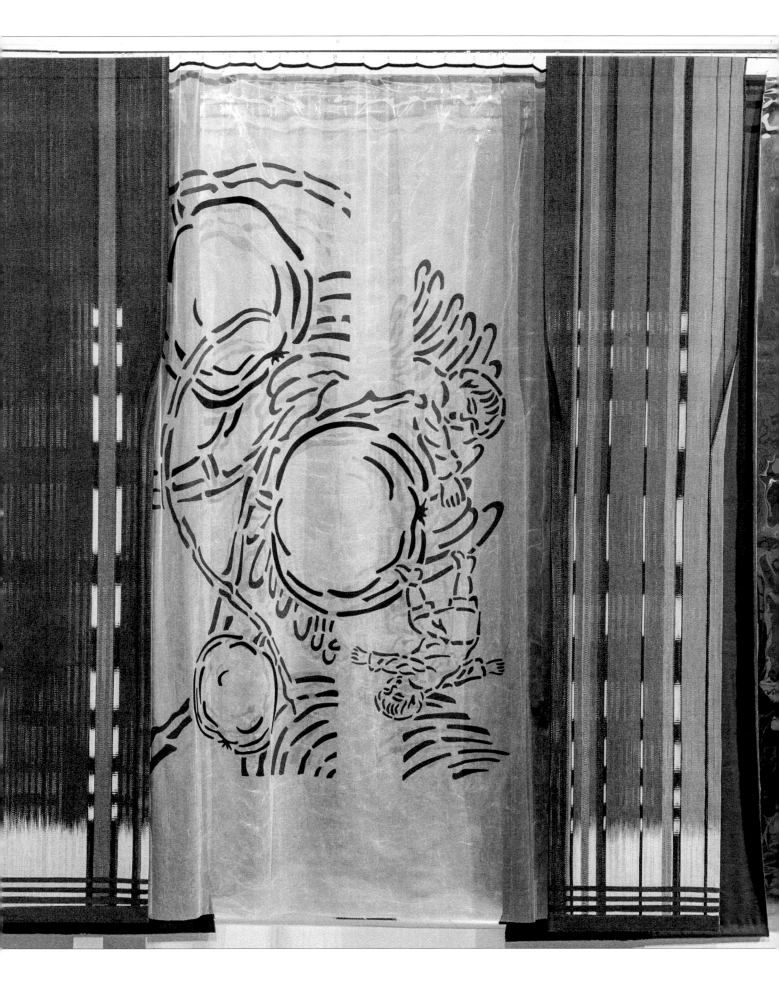

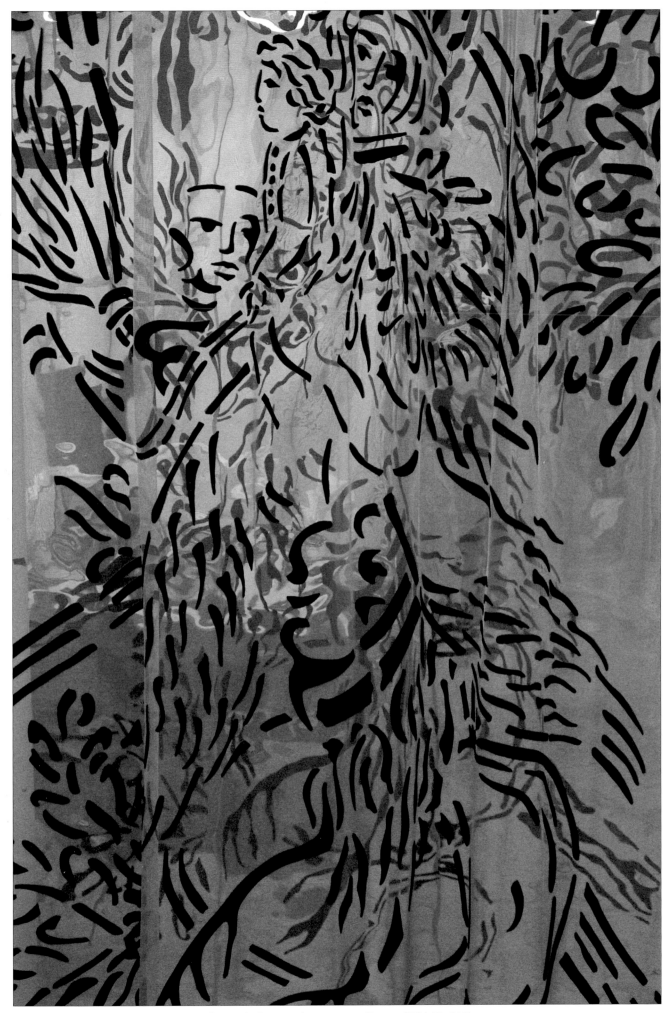

CALVINO'S CURTAIN: INVITATION TO FUTURE, 2014 (C. 267)

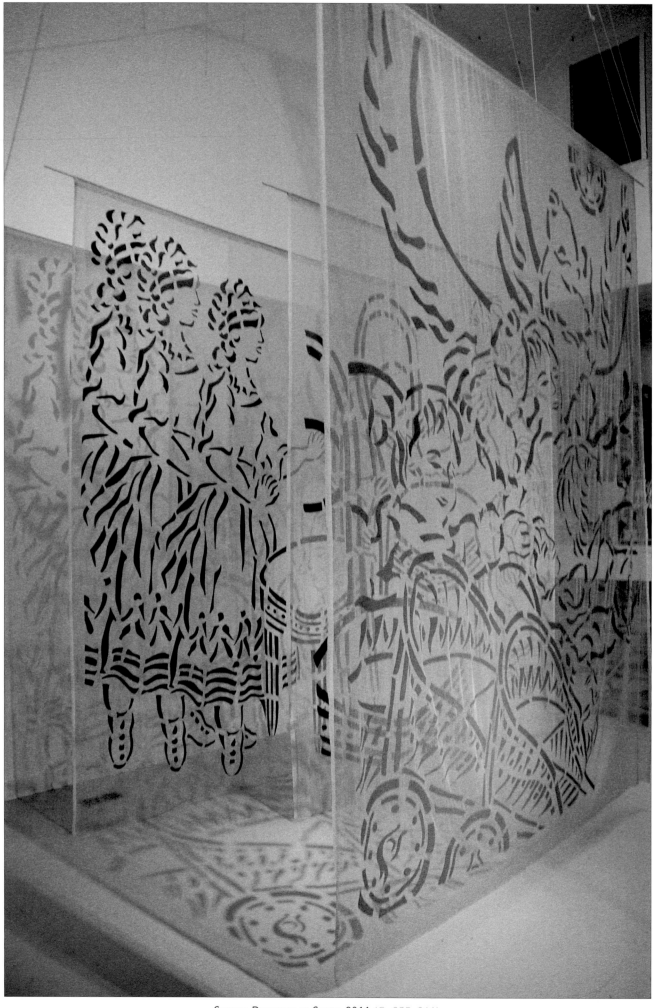

STENCIL DRAWINGS IN SPACE, 2011 (C. 255–261)

STENCIL DRAWINGS IN SPACE, 2011 (C. 255–261)

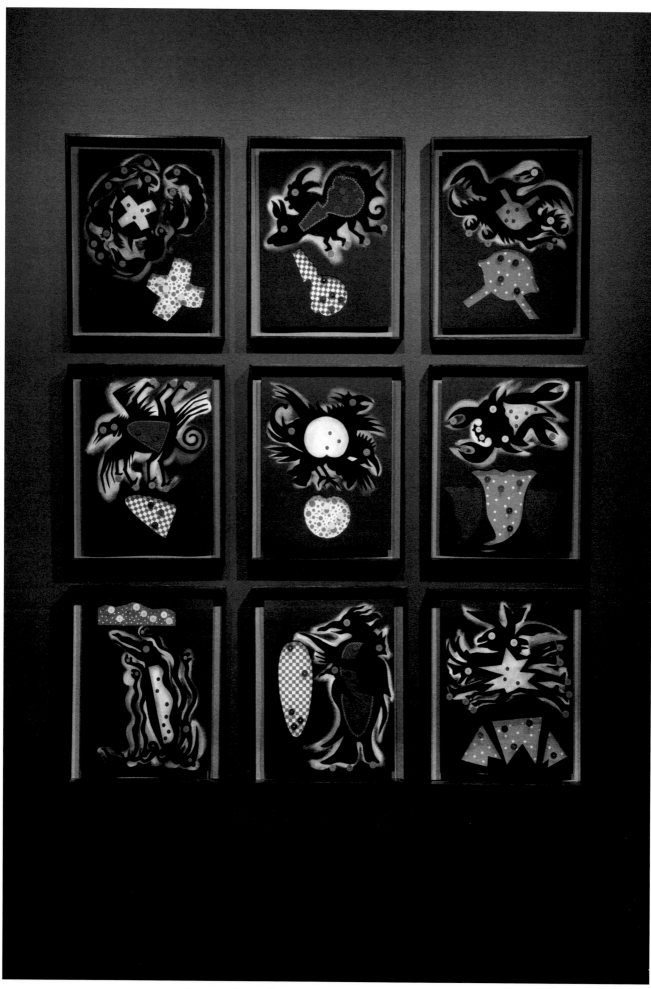

RECOVERY GAMES: STRANGE ENCOUNTERS, 2007 (C. 225–233)

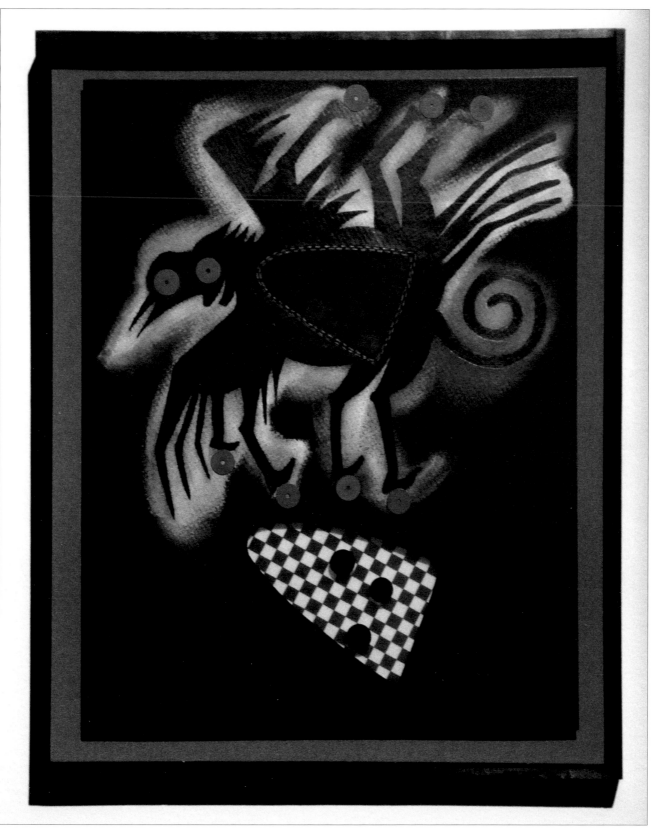

RECOVERY GAMES: STRANGE ENCOUNTERS, 2007 (C. 225–233)

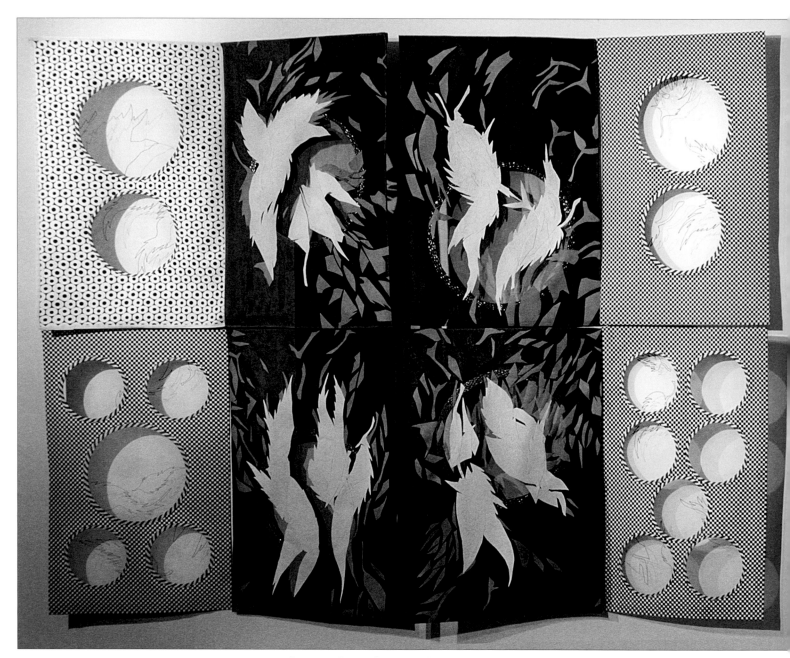

RECOVERY GAMES: SKEEBALL, 2007 (C. 223)

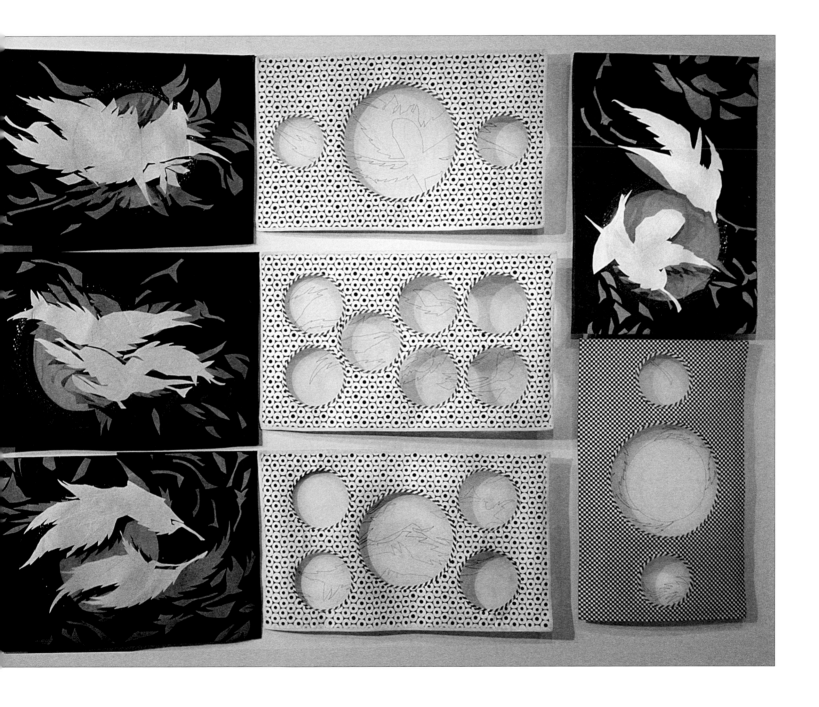

PROLIFEROUS POSSESSIONS POSSESSED, 2010 (C.241)

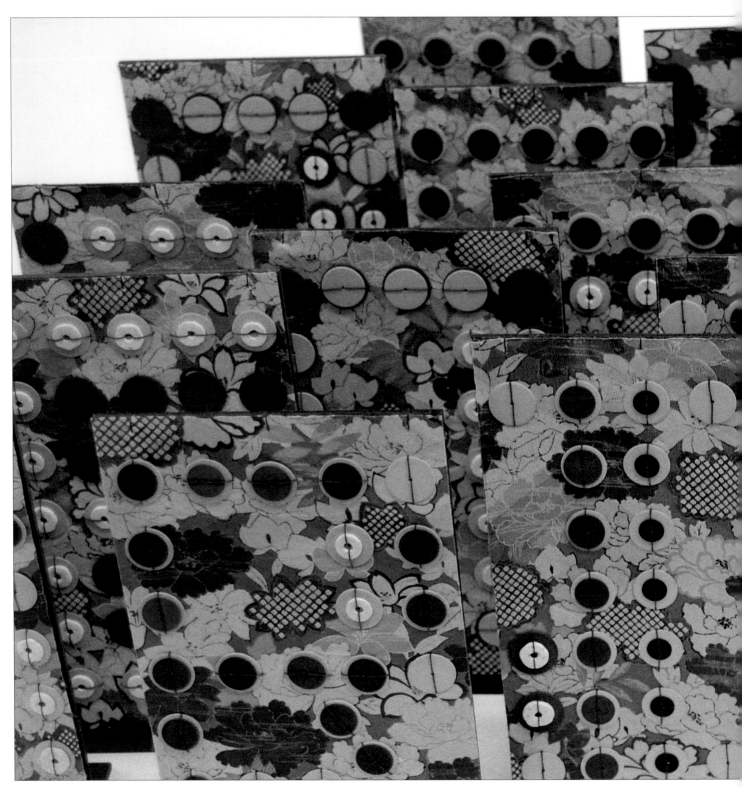

P/R/O/L/I/F/E/R/O/U/S/ P/O/S/S/E/S/S/I/O/N/S, DETAIL, 2010 (C. 241)

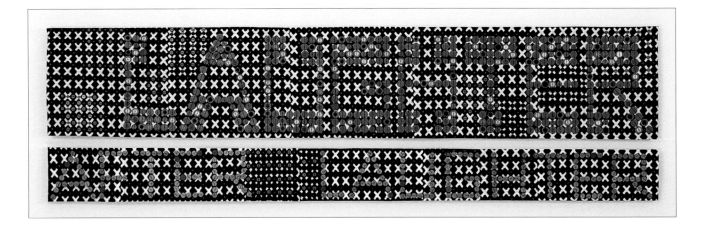

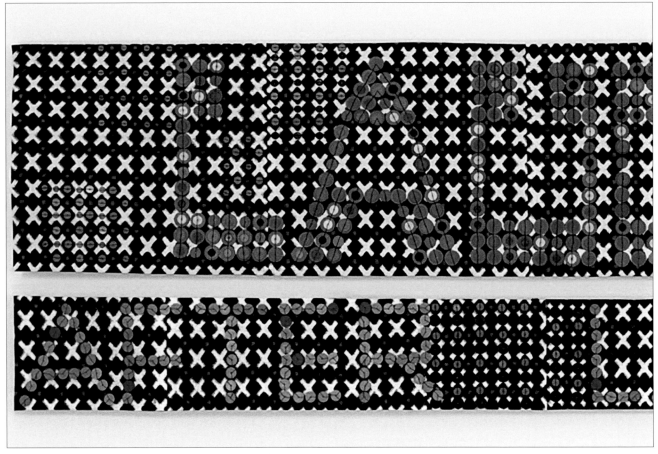

Laughter/After Laughter #1, 2009 (C. 236)

LAUGHTER/AFTER LAUGHTER #2, 2009 (C. 237)

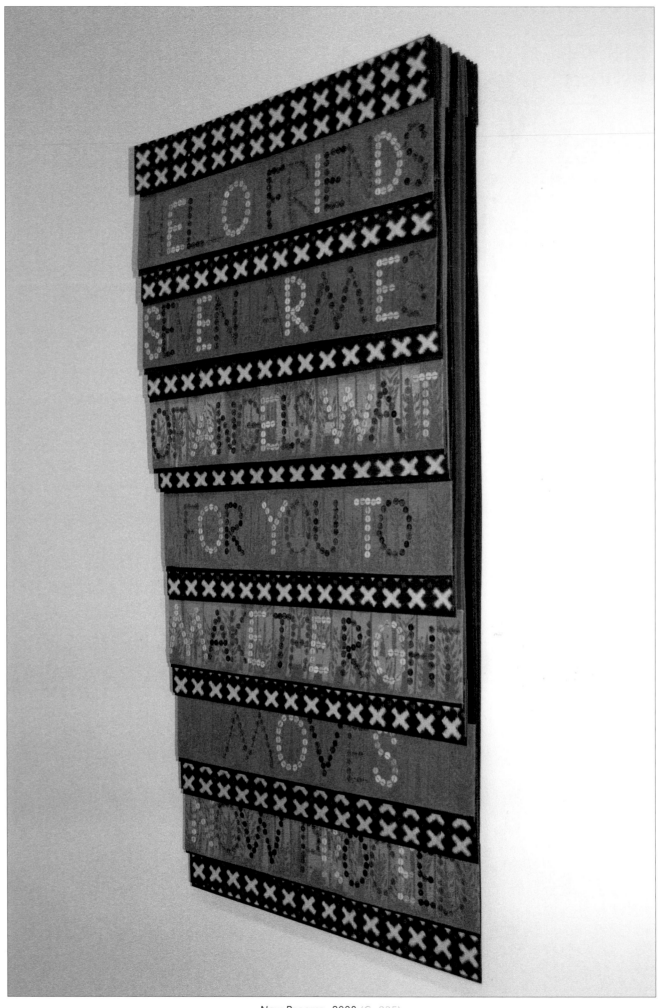

Now Proceed, 2008 (C. 235)

TEXTILE TRACES, 2008 (C. 234)

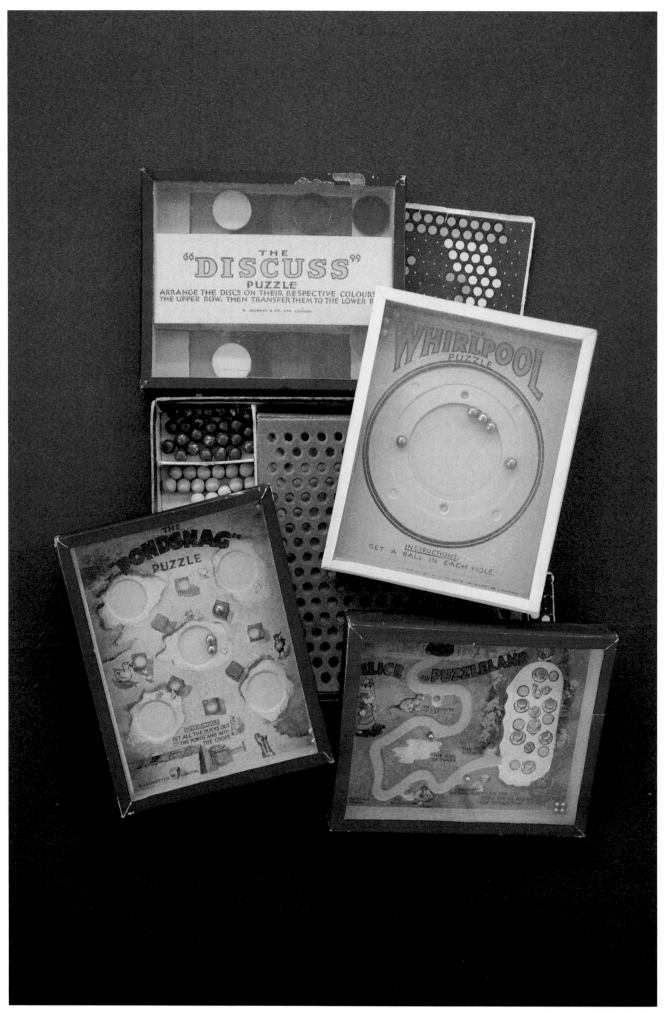

COMMERCIAL DEXTERITY GAMES, 19TH AND 20TH CENTURIES

FEEDING FRENZY-BLACK, FEEDING FRENZY-RED (C. 246, 247)

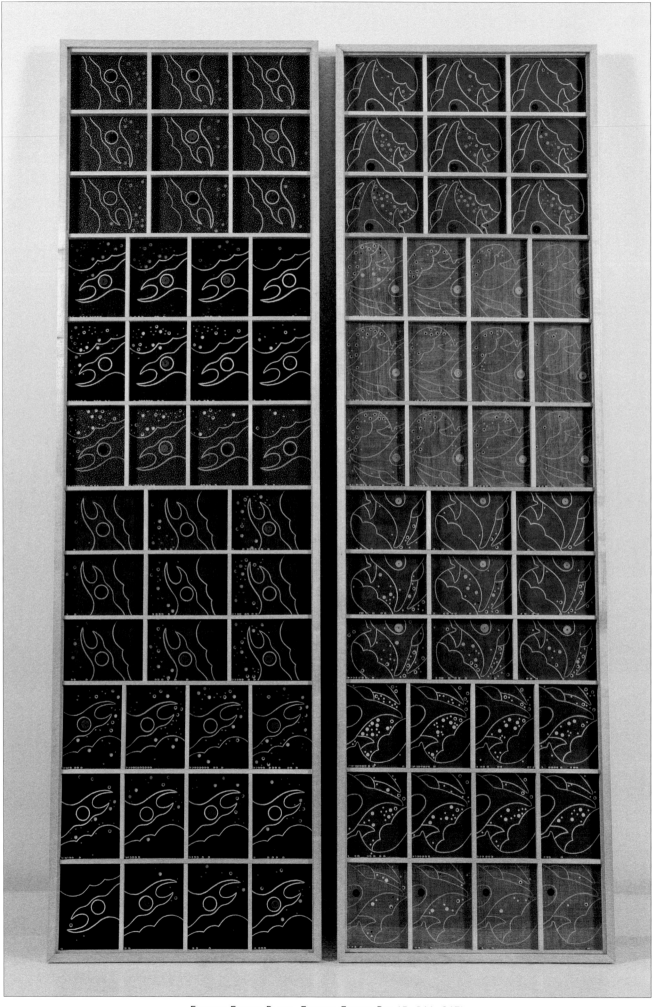

Feeding Frenzy-Black, Feeding Frenzy-Red (C. 246, 247)

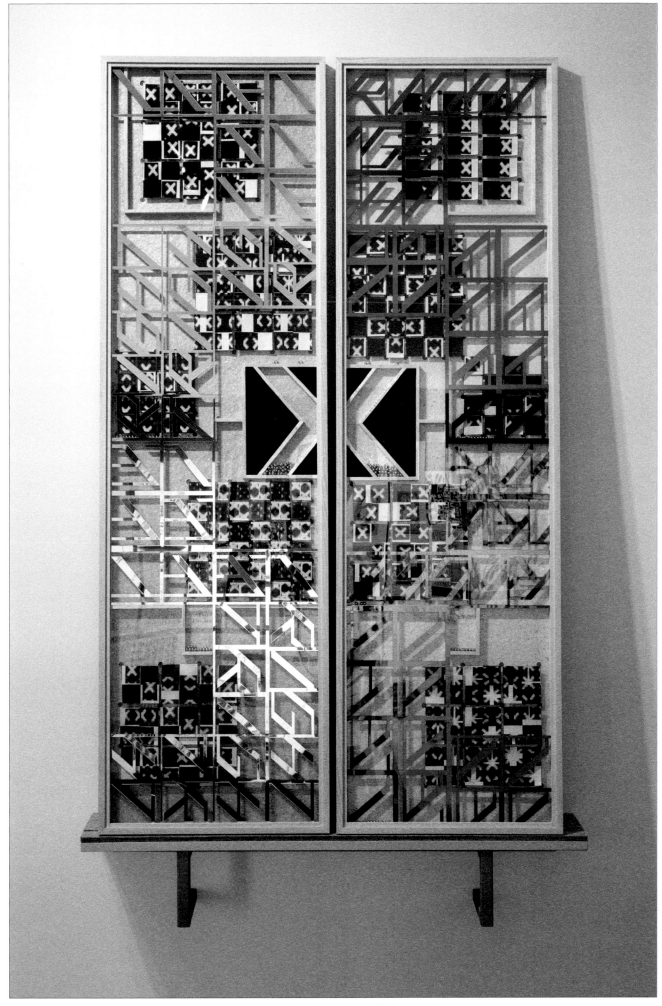

Left, Right, Left-Right-Left, 2010 (C. 239)

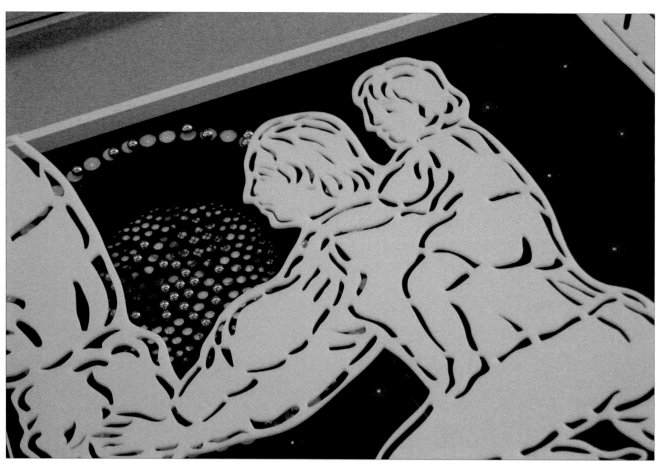

LEARNING TO ACT/ACTING TO LEARN: SIX TIMES EIGHT (DETAIL), 2010 (C. 245)

HOPSCOTCH (DETAIL), 2010 (C. 248)

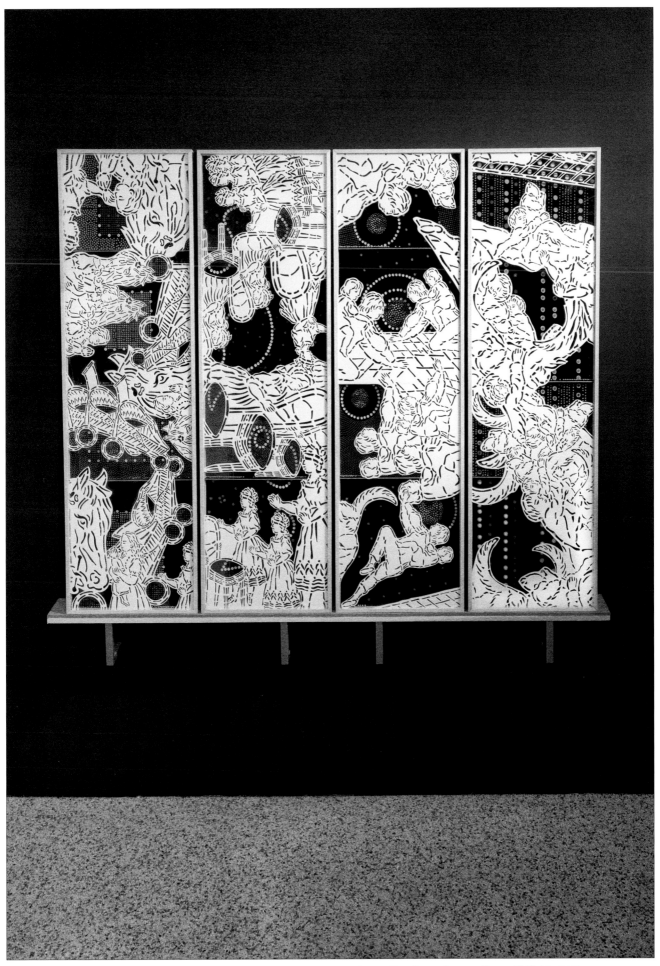

Learning to Act/Acting to Learn: Gaze; Risk; Six Times Eight; The Other Side of Cold, 2010 (C. 245)

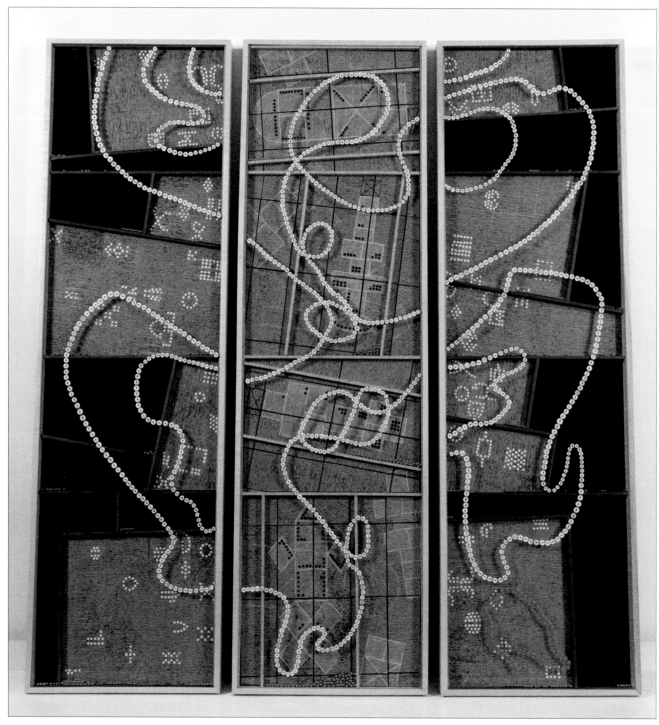

HOPSCOTCH, 2010 (C. 248)

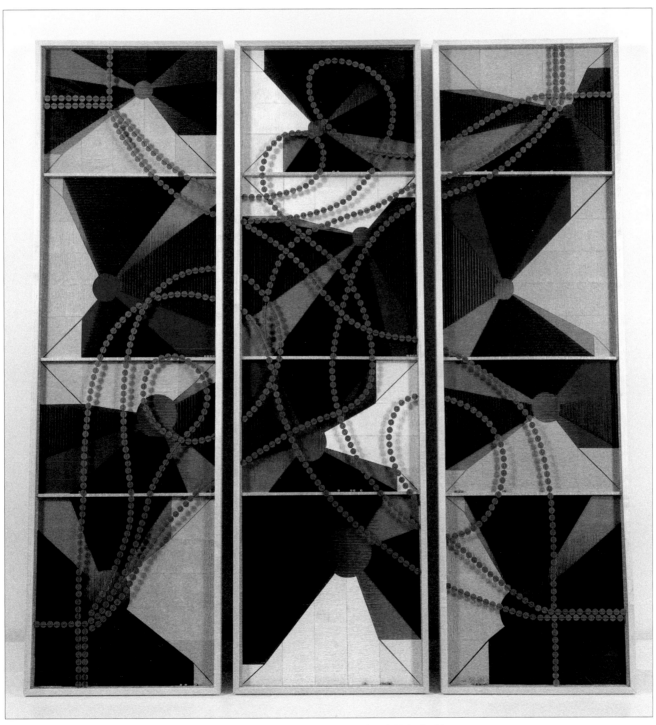

GATHERING FOUR CORNERS OF THE SKY, 2011 (C. 251)

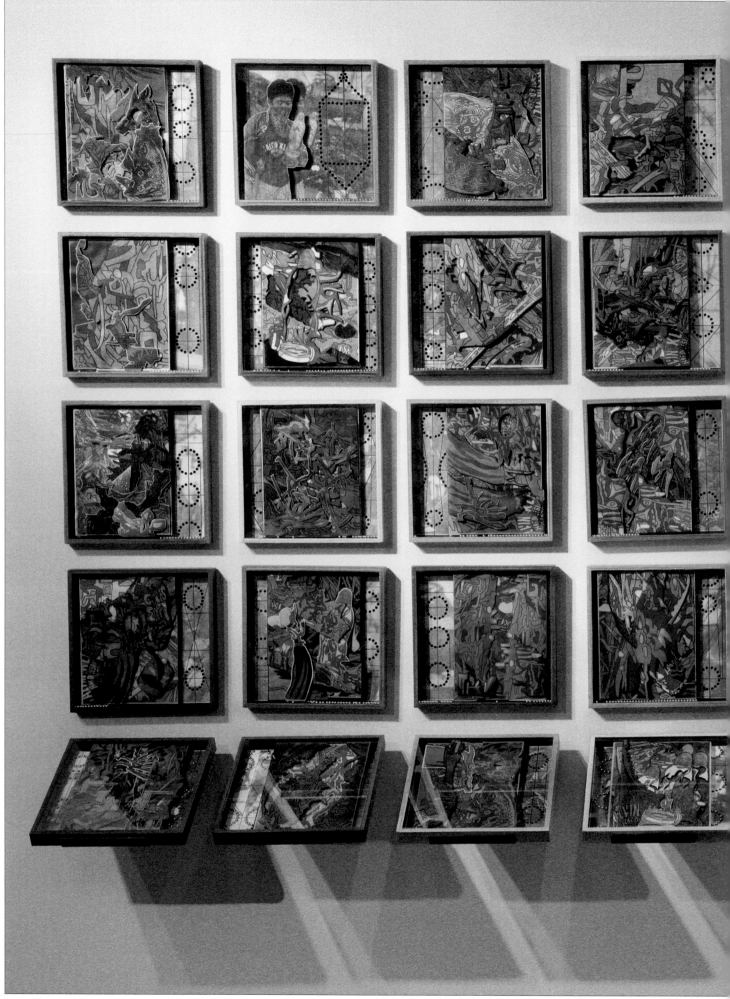

START ALL OVER AGAIN, 2014 (C. 268–291)

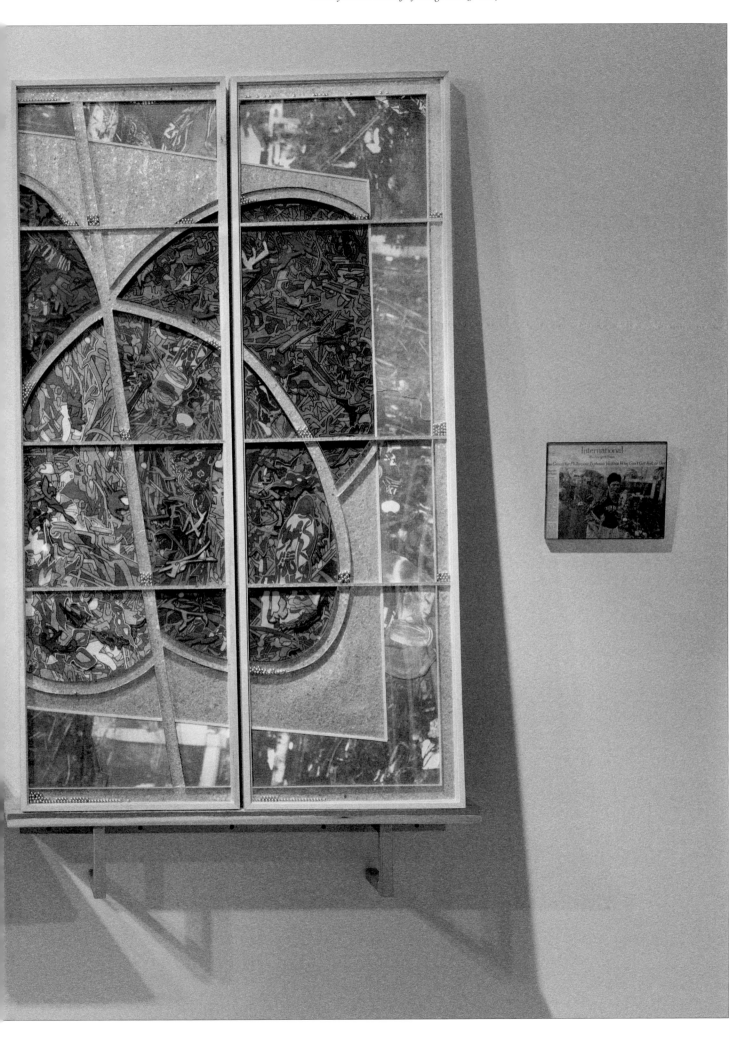

WHOOSH (DETAIL), 2011 (C. 252)

WHOOSH, 2011 (C. 252)

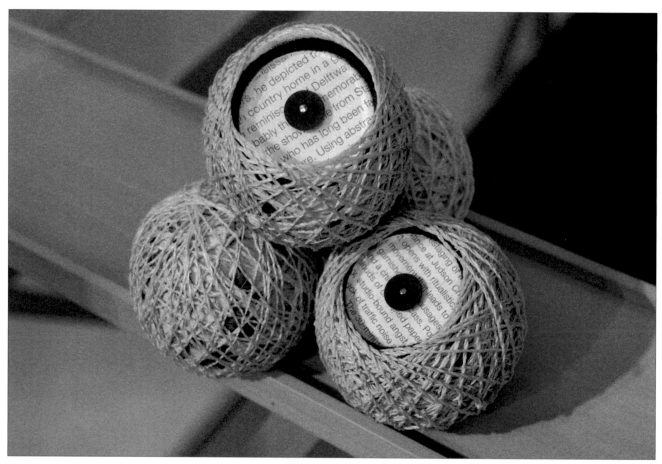

WHOOSH (DETAIL), 2011 (C. 252)

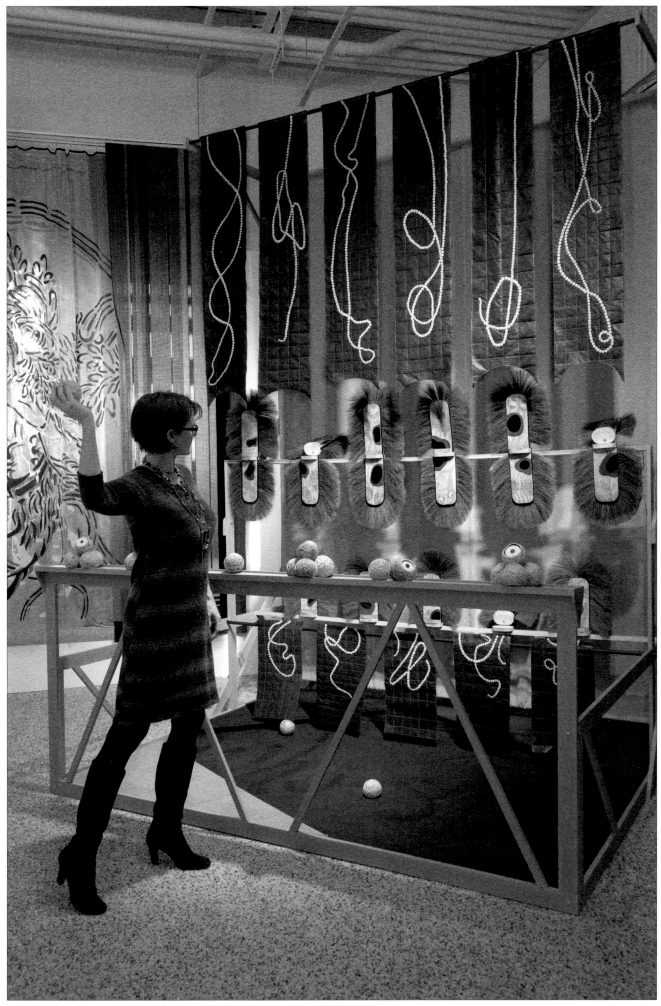

Whoosh (playing the game), 2011 (C. 252)

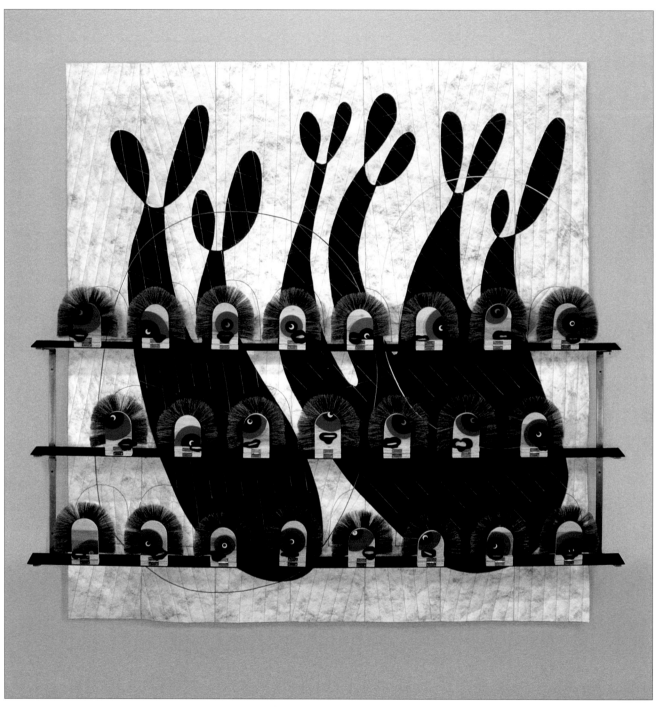

Do You See What I See?, 2011 (C. 254)

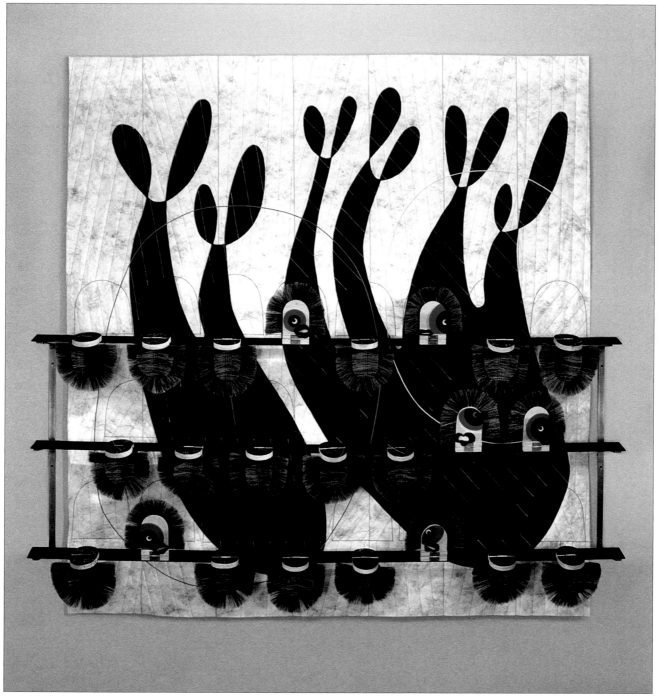

DO YOU SEE WHAT I SEE?, 2011 (C. 254)

Do You See What I See? in construction, 2011 (C. 254)

63

DO YOU SEE WHAT I SEE? (DETAIL), 2011 (C.254)

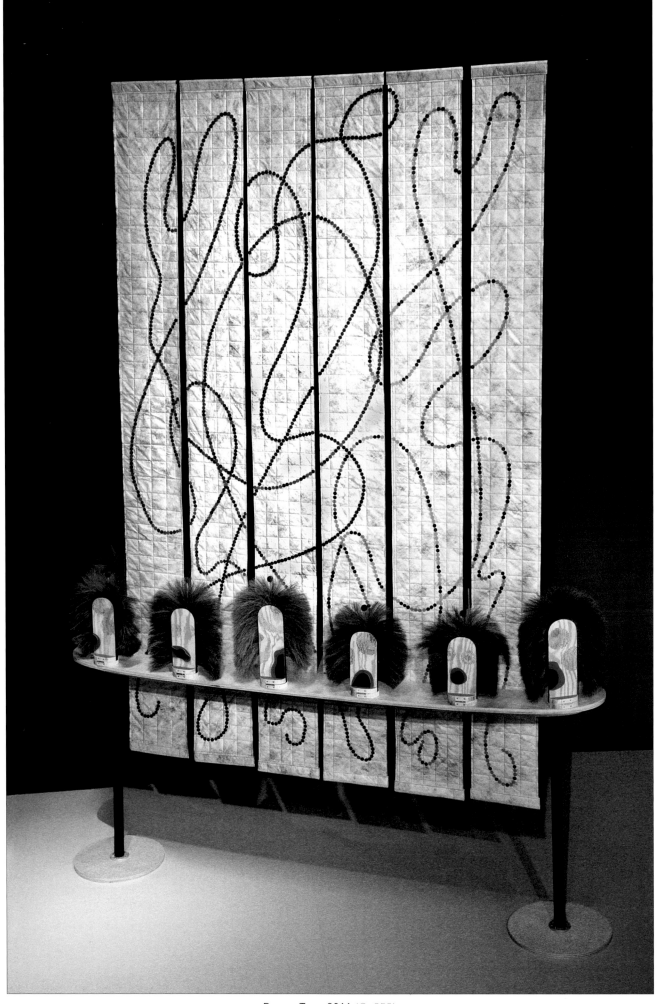

Dinner Talk, 2011 (C. 253)

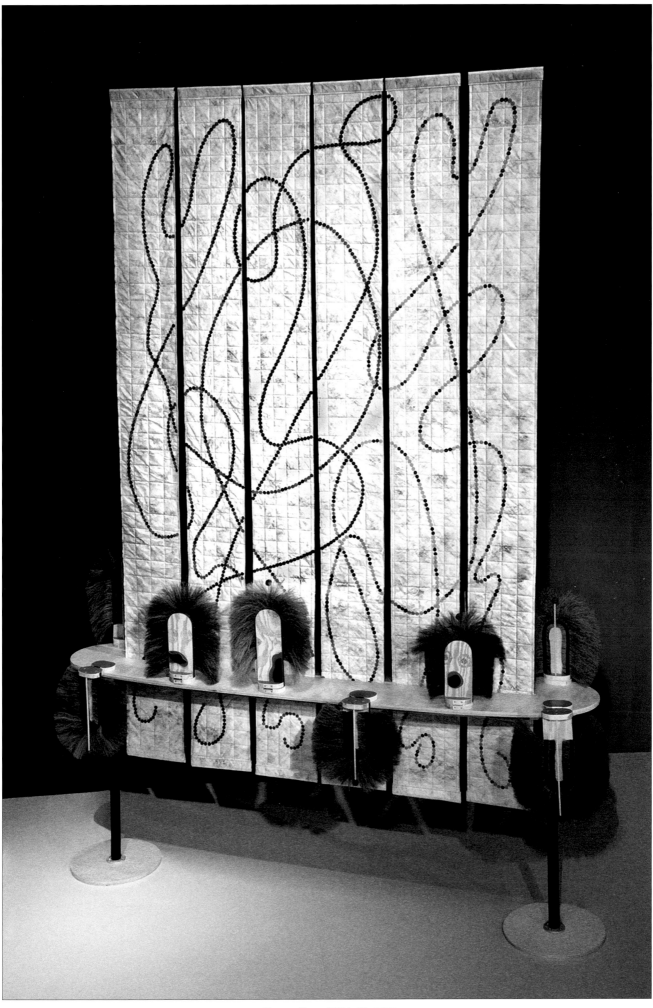

DINNER TALK, 2011 (C. 253)

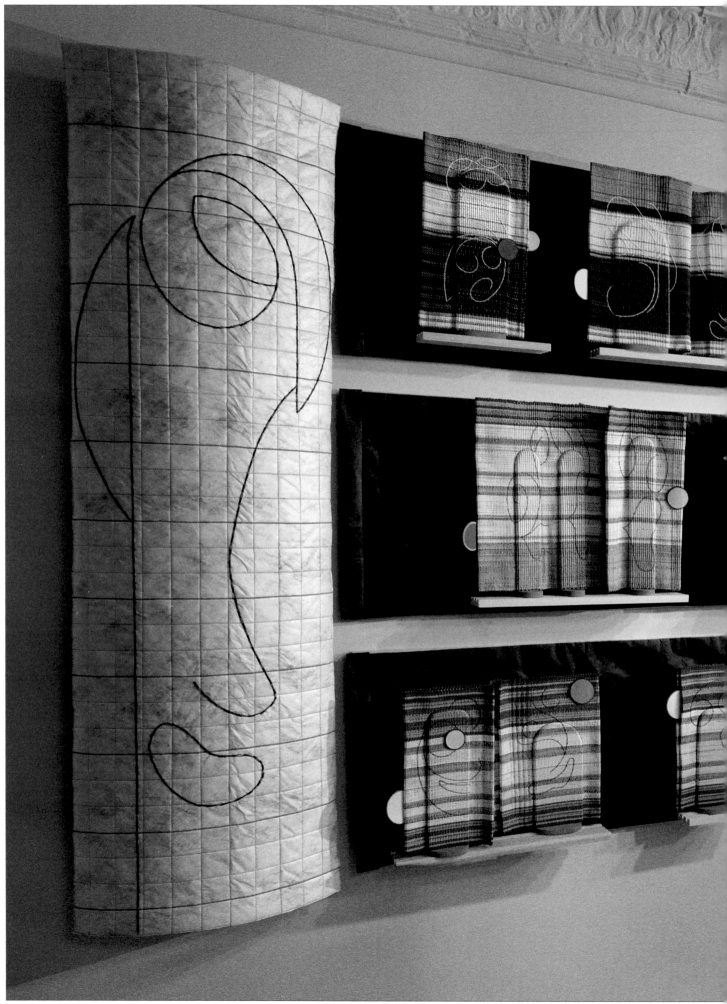

ENDGAME, 2013 (C. 266)

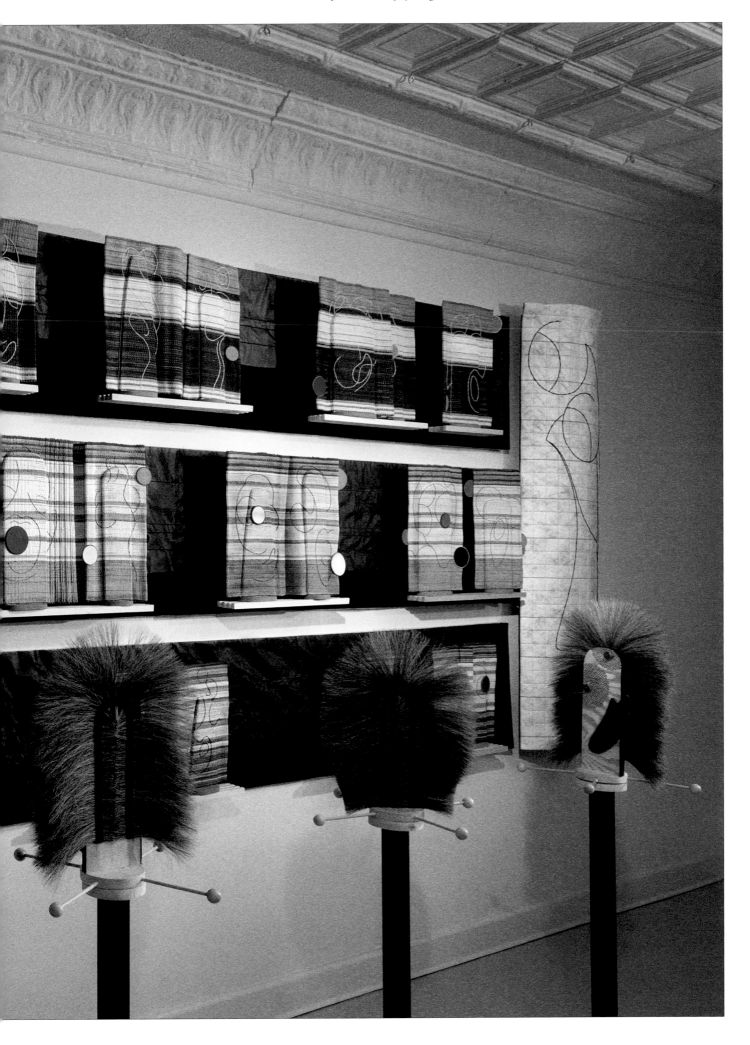

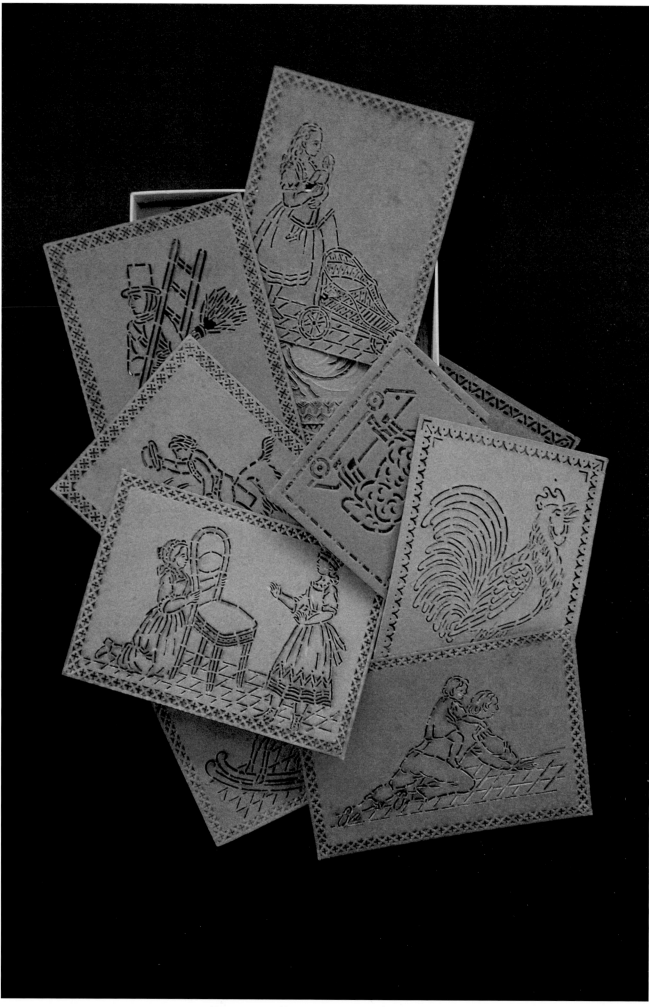

COLLECTION OF VICTORIAN STENCILS, 19TH CENTURY

EMBRACE, 2009 (C. 243)

EMBRACED (DETAIL), 2009 (C. 244)

EMBRACED (DETAIL), 2009 (C. 244)

EMBRACED, 2009 (C. 244)

Embraced, 2009 (C. 244)

STENCIL DRAWINGS IN SPACE (CONSTRUCTION DETAIL), 2012

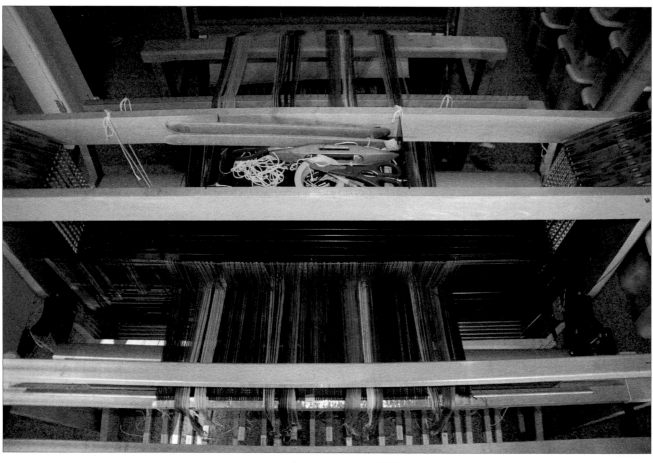

LOOM IN KNODEL'S STUDIO, 2012

STENCIL DRAWINGS IN SPACE (DETAIL), 2012

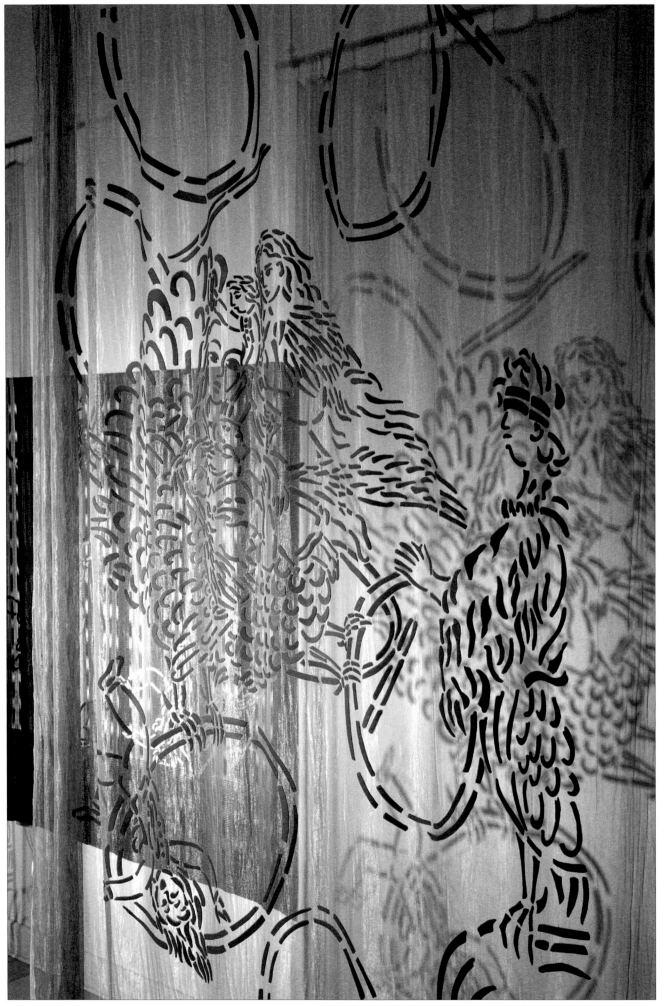

Caught in the Act: (Wondering) (detail), 2012–2013, and *Interlude: Red*, 2011–2012 (C. 261, 262)

77

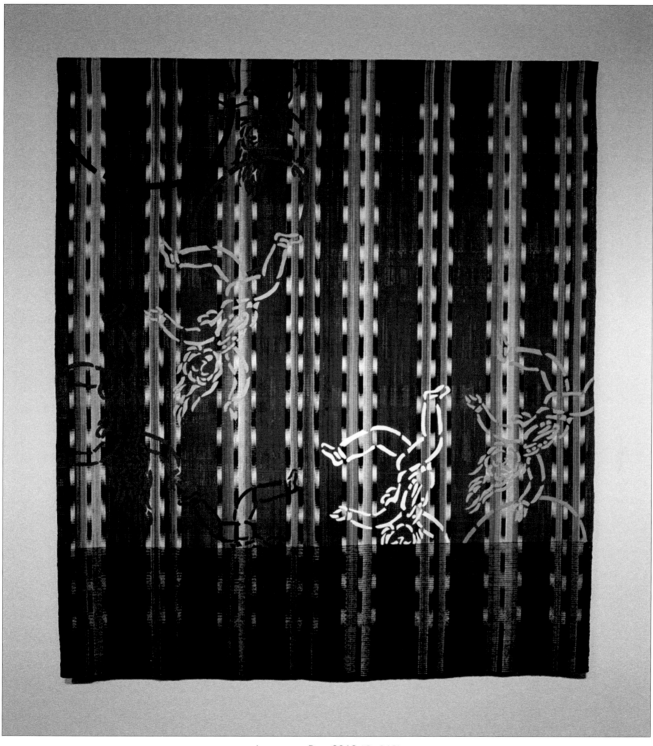

INTERLUDE: RED, 2012 (C. 262)

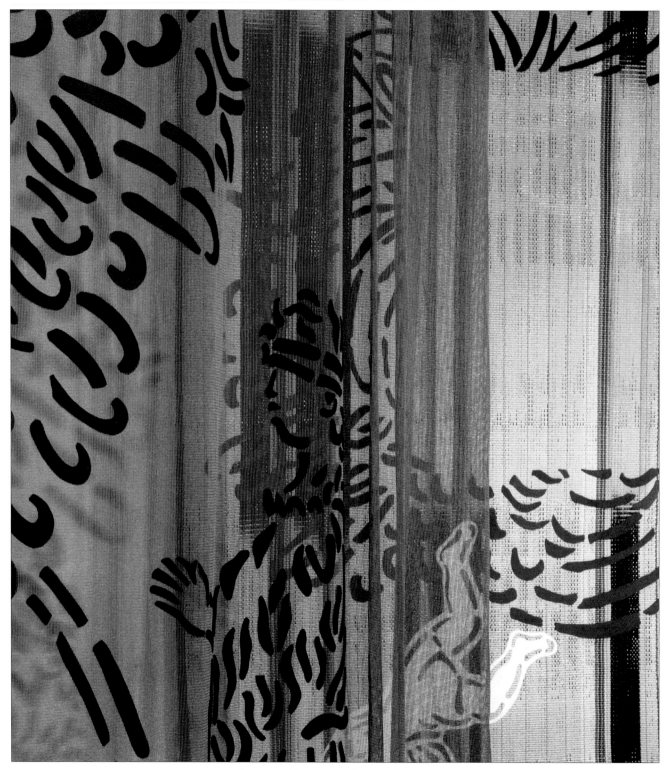

Interlude: Yellow with Shadow Curtain

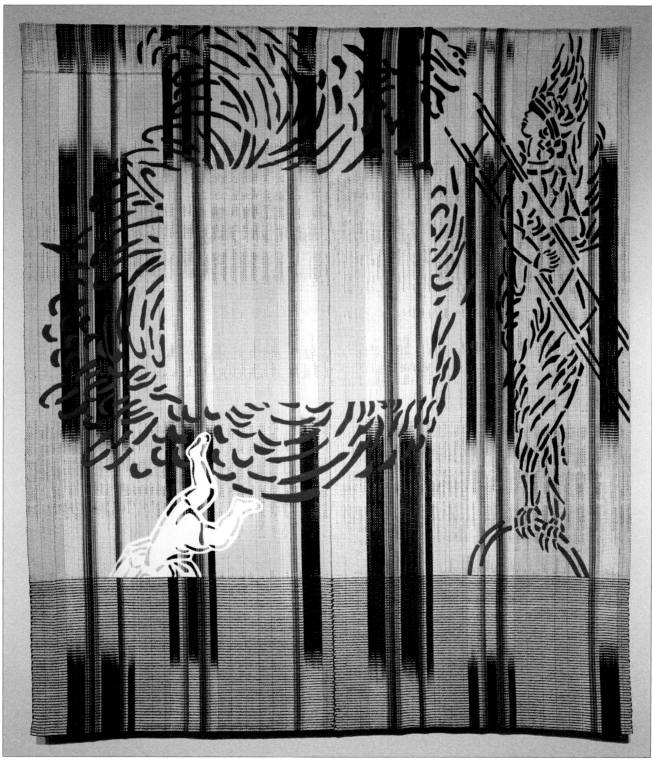

INTERLUDE: YELLOW, 2013 (C. 265)

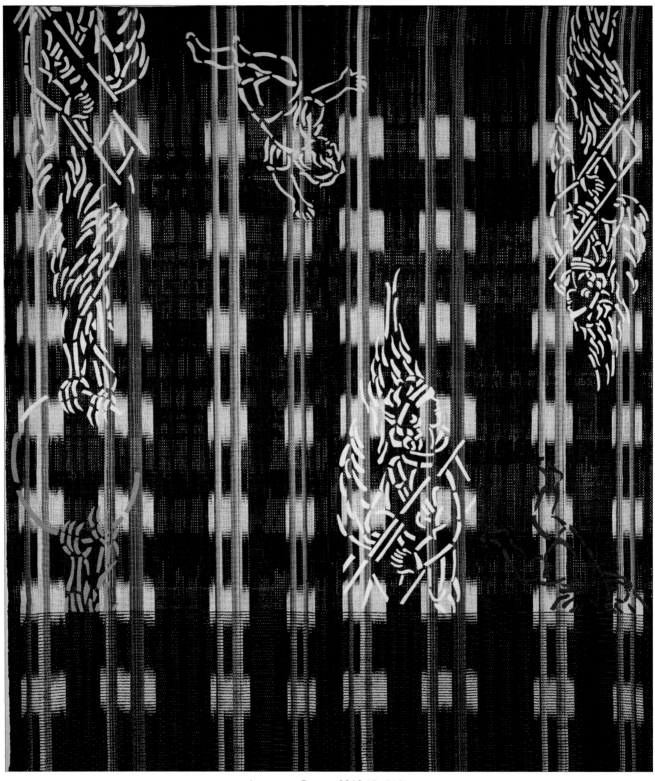

INTERLUDE: PURPLE, 2012 (C. 263)

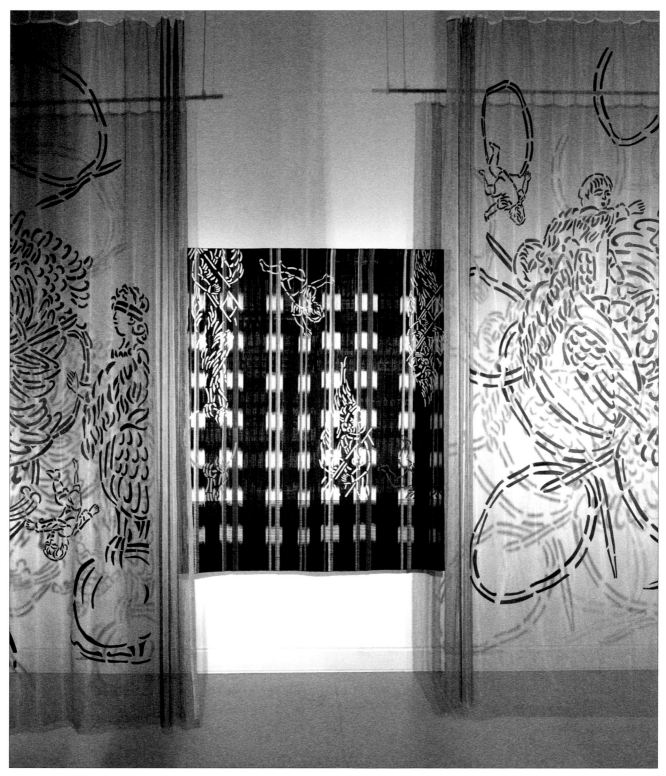

CAUGHT IN THE ACT: (WAITING, WATCHING), 2012–2013 AND INTERLUDE: PURPLE, 2012–2013 (C. 259, 260, 263)

82

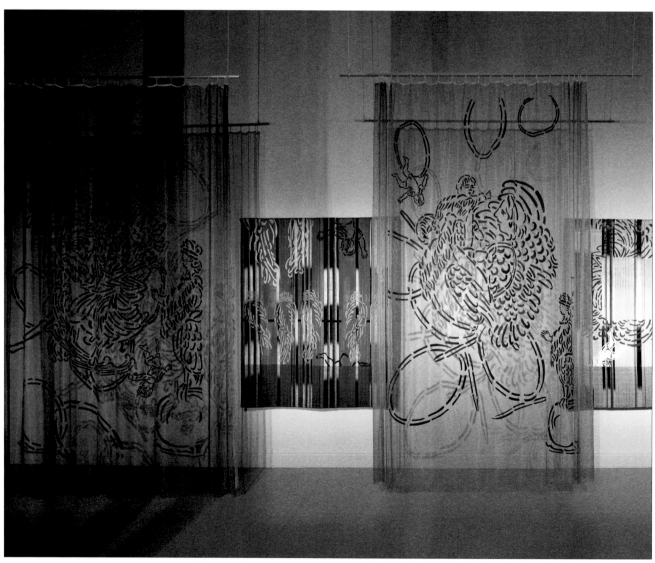

CAUGHT IN THE ACT: (WAITING, WATCHING), 2012–2013 AND INTERLUDE: GREEN, 2012 (C. 259, 260, 262)

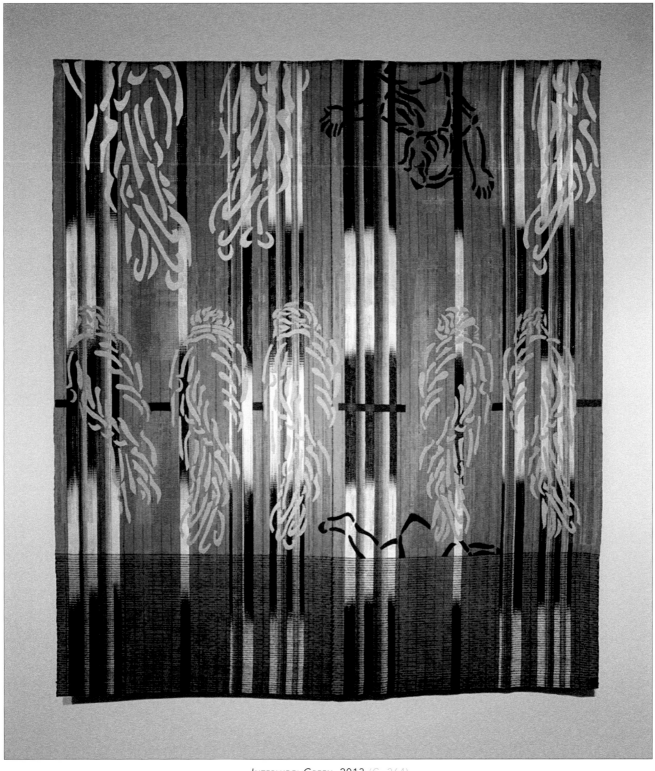

Interlude: Green, 2013 (C. 264)

Interlude: Red (detail), 2012 (C. 262)

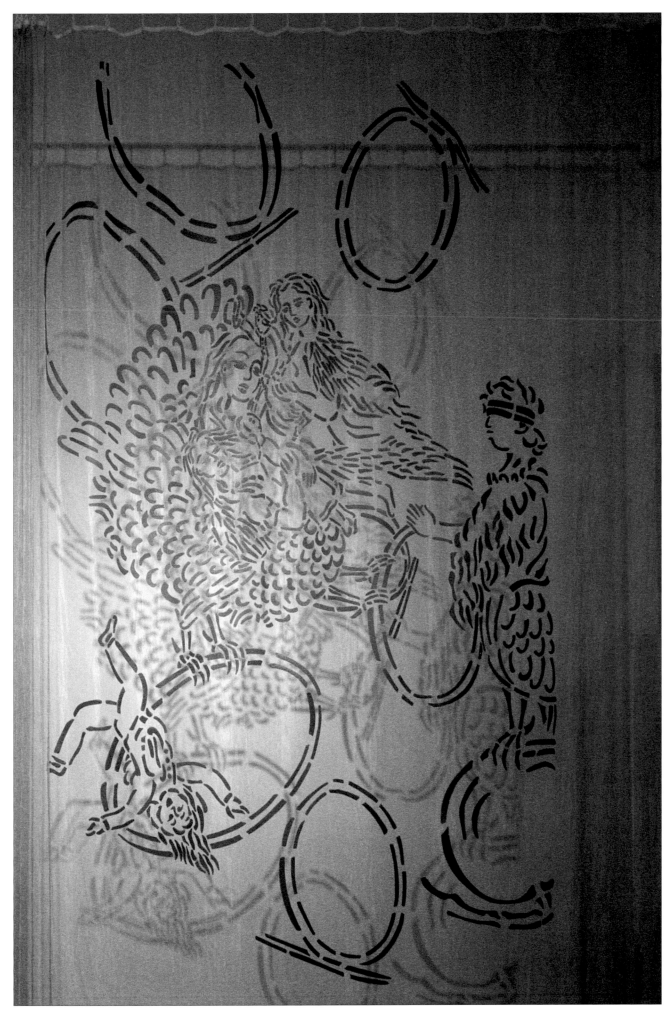

CAUGHT IN THE ACT: (WONDERING), 2012–2013 (C. 261)

3.
Let the Games Begin!

Recent Work

Shelley Selim

In the opening pages of Italo Calvino's *The Baron in the Trees,* the young protagonist, Cosimo, receives an ultimatum from his father: sit down and stop arguing with your sister, or leave the table. With adolescent resolve he protests, exiting the dining room and running to the yard, where he climbs a large oak tree. Cosimo spends the remainder of his life in the arboreal expanses of the town and surrounding countryside, never to return to the ground again. This story was the impetus behind *Calvino's Curtain: Invitation to a Future* (image 3.1), the final piece in Gerhardt Knodel's latest body of work thematically titled *Let the Games Begin!* In *Calvino's Curtain,* Knodel suspends eleven textile hangings in the form of two layered planes: in front, a sheath of tightly woven panels, sequentially pulled back to reveal transparent shadow curtains with fantastical figures behind. Knodel envisioned this work with young Cosimo in mind, building an artistic allegory for discovery and metamorphosis that echoes the boy's own transition into a new independent life committed to freedom of thought and action—through the curtained threshold and into a field of unknowns beyond.

Calvino's Curtain squarely embodies the manner in which Knodel realized his recent body of work. During the eleven years he served as director of the Cranbrook Academy of Art (he had previously been the Fiber Department's artist-in-residence from 1970 to 1996) he had little time to devote to his studio. In 2007 he chose to depart in order to—for the first time in over three decades—dedicate himself entirely to his artwork. With a reignited creative spark, Knodel approached his practice from a fresh and imaginative perspective, not unlike that of Cosimo from his lofty, wooded perch. Unburdened by the responsibilities of commissions and deadlines, Knodel was able to freely conceive, develop, and execute his work, gradually filling the studio with evidence of an evolving process entirely mobilized through the simple enjoyment of making.

New Beginnings

Upon returning to the studio, Knodel's most significant change in approach was the decision to work alone. The motivation behind this was due in some part to a longstanding affinity for the comfort and autonomy a secluded refuge provides. In an oral history interview for the Archives of American Art, he recalls the lasting influence of a few stolen moments during Sunday dinners at his grandparents' house. Becoming restless with the formality of these occasions, he would retreat under the table and enter his own private enclave bounded by the mahogany table legs

and the lace canopy of the hanging table linen. Years later when he was asked by architect Paolo Soleri to remember specific sensations that impacted his own work, he immediately returned to that space beneath the table, one that offered "a degree of security and visual environment," where the outside world was perceivable, but completely detached. "Nobody else saw the world that I was seeing," Knodel remarked. "That was my space, and I didn't create it, but I appropriated it as children do in the process of play, by making meaning out of everything—anything." Following such a long absence from total creative immersion, it was only natural for Knodel to cloister himself in his studio, where—after years in a leadership role that required constant interaction to benefit the Academy—he was finally able to work on his own terms. Here, he could observe the world around him with a comfortable degree of separation that provided the exact freedom for experimentation he was seeking.

When Knodel first returned to his artistic practice, he faced the daunting prospect of where to begin. After spending days in his studio, sifting through the vestiges of years of projects and travel, he made a commitment to himself that as a launching point he would use only the materials he already had at hand. "Familiarity is a good place to begin," Knodel states, and through this method he was able to set creative parameters that immediately provided direction. Armed with the material memories of a forty-year career, Knodel placed his trust in his artistic intuition, allowing these textile fragments, notions, and souvenirs to build themselves into an entirely new story.

3.2 RECOVERY GAMES:
SKEEBALL, 2008 (C. 223)

The first piece he created in what would eventually become the *Recovery Games* series was *Skeeball* (image 3.2), a suite of sixteen panel hangings that emerged in their most elementary form from a box of white leaf-shaped silk fragments, originally used in a 1993 installation called *American Chestnut*. In a process that would characterize much of his new work, Knodel let the materials speak to him, shifting around shapes and forms until new configurations developed. Leaves were transformed into abstracted birds, a universal symbol of both migration and freedom. These were overlaid on fabric panels inlaid with transparent circles, representing the

entrance to a birdhouse. By mounting the panels at a distance from the wall he created a layered visual dimension that evoked the same sense of movement and depth as that of a bird in flight.

After completing seven of these panels, a breakthrough for Knodel came when he was searching for another element to complement the piece. He realized that the notion of the circle-as-threshold echoed the aperture in a bean-bag toss, and his mind was opened to the potentiality for games to be a central avenue for artistic form typologies. Consequently, the crystallization of *the act of play itself* as a central impulse in his creative process is of paramount importance, informing an organic and exploratory practice that reverberates in the playful, participatory nature of the series of artworks that ultimately emerged.

Dexterity Games: In Pursuit of Play

Abraham Maslow remarked that "almost all creativity involves purposeful play," and indeed since the nineteenth century, psychologists including Sigmund Freud, Jean Piaget, and Brian Sutton-Smith have explored the potential of game playing to expand the human capacity for pleasure, expression, cognition, independence, control, socialization, and imagination. More recently, psychologist Thomas S. Hendricks examined play as a mode of self-realization, writing "play is a commitment to the act of transformation and to the forms of self-awareness that arise during this process." While working is motivated by monetary reward, "play distills experience and encourages us to try new practices."

For an artist such as Knodel, who has devoted much of his work with textiles to engineering new understandings of space and environment, exploring the ability of play to reinvigorate his own sense of discovery as well as that of his viewers is a natural progression in course. In *Let the Games Begin!*, he often takes this notion one step further, encouraging the viewer to interact with his creations and enjoy the tactile process of play just as he did in making them, without the incentive of a final weighted outcome. The notion of gaming without conclusiveness is of particular interest to Knodel, who wonders, in this situation, "[d]oes one simply shrug one's shoulders and walk away when one realizes the game can't be won, or does something reside in that condition that can be lived with in a productive way? There may be a 'transformative' aspect involved, but in the long run isn't that what is accomplished by the work for both the artist and the audience?" For Knodel, the pleasures of game-playing and creative invention are autotelic: it is not about the external reward, but rather the experience itself—the playful, suspenseful disquiet that activates the senses and imaginations of both maker and participatory viewer.

The *Dexterity Games* subseries illustrates this point, particularly *Feeding Frenzy-Black, Feeding Frenzy-Red* (image 3.3). In this duo, installed as a see-sawing diptych, Knodel draws on the nineteenth-century tradition of the palm puzzle, wherein the player tilts the game capsule to direct a rolling silver ball into a small circular hole. In both works, the game board is divided into four sections, alternately containing nine and twelve smaller rectangular playing fields.

Employing one of the fundamental practices in pattern design, an abstract motif is repeated in the background, rotating a quarter turn in each section. As players interact with the game, either alone or with a partner, they immediately realize the impossibility of reaching a conclusion in the traditional sense, and instead immerse themselves in examining the changing work itself, and the potential of the repeated image as it is transformed in various positions. The silver balls in this instance are not means to an end, but instead become animated particles to activate the viewers' dynamic perception of the piece as they interact with it.

3.3 FEEDING FRENZY-BLACK,
FEEDING FRENZY-RED,
2009 (C. 246, 247)

Conceptual Games with Historic Textiles

In studio notes from 2011, Knodel wrote, "[f]or years I have imagined my work to be meaningfully related to the 'culture' of textile makers. The relationship goes beyond respect for what has been made in the past, and is more about relationships in the active dimension of making in which one thinks thoughts that have been thought before, and throws a shuttle as shuttles have been thrown, and one feels energy as an active agent in the momentum of those activities, through time." As a weaver, Knodel has repeatedly pointed to his awareness of textile yardage as one moment in a larger, continuous trajectory. When an individual buys a length of fabric from a fabric store, Knodel explains, he is "slicing a piece from a larger object. Somebody bought the five yards before you and somebody else is going to buy three yards after you. You never know what has happened before and what will happen afterward. And likewise with the game, it seems to have unending possibilities. It can be played over and over and over again. This

sense of endlessness is very much rooted in the whole history of textiles. One inherits techniques; one passes them along to other people. One inherits images, and passes them on...there's always this sense of cycling."

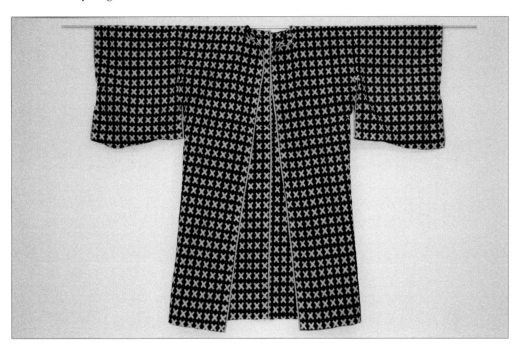

3.4 Kimono #1,
early 20th century

In the subseries *Conceptual Games with Historic Textiles*, Knodel explores the capacity for textiles to find new life, this time digging into an old collection of Japanese kimonos from the 1970s, which he purchased in bulk after their days in vogue in Japan had passed. "Back [then] kimonos were being exported like we export old Levi's," he jests. The first works in this grouping were built from Kimono #1 (image 3.4). Its surface pattern was made with an ikat weaving technique that created alternating rows of white X shapes and red dots—a reflection of the graphic visual language of a game of tic-tac-toe. Most of the garment was used in the creation of *Laughter/After Laughter #1* (image 3.5), a dizzying double panel first conceptualized during the near collapse of the United States economy in 2008. Using red and blue plastic discs from an African necklace purchased years ago in the Netherlands, Knodel embroidered the words "Laughter" and "After Laughter" onto the silk. This juxtaposition evokes the utter physical exhaustion that follows a momentary period of euphoria as a candid metaphor for the feelings of accumulation and loss that accompanied the turbulence surrounding the national financial crisis. The actual shape of the lettering itself provides a dual meaning: while its stippled form recalls the established textile tradition of needlework sampling, it also resembles the monospaced LED typefaces that today survive most conspicuously on large-screen, electronic stock tickers.

3.5 *Laughter/After Laughter #1,*
2009 (C. 236)

In the second kimono series, Knodel used a garment made for *Hinamatsuri* (Girl's Day or Doll's Day), a Japanese holiday created to celebrate and pray for the happiness and growth of young girls. According to custom, families with daughters place *Hina* dolls on a tiered altar draped in red cloth, and the young girls dress up in traditional kimonos and enjoy the day's festivities. The richness of both display and costume often represented a family's social status. As a meditation on this idea—which is certainly not unique to Japanese culture—Knodel contemplated the human desire to possess as a mode of quantifying power, control, and prestige. Both *Proliferous Possessions* pieces explore this idea quite literally, while his approach to *Embrace* is symbolically more complex (image 3.6). For this work, Knodel cut out shapes from the kimono fabric into loose forms that are concretized by the dots and lines that delineate a geometric shape. Exploring the same visual language as the star atlases used to map the constellations, which themselves are an avenue for humans to impart some sense of order and control over the universe, Knodel attached swirling, embroidered tentacles to symbolize the desire for possession. For its complementary center components, Knodel again reverted to the act of play by toying with a set of Victorian stencils, which operate not unlike constellation drawings—summoning an image from fragmented lines and points. The subjects of the stencils largely represent children playing in ways that appear both joyful and dangerous; a blindfolded girl happily seeking her friend in a game of Blind Man's Bluff could easily trip over a chair and break her arm. Coupling the resulting drawings with the prism-like forms in the kimono silk, *Embrace* juxtaposes the search for conceptual order and clarity with a collapse of perceived control—in Knodel's words, the moment when "play becomes something else, the turning point where trust becomes doubt, where potential becomes barrier, where the future becomes an abyss."

Visual Games: Shadow Curtains

Throughout his career, Knodel has consistently explored the capacity of large-scale artworks to transform and activate a space. Whether in sweeping architectural installations such as *Lifelines* (1996) and *Echo of Flora Exotica* (2005), both at Beaumont Hospital in Royal Oak, Michigan, or in 1991's moody and spectral *Walls*, mounted at Seattle Pacific University, his

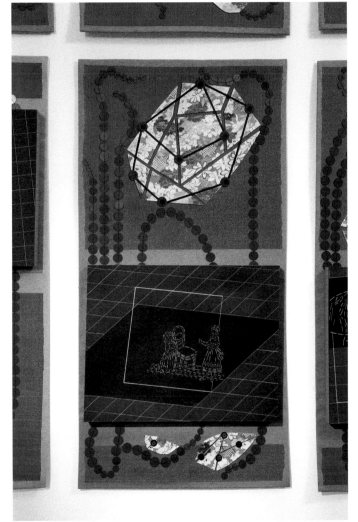

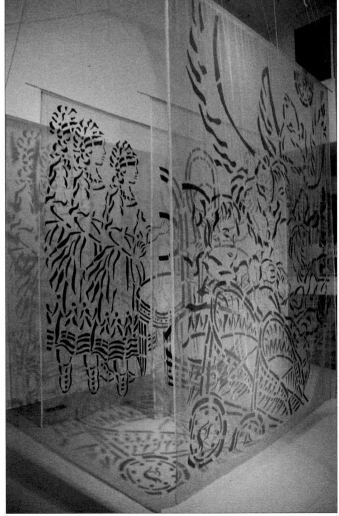

3.6 EMBRACE (DETAIL), 2009 (C. 243)

3.7 STENCIL DRAWINGS IN SPACE
(WITH AFTERIMAGES),
2011 (C. 255–261)

94

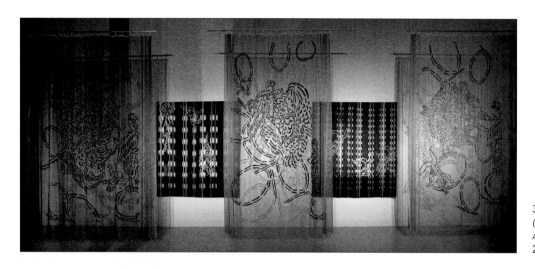

3.8 *Caught in the Act:*
(Waiting, Watching, Wondering),
and *Interludes Red* and *Purple,*
2012 (C. 261, 262, 263)

Preliminary drawings
for *Caught in the Act:*
(Waiting, Watching, Wondering),
2012

woven sculptures envelop, cleave, and amplify the built environment, heightening and augmenting the viewer's awareness of the space he traverses. In the *Shadow Curtains* series, Knodel appropriates his own intimate experience of the stencil drawings and magnifies it, transposing and reorienting the subjects onto sweeping, transparent fabric panels, vertically suspending the stenciled graphics in midair. *Stencil Drawings in Space (with afterimages)* layers sheets of shadow and structure, conjuring a narrative drawn by Knodel's chimerical characters inside a hazy, volumetric chamber (image 3.7). Viewers can observe, alter, and physically enter the space, transforming the dramatic composition by expanding, contracting, revealing, or concealing the imagery.

In *Caught in the Act: (Waiting, Watching, Wondering)*, many of the original stenciled human figures have been hybridized with birds, while others float and swirl in a constant state of *rhythmos* (image 3.8). Together, they coalesce in the suggestion of potential for both flight and free-fall, what Knodel equates to the ability "to be present and absent simultaneously." When the curtains are spotlighted, the interval between the concrete image and its projected shadow on the wall echoes that same notion of liminality that separates the start and end of an action or experience. With eerie, mythical figures frozen in momentary suspense, *Caught in the Act* radiates an enigmatic, phantasmagorical energy.

Interludes Red, Purple, Green, and *Yellow* were woven as a counterpoint to *Caught in the Act*, and many of the stenciled figures from the prior work are echoed in appliqué. Inspired by the textiles he had discovered during a recent trip to Guatemala, Knodel created these vividly colored weavings to contrast with the patterned transparency curtains in *Caught in the Act*. The artist enjoys the idea of one work begetting the next, a "generational notion" that characterizes much of his recent output. In *Let the Games Begin!*, what started with aimless stenciling devoid of a conscious purpose, ultimately evolved from *Embrace* in 2009 to *Caught in the Act* and *Interludes* three years later. This sense of continuity, often symbolized in his weavings, is something Knodel considers obsolescent in contemporary culture, particularly in the traditions of making and writing by hand. The critical negotiation of form and construction that emerges through the physical act of making can conceivably be lost in an age when our designed and built environments become increasingly immaterial, and for Knodel this is a source of concern. The moments of fracture and void in the aforementioned works subtly highlight this idea, but through his own practice he continues to celebrate and perpetuate the tactile.

Gaming with Ideas about Art

Of the many conceptual points circulating through *Let the Games Begin!*, an important recurrence is Knodel's almost instinctual commitment to tension. The ideas of alliance and divergence, of action and counteraction, are embodied in the kinetic nature of his *Dexterity Games,* in the notions of possession and loss in his *Historic Textiles* series, and in the interval

spaces of the *Shadow Curtains*. In *Gaming with Ideas about Art*, Knodel studies the tension inherent in competition and strategy, pinning the wits of the art critic against that of the viewer in droll, theatrical installations.

With a long career to reflect upon, Knodel has patience and respect for critics, but considers the authority they wield over both artist and audience to be potentially problematic. Particularly among young artists, whom Knodel has actively mentored and engaged with for over forty years as an educator, director, and Director Emeritus of Cranbrook Academy of Art, he has observed the profound impact art critics have on the field's most impressionable players. Knodel highlights this power imbalance by drawing from the visual tropes of carnivals, another setting where the odds are overwhelmingly in favor of the house. *Whoosh* (image 3.9) pays homage to the popular "cat rack" game, in which players throw baseballs at the stuffed caricatures of felines, which are often adorned with radiating shocks of hair. In Knodel's interpretation, the targets are farcically rendered "critics" with colorful, nebulous facial features, hovering below plunging vertical panels appliquéd with gestural lines seemingly manipulated by some unseen force above. The projectile element is the "eye" of the viewer, a ball implanted with text taken directly from *Art in America*. When the target is knocked over, a recorded voice provides critical commentary that is clearly antithetical to the artwork, thereby challenging and upending the "house always wins" maxim, and artfully empowering the spectator.

Knodel expounds upon this idea with *Dinner Talk* (image 3.10), depicting twelve critics situated around a dinner table, faced outward to observe the audience in the gallery as the artwork hangs behind them. Twelve individuals were invited to write and record criticisms about the piece, and when each critic is flipped down by the viewer, the individual voices begin to speak. As the critics are gradually activated, their musings crescendo into a cacophonous jumble and then slowly dissipate, leaving the full artwork exposed for the audience to finally enjoy, while the critics continue their discussion under the table—in both the literal and figurative sense. At the heart of what Knodel is really exploring here is the subjective nature of the viewer/artwork relationship. We all project our own histories, assumptions, opinions, and identities onto what we observe. In both the remaining works in this subseries, *Do You See What I See?* and *Endgame* (image 3.11), the role of the caricaturized, "cat rack" viewer—whether critic or neophyte—becomes graphically incorporated into the "artwork" he views. As Knodel posits, "In the long run what is the recourse? I don't think there is anything to be done except simply to look on your own terms…. [Art] is an extension of the people who create [it], but the completion of the circuitry informing art is when the eyes of the viewer and the minds of the viewer come to the work and interact with it."

As its title suggests, *Let the Games Begin!* is a reciprocal exploration of the spirited and visceral enjoyment that accompanies making and viewing art. Knodel has long been intrigued by the wonder of the experiential state, when one reacts to artwork without deliberately contem-

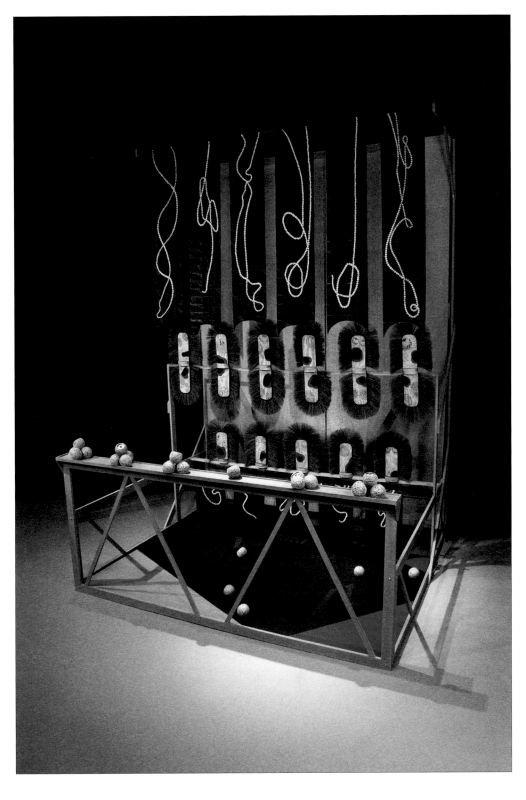

3.9 *WHOOSH*, 2011 (C. 252)

98

plating it. Although his recent work has become more conceptual, Knodel still essentially seeks a Kantian ideal of "free play," when a viewer approaches an object without conscious judgment of its value but instead through the unadulterated neurosensory stimulation it provides. This mode of viewing is fundamentally active, and implores the audience to process artworks on a spontaneous, almost mechanical level. In his approach to making itself—trusting his instincts, drawing without purpose, letting the materials find their own forms—this same preanalytic state is emphasized as a method for fostering a nimble creative process that broadens his own perspective. By centering the overall theme of this body of work around the game, Knodel echoes this process, encouraging the viewer to address his artwork in a similar moment of poise. Outcomes of a game may vary, but the unfettered, impulsive excitement that comes from the act of playing is what connects Knodel directly to his audience—whether they are tossing a ball, pushing a curtain, or piecing together stenciled imagery, they participate in a sportive sense of discovery that exists in tandem with the artist's own quest for new challenges, techniques, and creative visions.

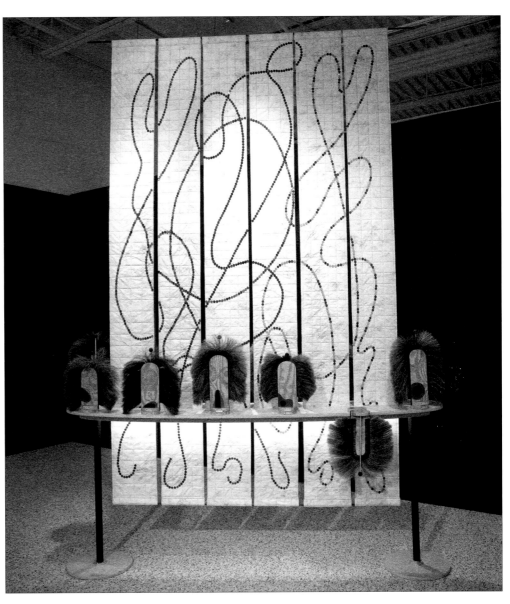

3.10 *Dinner Talk*, 2011 (C. 253)

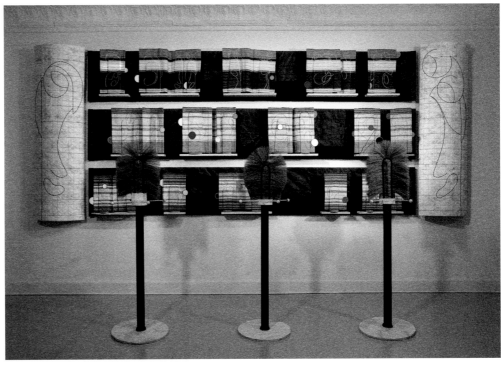

3.11 *Endgame*, 2013 (C. 266)

4.
A Question of Relevance

Historic Textiles and the Contemporary World

Throughout Gerhardt Knodel's professional life he has been interested in textiles of the past and in the careful scholarship undertaken by individuals who are likewise attracted to the visual impact and implied value of objects that now mainly exist as orphans, away from their original contexts. Early in his career, and especially via international travel, he discovered it was possible to complement his own working environment with textiles from various corners of the world and various periods of history, textiles that spoke of their essential role in the lives of people who made them.

In most cases, the textiles he collected were generated by people with a focus of time, attention, ritual, and care that is antithetical to expectations of textiles in the contemporary world. The distance between the way textiles were produced and used in the past, and the way they are made and experienced in the present, has assigned old cloth, in the opinion of most people, to the dustbin of history.

While it is impossible as an outsider to fully comprehend the powerful relationships between individuals and the objects that give meaning to their lives, we nevertheless can benefit from information, speculation, and even creative interpretation of these remnants of the past. So it is that Knodel has lived for decades with many beautiful old textiles, and has been influenced by them to the degree that his work as an artist claims roots within these objects.

Storytelling is very much at the core of many old textiles, and so it is with much of Knodel's work that attempts to integrate the language of living experience with the formal qualities of design and craft. Those interests were first generated by encountering the rich embroidered narratives found in Sumatran tapis, textiles that are obviously telling stories, but because of estrangement created by time and physical distance, can no longer be read. Nevertheless, the elegance of their voices continues to be irresistible.

Douglas Dawson eloquently provides the viewer with evidence of the power of the past narratives that textiles of diverse cultures convey. This power is the bedrock supporting Knodel's commitment to his own work. Knowledge of their existence provides reason and inspiration for continued pursuit of the special language of textiles in our own time.

Dawson's essay is followed by observations on Knodel's collecting interests, thoughts culled from several interviews with Rebecca A. T. Stevens, who inquired about Knodel's broad considerations in the "game" of collecting.

The section concludes with a series of photographs and brief essays by Knodel on selections from his own collection of historic textiles.

Narrative Textiles

Douglas Dawson

During the summer of 2013, while I was refueling my car at a gas station in Iowa, a lone male motorcyclist passed by. The back of his T-shirt read, "If you can read this the bitch fell off." Setting aside the political implications of his choice of words and the possibility of his riding partner languishing unconscious in a nearby ditch, I found the message intriguing. Until the curious loss of his friend the message remained obscured—hidden from fellow travelers by the affectionate enveloping grasp favored by women-on-the-backs-of-motorcycles. Once his unfortunate female companion was lost the message emerged, broadcast to the public. Like so many cultures before, our motorcyclist chose a textile—the ubiquitous T-shirt—to project his world view into the public realm.

The Iban people of Borneo produced one of the most sensational ikat patterned textiles in the world. These large blanket-like textiles, pua, are warp-face ikats wherein the warp yarns are resist dyed into staggeringly complex, interlocked patterns that encode the ancient animistic cosmology of the Iban. To the non-Iban eye pua are marvels of craft and things of beguiling beauty. To the Iban they are a woven billboard projecting a powerful symbology that guides them through the perilous negotiation between the spirit and mundane worlds. Like the biker's T-shirt the information embedded in the pua does not immediately reveal itself, but rather becomes relevant and potent through use and specific situation.

Every physical aspect of the pua reinforces its function as a ritual tool. The deep rust-red color is the color of dried blood—vestigial of the tradition of head-hunting among the Iban until the twentieth century. The color also links the cloth to the menstrual cycle of women and thus to fertility and rebirth. In fact, Iban women used to isolate themselves during menses at which times they claim they were able to tap, on some level, into the experiential base of female ancestors, which enabled them to execute the unfathomably complex patterns. This phenomenon, known as epigenetic inheritance, suggests, through studies in animals and people, that experience can be encoded in DNA and passed between generations.

Crocodiles, hook and rhomb, serpents, vines, anthropomorphs, and a menagerie of supernatural creatures inhabit the surface of the cloth. However complicated the process of dyeing and weaving a pua might be, it is the use of the pua as a membrane—a curtain of sorts—between the spirit and mortal worlds that distinguishes it. Pua were used to wrap and present the severed head of an honored enemy, to envelop the first rice harvested, to encircle—like a shroud—the trunk of a great tree cut down, and to provide physical and metaphysical shelter for a woman giving birth. The use of the textile animated the totemic images on the textile and projected them into the realm of reality. It is this symbiosis between process, content, and context that ratifies the pua's role in everyday Iban life.

The capacity of textiles to fix, quite literally within the web of warp and weft, social and cultural history is nowhere better illustrated than in the textiles of the Ainu, the aboriginal inhabitants of Japan. The enigmatic Ainu, a people today numbering only in the thousands, survive in present-day Hokkaido, Sakhalin, and the Kuril Islands—the far fringe of East Asia. Their language, considered an isolate, is related to no other and is considered endangered with only a few dozen speakers left. Theories of their origin vary from Pleistocene north Asia to the Caucasus to descent from the Jomon people of ancient Japan—makers of the oldest ceramics in the world. Some anthropologists believe the Ainu are vestigial of a Paleo-Asian population that inhabited Asia before the arrival of the Mongoloid-descended Japanese, Koreans, and Chinese. What is certain is that Ainu culture is of great antiquity—and this is obvious in their textiles.

The most arresting of Ainu textiles are long robes worn by both sexes. Conservatism seems to be a universal characteristic of traditional dress throughout the world, and the robes of the Ainu are like a scrapbook of their passage through time and space—conserving the influence of the many cultures they came in contact with over millennia. The most archaic type of robe is of woven elm bark (*attus*). This exotic bast fiber was laboriously processed into long yarn-like strips and woven on the backstrap loom. Without doubt the first clothing not produced of animal skins was made from bast fibers like hemp, ramie, flax, raffia, and, in the case of the Ainu, elm bark. After weaving, the robes were constructed into a kimono-like garment, reflecting contact with the Japanese, who persecuted the Ainu into near extinction. The sleeves of these robes, however, reflect contact with the Chinese—which the Ainu had when inhabiting the Kamchatka/Amur River area and regions farther west on the Asian mainland.

Interestingly, although the construction of the robes is based on foreign influences, the imagery on the surface of the robes is that of the most ancient, animistic, totemic type, reflecting the depth of shamanism in Ainu culture. Undoubtedly the Ainu understood the efficacy of the textile format for projecting the most important spiritual information of their world. The great robes are covered with highly abstracted designs said to represent the skulls of bear—the most important totem of the Ainu and the top carnivore in their dark forested world. Like all symbolism, however, literal interpretations of a motif are most fluid, changing over time and finally becoming canonical when a society becomes literate and anthropologists attempt to describe it. No matter what the ancient inspiration of the motifs might be they represent the beginnings of man's attempts to encode and make manifest the spirit world. Other motifs on the robes resemble the abstractions found on the earliest Chinese bronze vessels and on fish and bird skin garments of the ancient shamanic peoples of Siberia. This is perhaps not coincidental, as all these cultures shared a common geography. The Ainu would not have been surprised to see how the American motorcyclist used his T-shirt to both conceal and project information depending on the situation. Their great robes, when worn, often showed only a portion of a motif—it being obscured by folds and sashes. The critical issue was that the wearer was wrapped in the protective iconogra-

phy—it became a metaphysical skin connecting the wearer with all that came before and the spirit-saturated world that he or she must confront on a daily basis.

There is an apocryphal story about the arrival of Francisco Pizzaro, the Spanish conquistador, into the Inca capital Cuzco in 1533. According to the story the Inca fled the capital abandoning all the lavish gold and silver trappings of the temples and palaces, their servants, their livestock, and foodstuffs. All that they took in their flight were their textiles. The thought of their most prized cultural commodity—textiles—falling into the hands of the barbaric Europeans was obviously too much to bear. Whether this is a true account of that calamitous event, the claim of the priority of cloth over all else was true. No other culture on earth has imbued the textile arts with such importance. The Inca, like their Mexican cousins the Aztec, are the best-known of pre-Columbian cultures perhaps due to their unfortunate contact with disease- and metal-bearing, literate Europeans. They are, however, only the tip of a very ancient and astonishing cultural continuum extending back, in the case of Peru, at least six thousand years. They were the heirs of that cumulative cultural experience. It requires a considerable suspension of disbelief on the part of most non-Andeans to grasp the importance of cloth in that ancient world. Peru appears to be the only place on earth where weaving was discovered before pottery making. The Andes were also blessed with a collection of camelids—alpaca, vicuña, guanaco, and llama—that provided some of the most luxurious wool on the planet.

This explains only part of the mystery of the ascension of textiles in ancient Peru into the highest position of the arts. Many cultures in the world have recognized the metaphoric potential of the crossing of the warp and weft in a textile, or the analogy of a continuous warp with the path of life, but none took weaving to the heights they reached—literally and figuratively—in the Andes. For the ancient Peruvians textiles were the fundamental structure of their society. Everything was projected in cloth, and everyone was defined by cloth. Even their trajectory towards literacy—the mysterious quipu—is a textile. The Inca were very successful administrators of their far-flung empire. The quipu, a series of knotted yarns, was used to record the many things that needed control such as harvests, corvée labor, census tallies, livestock—anything that could be enumerated in a series of knots based on the decimal system. Recent research suggests that the quipu also had a phonetic component, which implies that poetry (for which the Inca were famous), history, and other non-material aspects of society may have been recorded in this textile "book." An Andean Rosetta stone is needed to fully unlock the secrets encoded in the woolen knots of the quipu.

Among most visually astonishing of pre-Columbian textiles are the giant mantles of the Paracas culture that thrived in arid southern Peru from about 675 BCE until 150 BCE. These magnificent textiles, which have survived millennia in the dry tombs of the southern desert, are a woven mirror of the phantasmagoric spirit world of the ancient Paracas weavers. The textiles were discovered as shrouds, and indeed this may have been their principal function. However it is also likely that they functioned as high prestige objects reflecting the wealth and social position

of the deceased before death. They are large—several meters long—and covered with elaborately embroidered creatures that haunted the psyches of that world. It is as if by physically representing the pantheon of deities and totems on the shroud, the deceased was assured some degree of safe passage to wherever he or she might be going. These textiles were a woven liturgy that defined worlds beyond and connected with those worlds.

The pre-Columbian world of Peru was one where textiles were omnipresent. Taxes were paid with textiles. Imperial mummies were dressed in sumptuous textiles and paraded in ritual processions, temples and palaces were draped in gigantic architectural drapery, sacred stones, or waka, were covered in huge cloths and gold, the Inca army wore sensational checkerboard tunics of the finest tapestry weave, virgins lived in cloistered convents and wove only for the emperor, royal storehouses throughout the empire were piled high with textiles given as tribute and levy. It was a woven world.

In the West, art is understood to be in constant flux and evolving in a linear trajectory while always reflecting current cultural moods and trends. One particular style becomes popular and relevant and then passé and irrelevant. In the twentieth century the stairstep of Western art moved from Romanticism to Impressionism to Abstraction to Pop to Minimalism and so forth with little overlapping. An accomplished artist in one style could suddenly find him or herself sidelined as the art world moved on. The ancient weavers of Peru—most likely women—suffered no such relevancy issues. There was no anticipation of the "retrospective" or "the early years" exhibition. Besides mastering more weaving techniques than were found any place else on the planet (many techniques used by pre-Columbian weavers were unknown elsewhere) the artist/weavers explored, simultaneously, myriad aesthetic possibilities. Highly abstracted color-field compositions—the most famous being the large mantles of the Nazca culture—were being woven at the same time as huge painted cotton panels that look like twentieth-century German Expressionism. Elsewhere the Wari were producing mind-bogglingly complex tapestry-woven tunics with deconstructed images of staff-bearing gods and felines that presaged by a thousand years the similar imagery of Picasso and the Cubists. Painted, embroidered, brocaded, netted, plaited, resist-dyed, feathered, gold- and silver-encrusted, figurative, minimal, abstract, expressionistic—no possibility was left unexplored, and all were explored simultaneously.

And then there is the question of color. The back-to-nature movement of the 1960s and the rediscovery of natural dyes in the West produced a most impoverished palette. Most consumers understood "natural color" to include a tepid colorway of beiges, muddy yellow, off-white, and hues not far from the various tree barks that were a popular source of dye. The ancient Andean weavers suffered no such tawny world. Day-Glo fuchsia, lemon yellow, crimson, hot turquoise, acid green, and everything in between were in the dye pots of the master dyers. The only limitations that constricted the ancient weavers of Peru were sumptuary restrictions imposed for political or religious reasons. Their natural world provided all the requisite resources and their

spiritual world, based on reconciliation with and reverence for their majestic rocky environment, provided the inspiration. Politics fixed identity and destiny. Textiles were the matrix for it all.

But back to motorcycles. The value of the tribal textile in the modern art market is fueled by its aesthetic affinity with twentieth-century Western contemporary art. This is actually true of all kinds of tribal art. The more a piece of tribal art resembled masterworks of the twentieth century the more valuable it was, and is, in the marketplace. Endless references are made linking various tribal artworks to Rothko (Sumatran resist-dyed shawls or Aymara textiles of nineteenth-century Bolivia), to the Cubists (Wari tunics), Dubuffet (Chancay painted panels), and Matisse (the textiles of the historic Kuba kingdom of the Congo River basin). There is nothing fundamentally wrong with this associating and resultant market valuation. The associations are merely "points of entry" to appreciating something with which we share no common experiential basis. They are the initial bridge across significant differences of time and culture, and have value as such. However, there is much more to these textiles than a facile similarity with twentieth-century Western painting.

Kuba textiles came to the Western art market in the late 1980s and were a revelation to many of us who experienced them for the first time. African art collectors were generally indifferent, but contemporary art collectors were enthralled. There are two basic types of Kuba textiles of interest to collectors. Both types, great long ceremonial skirts and small squarish embroidered panels, are made of unspun raffia fiber. The fiber, extracted from the outer edges of the raffia palm, is woven on an unusual loom by men into panels whose size—about twenty-four by thirty inches square—is determined by the length of the raffia fiber, which cannot be spun into long yarns. Therefore, all Kuba textiles are predicated on this panel size. After the small panels are woven, they are joined into very long narrow skirts by women. They are usually one panel wide and up to thirty feet long. The stiff raffia fabric is then pounded in a mortar to soften it. This process results in many small holes being punched through the cloth. These holes are then covered with patches which, through their necessity, produce an embryonic pattern. The Kuba women then "complete" the pattern by adding additional patches. The successful result is a visual dance across the surface of the cloth of small geometric patches contrasting with the buff color of the ground cloth. The effect is one of effervescence—of an unpredictable scattering of images that still seem purposeful and structured. It is the magical combination of the necessity of patchwork and the artistic intuition of the women applying the patches that results in such artistic success.

This is an important lesson in creativity—necessity, response to cultural mores, and intuition combined. When mounted and displayed on a white wall in an American or European gallery these great skirts are immediately accessible to the twenty-first-century Western eye—"Matisse must have seen these." However, the Kuba never saw the skirts displayed in a similar manner. Rather, they were wrapped and layered in great numbers (depending on the status of the wearer)

and further obscured with cowry shell trappings, overskirts, and other prestige trappings. The subsumed, abstract message encoded in these great skirts was implied, not stated. It was use/ display, movement, and the tapping of a collective consciousness about the role of textiles in Kuba society that produced meaning.

In the early twentieth century, a group of Belgian missionaries arrived in the Kuba kingdom on motorcycles (presumably without their "bitches"). Intent on impressing the "natives" with an example of the technical prowess of Western technology—the motorcycle—they were certainly startled and possibly disappointed to find the Kuba far more interested in the tracks the tires of the motorcycles left in the path than in the miracle of internal combustion. The second type of Kuba textile now well-known in the West is small raffia fiber panels covered with complex, embroidered, geometric designs. Known in the market as Showa panels, they are exceedingly refined and endlessly creative but within a rigid canon dictated by both material and culture. Geometric motifs swarm across the surface of the embroidered panels—morphing into each other, one subsuming beneath another only to re-emerge in another section of the cloth. Curvilinear and representation images are not allowed but geometric images can be created, modified, expanded or shrunk. The creation of a new geometric line bestows prestige upon the woman who created it. She may "own" it and pass it to her daughter—thus the intense interest in the geometric patterns left in the dust by the Christians' motorcycles. Ultimately these tire track designs entered the Kuba design repertoire. These raffia panels functioned as a sort of proto-currency for the Kuba. They had a collectively recognized abstract value and were a rare and much valued vehicle for women to increase their status. They were hoarded and sometimes exchanged.

The Kuba had one final use for their remarkable textiles. They accompanied the dead into the afterlife as sacred and prestigious funerary offerings. The great long skirts were rubbed with ochre and placed in the grave with the deceased, providing a woven link with the world left behind and the one ahead.

How would an evolutionary determinist understand the evolution of the textile among many pre-literate societies as the essential vehicle for communication? What is so fundamental about cloth—is it that it is so close to skin?—that inspired so many cultures to regard it as the matrix for enmeshing the most crucial cultural information about themselves? I suspect that, in part, it is the physical nature of cloth—its capacity to move, to envelop, to obscure, and to reveal—that made it such an obvious choice over stone or wood. That, plus the metaphorical potential of the intersection of warp and weft. These innate qualities, whether unconsciously exploited by a Midwestern motorcyclist or an Ainu shaman, project cloth into a special realm with which the written word cannot easily compete.

Does anyone fully understand what is being said in a textile? Probably not—and it probably does not matter. What matters is the collective realization that what is encoded in the textile is the equilibrium in life that everyone seeks.

A Game of Collecting

Rebecca A. T. Stevens

Gerhardt Knodel lives with fine textiles of the past that he has acquired over decades of collecting. These textiles are essential to his life and work. They are his visual delight and his muse. Because they were often acquired on his global travels, they also embody powerful memories of the joy and discovery he experienced when he acquired these vital records of human culture across time and space. For Knodel, textiles are the physical record of the social exchanges, rituals, and celebrations of man's life on earth of which he is an active participant as an artist and as a mentor to younger artists. His textile collection informs and is a reflection of his persona. As Knodel describes it, he draws positive information from these textiles, the people he meets, and the places he travels, and he integrates all this information into his thinking and art making.[1] Gerhardt Knodel's great game of collecting is central to his life.

The game of collecting textiles is nuanced and comes with no instruction manual. Do you look for the perfect example of a particular genre of textile or do you take a chance on the unusual object regardless of its condition? Is the piece an authentic artifact? Does it matter? Each player must formulate his own rules and goals, collecting for personal reasons—peer status, investment, family history, documentation, acquisition of beauty, and more. The ultimate objective of the game for most is to capture the desired textiles, but for Knodel participation in the game is itself important. The act of finding and saving historical textiles from the dustbin of neglect is its own reward.

Knodel believes that textiles are the tactile accumulation of experience and knowledge that feeds one generation to the next. Each object has its own subtext. In the course of learning the language of a new textile find, Knodel develops strategies for understanding the generational connections the textiles reveal. The challenge is to decode the nonverbal message and realize the underlying potential of each piece as it relates to the community of humankind. A collector preserves this textile art history for future makers.

Knodel believes textiles are keepers of a powerful code for deciphering the hidden stories of the past, which he interprets and reinterprets every day in making art. The textiles he collects are tactile stories that reveal not only transcendental cultural messages, but also the secrets and obsessions of the maker, which resonate with Knodel's own passionate involvement in pursuit of art.[2] When looking at a pre-Columbian textile he recently acquired, Knodel said he could sense the patience and skill of the long-ago weaver who manipulated one thread at a time to make this cloth. To Knodel, that weaver is talking directly to him across the divide of a thousand years.

Knodel plays the textile collecting game as he travels the globe participating in international exhibitions and research projects. His travels have given him the opportunity to experience a variety of textiles firsthand. He cannot resist buying the sometimes humble but nevertheless spectacular textiles he sees in the exotic markets he visits and in the dealers' inventories he encounters. Most of his textiles are selected intuitively. He buys what immediately impresses him and what he feels he would be bereft without. It is a very personalized approach to collecting—

not impulsive but akin to falling in love at first sight. These textiles reveal unfamiliar stories and juxtapositions of patterns that are richly evocative for him and enhance his own textile language.[3]

Knodel's collection has grown apace and today numbers hundreds of objects. They are a visual and tactile reference library, a resource that allows him to pursue the "adventure of penetrating history via the medium of textiles."[4] Knodel's textiles inform his own commentary on art, life, and the human condition. He advocates paying attention to textiles to inspire creative speculation about both the object and the person who made them—the how and why of human-kind's material culture. These textiles have also become an integral part of his social network. Discussing his textiles with fellow collectors, discovering the scope of what is possible within the medium, and sharing those possibilities with others is especially meaningful to him.[5]

Knodel's collecting, observing, and absorbing the language of textiles mirrors the same type of powerful influence textiles have had on many other artists, such as Henri Matisse, Frida Kahlo, Donald Judd, Richard Tuttle, and Robert Kushner, who share in this textile collecting passion. What is it that motivates an artist to seek and possess historical textiles? Perhaps it is the allure of the anonymous textiles, familiar and yet mysterious, that resonates with each of these artists' creative spirits. Or perhaps it is the kinship felt with the successes, failures, joys, and sorrows of the skilled makers who lived in another time and place. Or perhaps these artists are simply drawn to the beauty of the colors and the juxtaposition of patterns. A major exhibition at the Metropolitan Museum of Art in New York (*Matisse: The Fabric of Dreams—His Art and His Textiles,* June 23–September 25, 2005) illustrated how Matisse first used his textiles as back-grounds and other elements in his paintings but later used the textiles as "the springboard for his radical experiments with perspective and an art based on decorative patterning and pure harmonies of color."[6]

While some artists, like Frida Kahlo, utilize textiles as identity markers in their art, borrowing directly from the patterns and cultural associations of the textiles in their collections, Knodel's use is different. Incorporating specific patterns and cultural associations in his art is not his focus. Instead his textiles act as a catalyst or reference for his thinking—as his muse. For example, Knodel once spent several years investigating how textiles can be used to reshape a living environment. His research led him to create a series of canopy-like artworks such as the monu-mental *Act 8,* which was featured in the *The Art Fabric: Mainstreams* at the San Francisco Museum of Art in 1981 and is now part of the permanent collection of the Cranbrook Art Museum. When exhibited, the tent-like space made of soft, moving fabric provides the viewer with an alternative place in the gallery to pause, rest, and reflect, just as a campaign tent was once used by Mughal rulers for respite on a long march. When Knodel found such a Mughal tent in a market in India, he immediately bought it for his collection, bringing the past and present full circle for him. He "discovered that his own inclinations for fabric structures...were actually the extensions of thoughts of other people in earlier times."[7]

Beyond the imagery of particular textiles, especially garments as identity markers, textiles have a powerful voice that transcends national boundaries, time, and place. Painter Robert Kushner writes eloquently about the influence of the "vitality and energy" of his Central Asian embroideries on his own artwork.[8]

Textiles are links to mankind's artistic heritage and connect with artists in real time. Gerhardt Knodel also believes the vitality and energy of textiles speak to us in a universal language rooted in human behavior. That language grows out of our common experience of living intimately with textiles from birth to death.[9] When words seem inadequate to express his ideas during a lecture or student discussion, Knodel brings out a textile from his collection that he feels will better make his point. He has used a quirky nineteenth-century American quilt in his collection to illustrate the quilter's unbridled enthusiasm and delight in materials, qualities Knodel believes are essential in making art. Knodel feels this quilt's visual appeal trumps any verbal explanation of the quilt maker's creativity.

For Gerhardt Knodel, being an artist, art mentor, and a passionate collector of fine textiles are seamlessly intertwined. He embraces life and its possibilities and plays the textile collecting game with great verve and enthusiasm.

Knodel writes about many specific textiles in his collection in the pages that follow. He recounts the sensations he experienced with each when he first saw them and the palpable pleasure these textiles bring to him every day. Each object in his collection provides him with an experience that transcends the intellectual and achieves a visceral "wow" factor which, for him, is the essence of art.

112

Notes

1. Conversation with the author, Oct. 16, 2014.

2. See "Mirrored shawl" commentary in Knodel's
 "20 Provocative Textiles: A Collector's Response" on page 114.

3. Gerhardt Knodel, "Through New Eyes," selections from
 the Gerhardt Knodel Collection at the Dowd Fine Arts Gallery,
 State University of New York, College at Cortland,
 March 25–April 2, 1994.

4. Telephone conversation, May 23, 2014.

5. E-mail, July 26, 2014.

6. www.metmuseum.org/exhibitions/listings/2005/matisse-textiles.

7. See "Tent wall" commentary in Knodel's
 "20 Provocative Textiles: A Collector's Response" on page 116.

8. www.robertkushnerstudio.com/silk-cotton-by-susan-meller/.

9. Oral history interview with Gerhardt Knodel, Aug. 3, 2004,
 Archives of American Art, Smithsonian Institution.

20
Provocative Textiles

A Collector's Response
Gerhardt Knodel

4.1 Mirrored shawl
Kutch, Gujarat, India
20th century, silk embroidery
on cotton with mirrors
$56 \times 16\frac{1}{2}$ in

When I was a child living with my family in Los Angeles, my parents had a friend, a lovely German lady, who oversaw the estate of a Hollywood movie director and his family. Once a year my family visited their home, and I clearly remember the excitement of being amidst exotic objects, including the Macaw parrots in the living room! I shall never forget our hostess showing us a brilliant red and orange embroidered shawl covered with reflective, mirrored discs. Its color and patterning were so exotic, and the weight and texture of the fabric so unusual, that I still have a body-based memory of it. She gave the shawl (which she described in terms that further invested the object with mystery) to my mother. I recall the shawl being carefully wrapped in tissue, housed in a gift box, and stored in the lower drawer of the hall linen closet in our home as a special treasure.

It wasn't until years later, as I became more involved in textiles, that my mother brought the shawl to my apartment and left it with me—the first piece in my collection—a piece remembered so well that many of its characteristics entered my early works.

I remember as a child seeing my reflection in the multiple mirrors. Years later, as a grad student I made a room-sized dining environment—all white—with a thousand mirrors that would reflect the color of what guests wore to the dinner party as they moved about.

I recall responding to the unusual embroidered patterns as a foreign language that I connected with the mystery of the word *gypsy*, and then attempting to imbue my own work with related visual intrigue.

I recall the sensation of revealing or concealing as the shawl was unpacked, opened, admired, then carefully returned to its place where it anticipated its next performance.

Over the years, many of these qualities entered my work whether I was conscious of them or not, but what inspired me most was a huge appetite to discover other textiles that held their own secrets, textiles powerful enough to represent an investment of personal obsession equivalent to my own involvement in pursuit of art.

So, as I traveled the world, I often brought back bits and pieces of the past embodied in textiles. In working with students, when words could not adequately express the level of intensity, the depth of commitment, or the insight and potential residing within this medium of communication, I'd bring out something from my closet that I thought embodied the message.

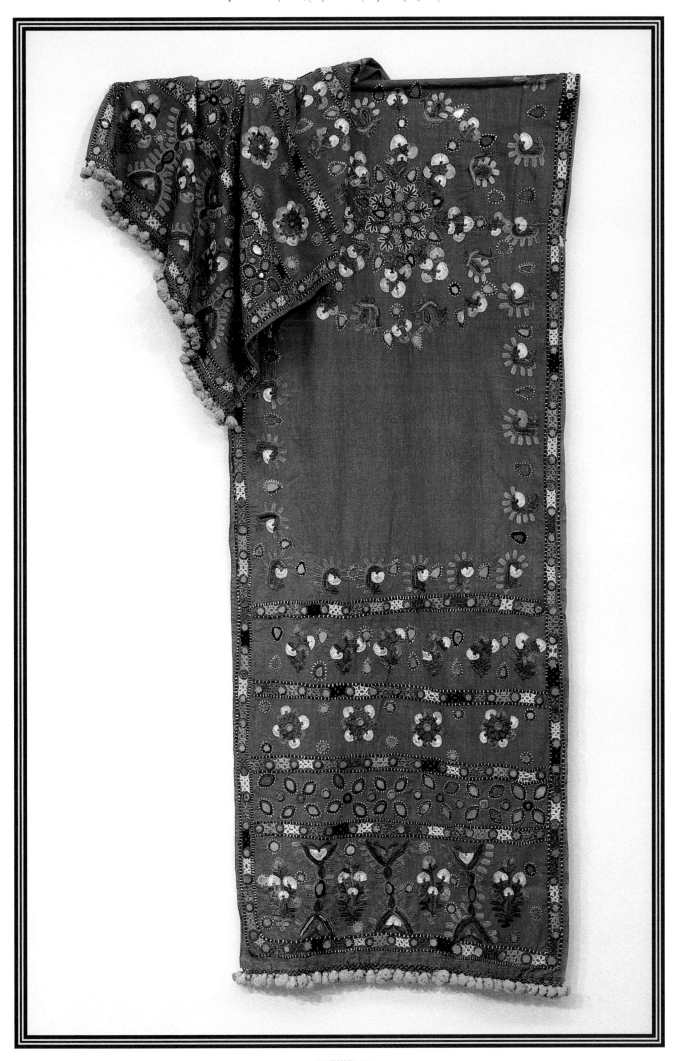

4.2 Tent wall
Jaipur, India
19th century
cotton, mordant painted and dyed
168 × 432 in.

It was during graduate studies, as my complete fascination with reshaping living environments with textiles grew, that I started to search for precedents. I quickly discovered that, despite the fact that tents were the primary means for sheltering people in many parts of the world, at the time there was no single book published on the subject of fabric architecture. So, with my love of patterning, and romanticized notions of idealized spaces defined by textiles as seen in Persian and Turkish miniature paintings, I had no choice but to set out into the world, to see for myself!

In Istanbul in 1971, at the Topkapi Sarayi, I met the palace's house photographer, who remembered a collection of film negatives showing tents that had once been set up in the courtyard of the palace. Hungrily, I waited for black and white prints to be made, and when they arrived I was dazzled to find that what I had seen in the miniature paintings actually existed!

The next stop on that trip was the Royal Castle in Krakow, Poland, where several Turkish tents taken by the Polish army at the siege of Vienna in 1683 were exhibited. My heart raced as I entered the first of those fantastic interiors totally covered with exuberant fields of floral and architectural abstractions rendered in appliquéd and embroidered textiles. For the first time I was physically immersed in a pool of sensations that fulfilled expectations formed earlier in my imagination.

Best of all was that I discovered that my own inclinations, projected in early experiments with fabric in space, were actually an extension of thoughts of other people in earlier times who must have had a similar appetite. What had started as a rather solitary pursuit, now was shared in history with others! The silk canopy *Act 8* that was begun in 1973 is a good example of how I channeled the excitement of those discoveries into my own work.

Ken Gross and I embarked on our first of many visits to India. In December 1973 I was dazzled by Moghul architecture, mainly because most of it appeared to have been inspired by fabric architecture and a nomadic love for openness and textiles! I was overwhelmed by the diversity of textile traditions and the wonderful opportunity to purchase palpable evidence of our experiences. We returned home with a variety of tribal and court-related pieces that, to this day, continue to conjure the excitement and sensations of that first visit.

Imagine, then, the thrill of owning a wall of a tent that originated in the court of the Jaipur Palace. It was in miserable condition when I discovered it, dirty, torn, deteriorating, patched, and with holes that probably resulted from hungry rats. I managed to get it back to my studio in Michigan, where I convinced eight graduate students at Cranbrook to work with me in restoring the wall to the best of our ability. In that process, we touched the past, and brought a bit of visual poetry into our corner of Michigan!

Tents are clothing for space that one can walk in, entertain in, or sleep in. Unlike the stable architectural structures of our own time, pliable tent walls move with the wind, transform light into shade, collapse, and are portable. Cannonballs had little effect when striking cloth walls.

No other living creatures, not even spiders, have come up with such brilliant technology that transforms fine fibers into massive spaces to live in. Ceremonial, palace, and circus tents are huge encompassing enclosures that ignore what is outside. Their interior is like silk lining in a woolen suit, or like the temporary stage set that envelops actors with an imagined environment that takes an audience to unexpected places.

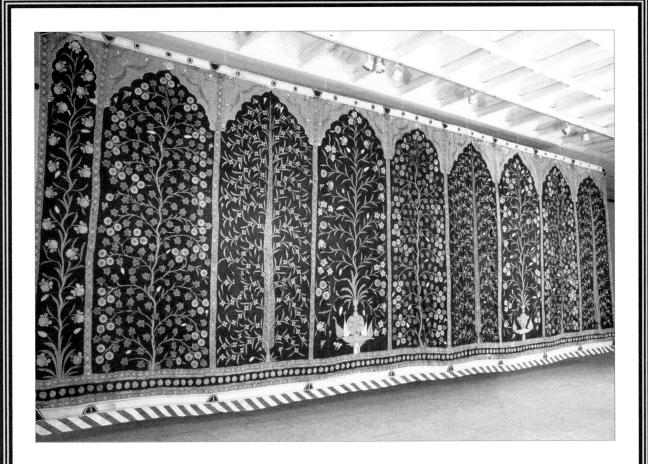

It was a night to remember. The sun had just set, and the sky was ablaze with brilliant red that came close, hugging the grand space of the maharaja's guest house, holding the night with a sense of sustained perfection. Between us and the sky, a procession of elegant plants existed as specimens of perfection within delicate architectural columns. Each plant blossomed with flowers facing us as if acknowledging our presence in this transient palace. Was it music that made these plants grow? The tent was fiction, we were fact. Was the perfection of this fabric environment intended to overwhelm us with self-consciousness about our own imperfection? Or were the quiet rhythms and subtle harmonies, and the persistent red sky, means to transport us to states of being that we all have the right to experience?

—**GK journal**

4.3 *Phulkari*
Eastern Punjab, India
Late 19th century
cotton, silk floss
83 × 54 in.

I've had a forty-year love affair with this textile! It was discovered in Connaught Square in New Delhi, where many merchants from the Kutch desert had set up temporary stalls to sell new and inherited possessions, necessary as a result of persistent drought in their homeland. Not knowing anything about the circumstances that brought these textiles to market, I simply concluded that the abundance was typical. (The following year the rains came, and the textile merchants were nowhere to be found.)

It was the range of the subject matter, and the distribution of silk embroidered motifs on a handwoven Khaadi cloth of handspun cotton, that attracted my attention. The basic organization is simple: four ribbon-like elements extending toward corners of the textile from a central disc, and connecting along the way with four blossoming trees (trees of life), symbols of abundance. Immediately, I perceived the space of four seasons, or the definition of cardinal directions, north, south, east, and west.

At the ends of the textile were processions of peacocks, which I had come to recognize as auspicious symbols. Above them was the most charming rendition of a simple train with cars carrying visitors. Where were they going?

Earlier on a visit to Mumbai, I learned that unexpected guests at a wedding were considered to be auspicious blessings, and once I identified the special couple, the bride with a pink headcloth and her groom, standing with a winged angel blessing the marriage, it set in motion an analysis of every image in relation to the wedding theme.

I came to learn that this type of textile, known as a phulkari, was traditionally embroidered by a grandmother as gift to her granddaughter, and that what I first thought to be a one-of-a-kind textile is in fact a very traditional one. The grandmother blesses the marriage with this headcloth, which is worn by the bride as a symbol of community welcome and support.

Notice the various characters that entertain the bride: dancers, jugglers, a musician, a couple of guys who seem to be engaged in a wrestling match, a woman spinning thread for the bride's dowry, an attendant that protects the bride from the sun, a butter churner who produces an essential element for the banquet. In the adjacent quadrant is a depiction of the bride's jewelry as a declaration of financial prosperity, presented between two peacocks: a male, demonstrating his full colors, and a demure female on the opposite side.

The third quarter presents more peacocks clearly in conversation with one another, and frogs, parrots, centipedes, crows, and other auspicious uninvited guests that join with all sorts of lowly creatures in other quadrants: scorpions, rats, lizards, snakes, and even a horse and elephant that have transported guests to the wedding.

The phulkari is a most wonderful depiction of belonging.

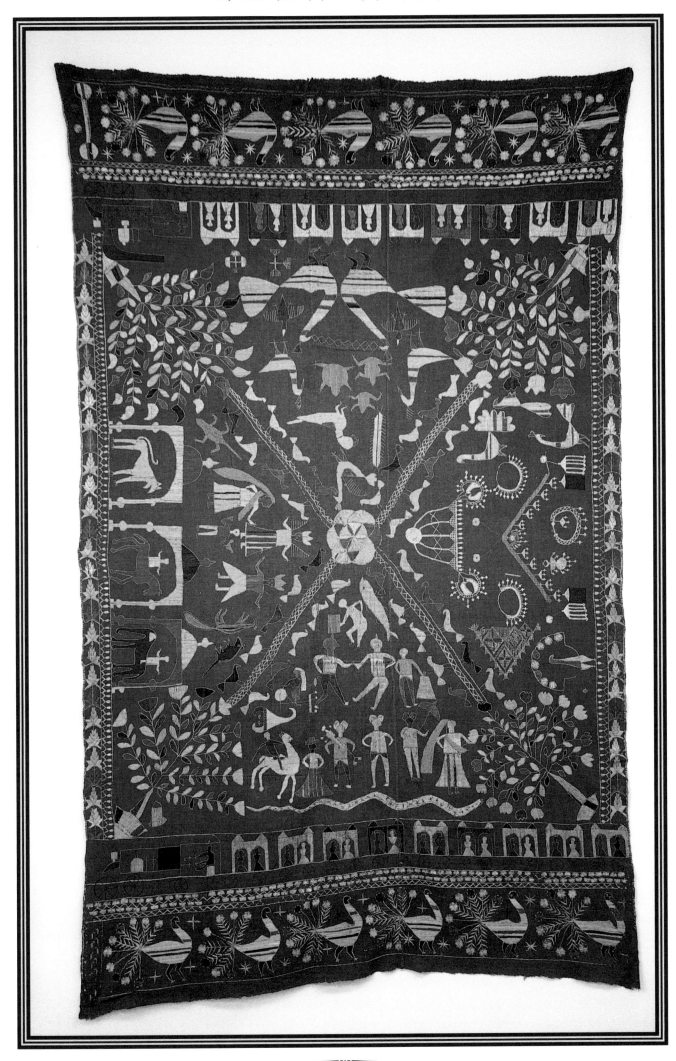

4.4 *Quilt*

American, perhaps Pennsylvania, 19th century
wool, cotton; pieced wool solid fabrics on the face,
cotton print backing, wool yarn, wool fill,
with wool fleece "pompom" embellishment
70 × 80 in.

The maker of this quilt may never have thought that her work would be considered relative to an exhibition entitled *Let the Games Begin!*, but the spirit of the piece is perfectly aligned with the ambition of that work.

What could possibly have inspired this "over-the-top" treatment of surface other than an attempt to embody common materials with flamboyant energy? Here the "artist" demonstrates an unbridled enthusiasm for the power of her choices that would affect others, while at the same time receiving the visual energy and joy that those choices transmit.

As with the case of Indian tribal embroidery, here there is no evidence of schooled training. The baby block patterning of the central field is probably an offshoot of a late-nineteenth-century preference for this pattern. But in no way does it hold to elegant, measured counterparts that may have been made by her neighbors. Instead, she has done a bit of pointillistic tickling of her block variations by sewing puffs of pink and yellow wool to the geometric pattern, with abandon. The game relationship is further suggested in the four squares tangent to the corners of the red playing field. Again, nothing is quiet in this geometry, where the superimposed grid of puffs avoids correlation with the pieced pattern underneath.

One can only speculate about what inspired the abundance of flower-filled baskets and additional floral motifs that accompany the central field. That speculation seems futile as no amount of mental dissection will affect the visual audacity and compelling wit of this quilt.

The two previous textiles (the Indian phulkari and the American quilt) each have a dominant central focus, an act of centering that establishes a home base for the maker in relation to her world view. The first anchors her local community with a simple universal diagram of the cardinal directions. The quilt maker's focus seems more of a private matter, perhaps the relationship to her family and home.

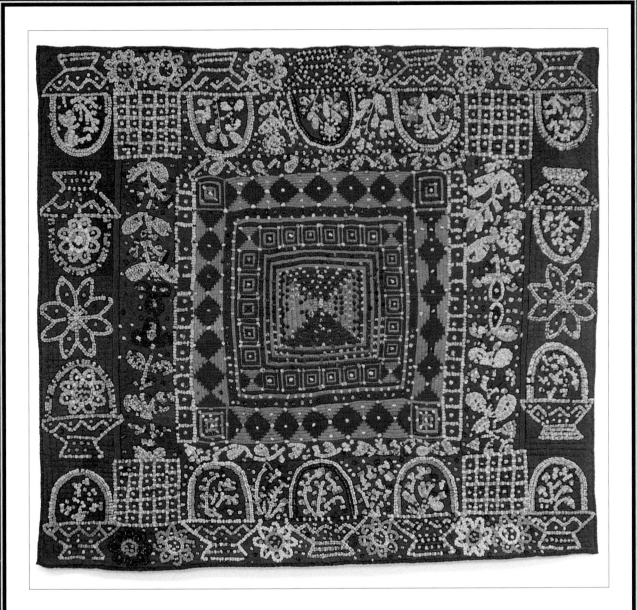

4.4 (detail)

4.5 *Vestment for a first-degree Taoist priest*
China
Early 19th century
silk with appliquéd forms of needle-looped
needlework, couching, gold- and
silver-leaf lacquered paper
50 × 76 in.

This splendid and quite spectacular Taoist priest's robe offers another view as it literally represents interaction between the priest and the star gods who dwell in different parts of the sky. In ritual, the priest communes with the gods, often with his back to the congregation, who are witness to a symbolic representation of the meeting in the form of a celestial diagram. This is seen on the back side of the priest's robe. At the center, an oculus provides a view of a tower that is the celestial home of the gods. Surrounding the oculus are couched gold discs representing lunar mansions that are controlled by individual gods. Beyond is a firmament of clouds, auspicious cranes, and other symbols of authority and power.

We are witnessing the field of a vast gameboard in which all of the symbols of wisdom, insight, power, and prestige present an ideal relationship, one that is not fluid or subject to chance. The priest participates in this diagram of energy and power in order to maintain it as an ideal, an environment of equilibrium to be desired. Rendered sumptuously with elegant materials, the garment seems to radiate confidence in all that it represents. Who would not want to inhabit this environment, this place of beauty and peace?

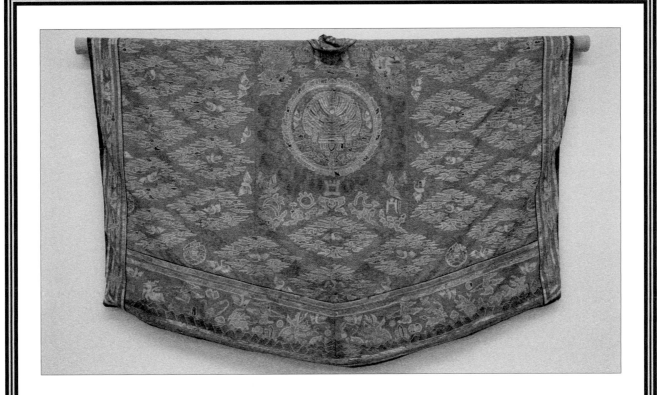

4.5 (detail)

4.5 (detail)

4.6 *Suzani (wall hanging)*
Kitab or Shahrisabs, Uzbekistan
Third quarter of the 19th century
silk, wool, cotton lined with printed cotton
94 × 73 in.

In the summer of 1975 I first exhibited work in the International Biennial of Tapestry, presented in Lausanne, Switzerland: *Parhelic Path*. That year at a separate venue in Lausanne, a special exhibit focused on textiles of Afghanistan, a region of the world rich in textile tradition. I was completely taken by the visual power of large embroideries called suzani and the dedication of Swiss collectors who spoke passionately about the people, their needs, and especially about challenges to the perpetuation of cultural history in the region. Of course, this was before the Russians, and then the Americans.

The following year, on a four-month round-the-world trip, still searching for new experiences with fabric architecture, I made a point of visiting Afghanistan to experience that nomadic life I first learned about in Lausanne. Specifically, to be able to visit and photograph yurts, the fabric and reed homes of the nomads. After two weeks in Kabul, we traveled with a guide and driver over the Hindu Kush mountains to the north of the country, adjacent to the border with the Soviet Union. It was there, in the town of Mazar i Sharif, that I discovered a shop selling regional textiles, including examples of suzani like those I had first seen in Switzerland. I fell in love with one explosively extraordinary example.

The moment I laid eyes on this dazzling and radiant embroidery I knew that it had to be mine. This large composition produced with endless chain stitches of silk thread on a rich purple silk ground is a performance of the highest quality. Its composition is traditionally formal, focused and centered, but the components of this magical garden are loaded with contemporary energy. It is as if the impulse for living things to grow (well understood by lovers of abundant gardens) is expressed with fearless abandon. Nature has been reinvented as a vibrant abstraction. The mystery of growth radiates. Stitches accumulate to define a visual field charged with energy. Flowers stare out from the garden like eyes wide open to the life around. The textile seems to be as aware of me as I am of it!

Every juxtaposition of color demands attention. Tiny outlines surrounding leaves, and stems and flowers, pulsate as three chain stitches of one color meet a fourth stitch of another. The maker's sensitivity to color reaches a climax when one observes that only one color is rendered in wool—the scarlet red—a color that obviously could not achieve greatest saturation on silk. Instead, wool has soaked up every ounce of vibrant red energy, and the embroiderer uses it to maximum effect!

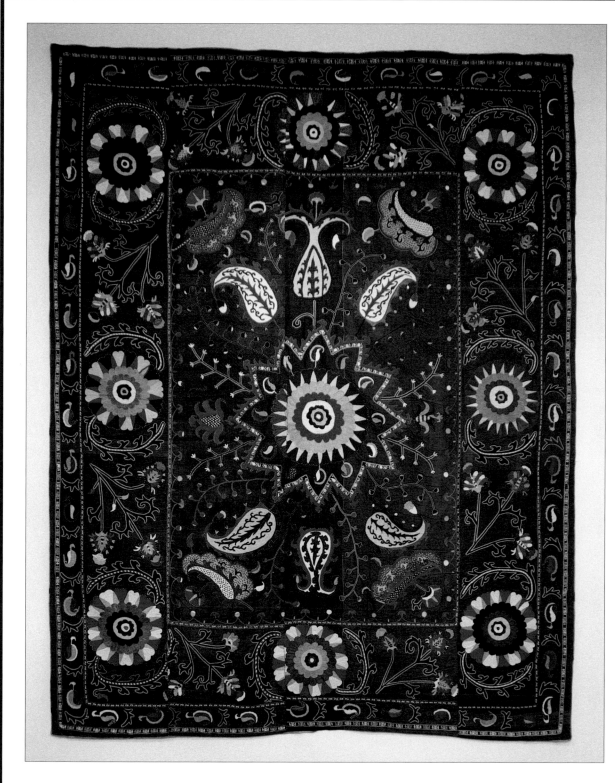

4.6 (detail)

4.7 Man's killing shawl
Nagaland, Northeast India
20th century
cotton, dog hair, cowrie shells
$59\frac{1}{2} \times 40$ in.

The notion of "centering" as a function of a textile takes an unusual form in this ceremonial shawl intended to provide protection to an individual in the traditional process of head hunting. This practice of the Naga people for propitiating the seasons, for ensuring fertility, and for demonstrating courage continued through the early twentieth century.

With my knowledge of the powerful symbolic relationship uniting the shawl worn by a man with his ritual of killing, I was curious about the sources and evolution of the design of the cloth. I frequently puzzled over the presence of perfectly formed circles of cowrie shells (where did they originate?) and the play between two patterns of organization that seem not especially concerned with one another (the circles and the red rectangles).

Leaving my studio early one summer's evening and driving south on the highway, I happened to glance at the sky, where an enormous full moon had just emerged above the horizon. Of course! And how obvious! The Naga, who practiced their grisly ritual at night, must certainly have found the light of a full moon to be beneficial. The careful positioning of two figures within the composition seems to emphasize that fact.

The pattern of shell circles stands in interesting contrast to the grid of rectangles made of dog hair (traditionally dyed red) that is woven with regularity into the ground cloth. The two patterns do not coincide, as if the white circles reflect the hunt, and the red, the hunted. The subtle shift between the patterns animates the surface of the textile with implied movement.

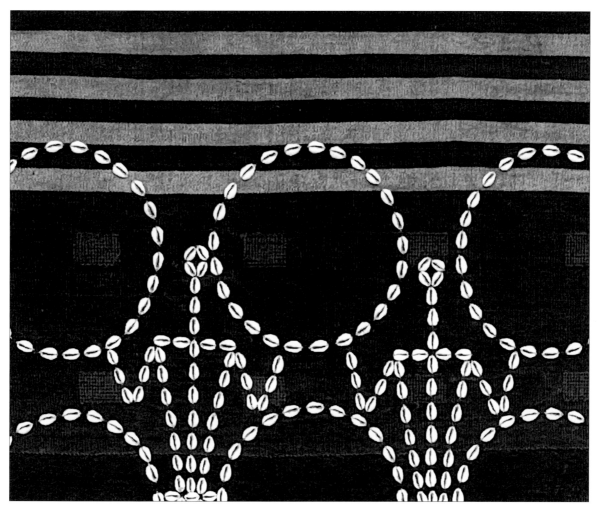

4.j (detail)

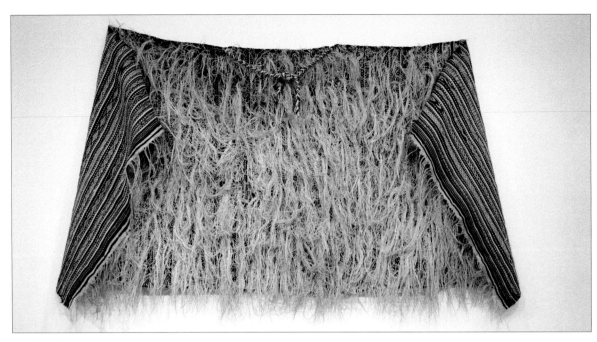

4.8a Beni Quarain cape

4.8a Beni Quarain cape
Morocco
Early 20th century
wool, cotton
84 × 35 in.

Over the years I have found attraction to aspects of textiles that are often ignored:

Significant inspiration resides in the back side of fabric. Thread, yarn, string, and rope are three-dimensional elements from which pliable planes of fabric are made. Textile constructions occupy space, and even those that hang flat to a wall have a back side, despite the fact that we most often choose to visually ignore it.

Fabric contains space. All textiles contain breathing space, intervals between fibers that expand or compress to facilitate movement and hold body warmth. This hidden characteristic of fabric, the space defined by fibers, is another source of inspiration, especially in relationship to architecture.

Vulnerability is an essential aspect of textiles. Textiles live as long as they are cared for. Light which illuminates, also destroys. Textiles that are thirsty for dye deteriorate in the presence of constant humidity.

Only unusual circumstances permit textiles to last beyond their functional lives. It is quite extraordinary to find cloth intact in Peruvian tombs dating 2,000 years back in time; to realize that people in many societies regarded textiles as evidence of their heritage, that they venerated and cared for old cloth as they cared for living relatives. And further, to discover fabric that has survived natural disaster and destruction; to discover fabric repurposed, used and reused to make something "new" from the last vestiges of an original identity.

All of these reasons contribute to a passion for collecting these survivors of time, and for speculation on circumstances and evidence that contribute to the rich legacy of textiles. Creative speculation is never avoided. In fact, it often unlocks the doors of understanding and appreciation.

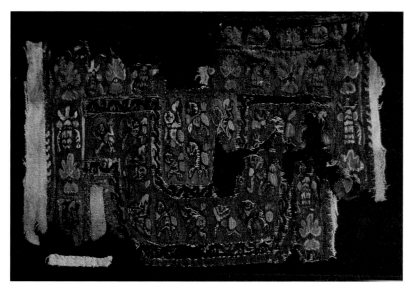

4.8b Front panel of tunic, Egypt, 8th century, wool, linen. 8 × 12 in.

4.8c Fish trap and shadow, Southeast Asia, 20th century, bamboo. 33 × 6 × 6 in.

4.8d Obi (reverse side), Japan, 19th century,
silk, metallic paper gimp on silk core, ramie. 164 × 27½ in.

4.9 Bag (bilum)
North coastal New Guinea
19th century, or earlier
interlooped bark cloth
$71\frac{1}{2} \times 37$ in.

The essence of this fabric seems rooted in the ability of a line to walk, just as bare feet travel over the land, stepping with regularity, but not within a preconceived, rigid format.

Look closely to see that the line that is interlooped with itself to form a pliable textile structure is a continuous one. Changes of color are not achieved by changing threads, but the color changes are spun into the line. There's no doubt that the maker's genius in producing this complex textile is the result of having taken this walk many times before. Like that of an accomplished jazz musician with a practiced ability to negotiate improvisational music making, the journey is always a new adventure, fresh with invention and discovery.

Is music encoded within the linear movement of this textile? In 2010, New Orleans jazz musician and scholar Michael White had an opportunity to live with this textile for several days. Challenged to penetrate its musical potential, he generated a work entitled "Life's Journey," and performed it on trumpet, guided by his notations.

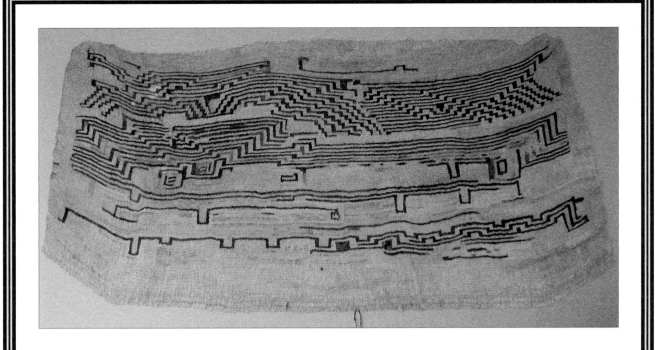

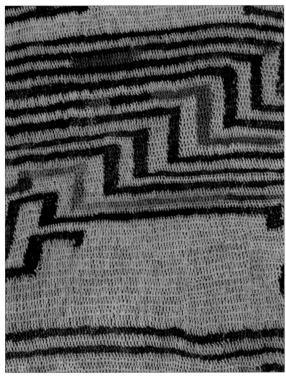

4.9 (detail)

4.9 (detail)

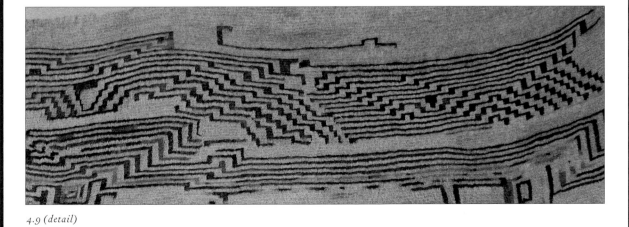

4.9 (detail)

4.10 *Wind screen or mat for a tent (escaber)*
Africa (Niger, Mali, or Algeria), Tuareg people
reed, leather, bast fiber; warp twining
20th century
233 × 35 in.

It is rare to find a textile that physically stands by itself, that supports itself. So it is a special pleasure to consider this pliable plane of weaving that offers functional variety as a divider of space and flexible delineator of inside and out. The ability of this textile to be reconfigured according to functional need immediately brings to mind the standing wood screens Charles and Ray Eames designed in the 1950s as room and space dividers. Both the Eameses and the Tuareg people produced portable architecture that is responsive to multiple requirements, and that ultimately is the perfect solution for people on the go!

In the desert, where this escaber originated, it would be highly valued as a portable component of a family's living environment. It is easily moved, and within a tent dwelling it is often used to close the space between the roof of animal skin and the ground level. Often it was tied to wooden poles to provide extra security from wind, sand, and sun, and to provide privacy around the sleeping area of the tent.

An ingenious byproduct of the weaving is the excess leather strips on the back that became a kind of packing material, padding to prevent breakage of the reed when the screen was rolled for transport. When set up vertically, the leather also responds to the wind, enlivening the environment of the tent with movement and sound.

Triangular motifs woven into its structure are considered amulets against evil spirits, and occur as a constant motif in other Tuareg arts.

4.10 (detail)

4.11 *Aksu, woman's overskirt*

Bolivia

19th century

handspun alpaca; warp-faced plain weave,
complementary warp weaves

$49\frac{1}{2} \times 50$ *in.*

The possibility of creating space by filling it has never been revealed so convincingly than in this Bolivian textile. Textile making physically occupies space, but it is an unexpected experience to discover an illusion of infinity in a woven cloth.

We see two sentries standing as columns on the left and right, elegant guardians in watchful attention, framing the edge of night. The sentries exude sensuous pleasure. Each identifies individually with a refined field of extraordinary color that only could have been born from millennia of refinement, learned and extracted from Nature; plum, ochre, raspberry, indigo, melon, snow, and avocado, each carried by three-dimensional threads of handspun alpaca that reflect and absorb light, cast shadows, and dip and dive in and out of richly patterned fields of stripes of the most exquisite proportions.

While the symmetrical composition of the cloth suggests that it should be perceived as a whole, I am fascinated to be attracted to an unusual exercise of perception. My left eye holds to the left column, my right eye connects with the opposite, and between them, corresponding to the physical interval between eyes, is the unknown, an uncharted darkness that both attracts and repels. There is a space to occupy with my attention.

Did the weaver of this fabric see what I see? Was the space of her own existence high in the mountainous region of the Andes mirrored in this textile for her body? Did her imagination walk in the relationship of light and dark passages as mine does? Was she sensitive to the expressive power of opposites—dark versus light, near versus far, compression versus endlessness? Did she see the central dark void as the focus of this textile? Did she discover, as I have, that profound mystery resides in this textile?

4.11 (detail)

4.12 *Mat*
Niger, Africa, Tuareg people
1900
leather (warp), reed (weft)
112 × 66½ in.

Life can be thought of as a flicker of light in the broad infinite scope of time and space. How does one visualize endlessness that extends beyond our own existence?

With rhythm at the heart of weaving, the repetitive intersection of warp and weft can be considered a critical activity on which all humans depend, like breathing. It is not surprising that this fundamental character is appropriate to convey a relationship of people to time and space, a motivating impulse for art of many cultures through history.

In this textile two fields of pattern evoke contrasting characteristics. I sense the lighter areas to be near to me, as an architectural wall penetrated with openings/windows through which I see a most fascinating phenomenon. Each opening provides a framed glimpse, a fragment, of what is beyond. Geometric patterns in the dark areas appear as though they resist being contained, floating freely in the space outside, as if slowly passing through a night sky, something larger than life. It is the incompleteness that interests me, the sense that the triangular patterns extend endlessly beyond the frames, and even beyond the outer borders of the mat. If a companion piece were placed nearby, the sense of connectedness of that night sky would expand from one to the next.

To experience endlessness within a contained rectangular woven construction is fascinating. Imagine the dreams generated by sleeping on this mat!

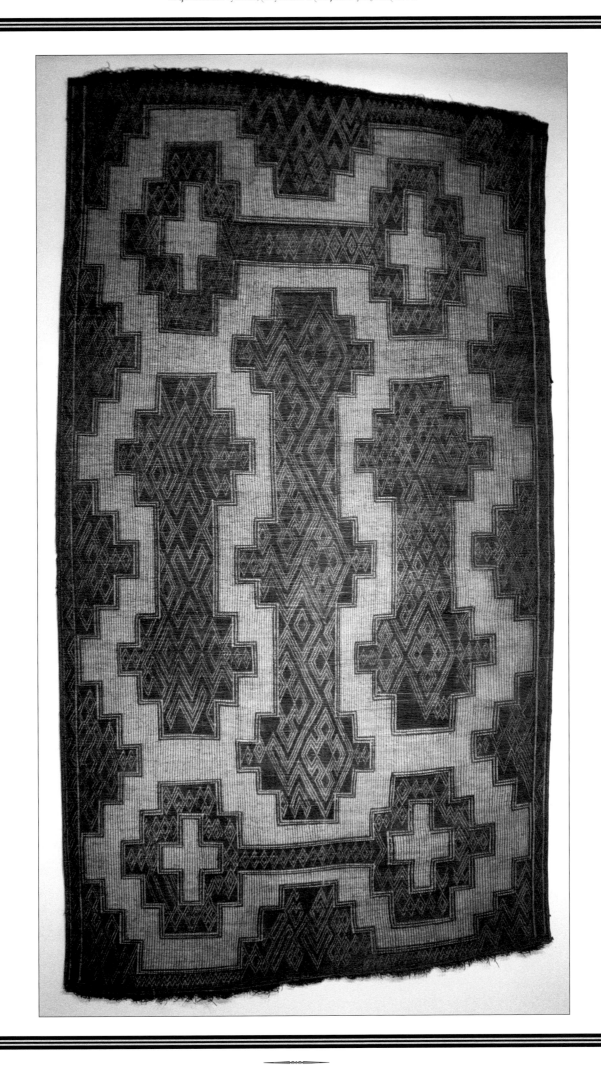

4.13 *Fireman's coat*
Japan
19th century
cotton
39 × 50 in.

Firemen living in the wood and paper cities of Edo-period Japan were often criminals whose only recourse for public acceptability was to confront mortal danger as firefighters. By banding together, they established status as outsiders, brave men who risked their lives protecting the possessions of others. But they were also marked men, living on the edge of society.

Their standard uniform included coats made of many layers of cotton connected and strengthened with parallel lines of stitches over the entire surface of the fabric. Before confronting the fire, the coat was saturated with water to provide a layer of protection.

Governance in the highly structured Edo Period imposed strict limits on what kinds of textiles could be worn in public. Richly patterned textiles were reserved only for the upper classes. Firemen, being limited to plain indigo-dyed cotton, reacted with ingenuity: by patterning hidden parts of their bodies with tattoos showing images of heroic conquest, bravery, and adventure, themes that parallel the comic book heroes in the West. Extraordinary full-body suits of tattoos based on mythical stories were functional talismans of protection in the face of danger.

Protection was also rendered inside the fireman's coat; skilled painters created environments of images to be worn in confronting fire. The coat's lining became a secret second skin, a psychological defense against destruction, and a vital source of empowerment.

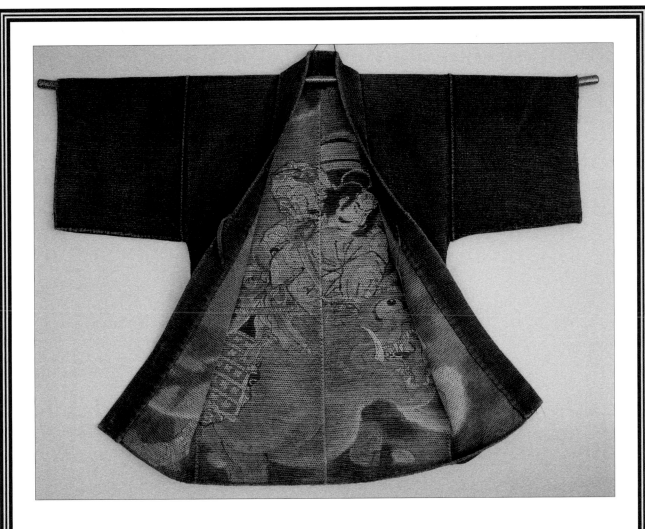

4.13 (detail)

4.14 Instructive bandage of the St. John Ambulance Association
England
19th century
cotton, rollerprinted
$26\frac{1}{4} \times 58$ *in.*

So there you are, lying on the field of battle with a significantly wounded arm and leg. No one is around. You're in pain, bleeding, but still conscious. With no one to assist, what to do? You recall being equipped with a personal first aid kit attached to your pack, and with great difficulty you locate it, open the bag, and recover the triangular bandage provided for exactly this kind of emergency, a self-help aid to a wounded soldier lying on the field of battle.

The bandage instructs about how it is to be applied—but then, it is also the bandage to be used to bind the wound. Which should be done first? Read or bind? What if you get it wrong? The men in the illustrations look so calm, so pain-free, and so well-dressed! Instructions are clear, but you can't move. You lose consciousness as the bandage falls to your side.

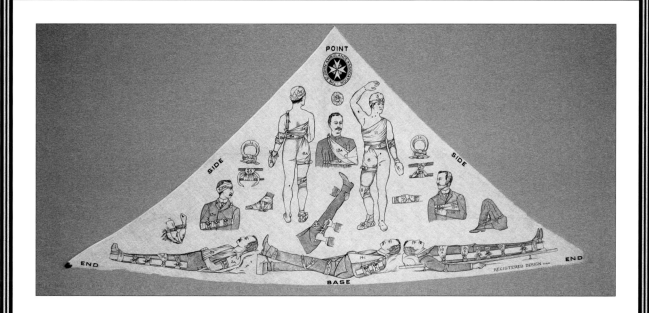

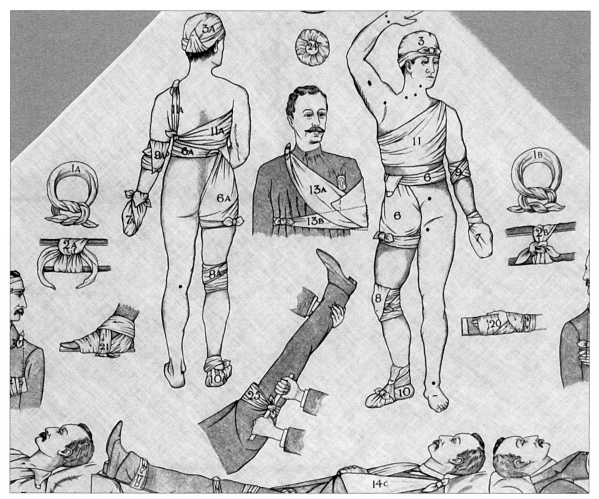

4.14 (detail)

4.15 *Ceremonial skirt*
Timor, Indonesia
20th century
cotton
52 × 61 in.

What is the heartbeat of a community? What is the place of origin for that which unites individuals? Ancient legends have imagined the birthplace of civilization as celestial abstractions relating to sun, moon, and stars, and have discovered within geometric diagrams a language of intersections and relationships that morph into more versions of themselves, endless mutations that reflect fascination of the conditions from which we come, and predict the destiny to which we all will return.

The complexity of this ceremonial skirt inspires an investigation of the sequence of its development. The skirt is composed of six panels, three pairs of different widths separated from one another. Panels 1 and 6 were woven together (note the bottom of each where they were originally joined), and 2 and 5 were connected, as were 3 and 4. The simplicity of Panel 1 suggests something similar to a narrative approach; the subjects to be elaborated are introduced as small, distant objects, like stars against a sky of dark indigo. Key designs are rendered in miniature, but moving on to Panel 6, a woven extension of 1, the patterned elements are developed, and then shown with a sequence of fourteen human figures. Three appear to be spinning thread using drop spindles, while others stand at the side of patterned textiles. Are these figures representations of the weavers showing their products? Are they merchants? Or are we seeing a ceremony indicating the importance of the textile in relation to its owner? Moving on to the wider warp of Panel 3, human figures are eliminated, and in their place diamond-shaped images stand above each textile. Progressively along the length of this weaving, patterns explode in importance, covering the indigo ground cloth with exuberant color and geometry. Panel 2, a narrow weaving, is introduced with a regular woven pattern that eventually erupts along its length with an energy that parallels developments in the adjacent panels.

Despite initial impressions of complexity and contradiction, we discover a path for following the weaver's visual narration of a sequence of unfolding events. Once the progression is understood, cutting and reassembly of parts into a functional garment does nothing to interrupt the essence of the idea that inspired the weaver. Ultimately, as the panels are stitched together to form a tube skirt, the components of the story become an environment of images that engulf, enhance, and elevate the owner with visualized energy connecting to the community of which she is a part.

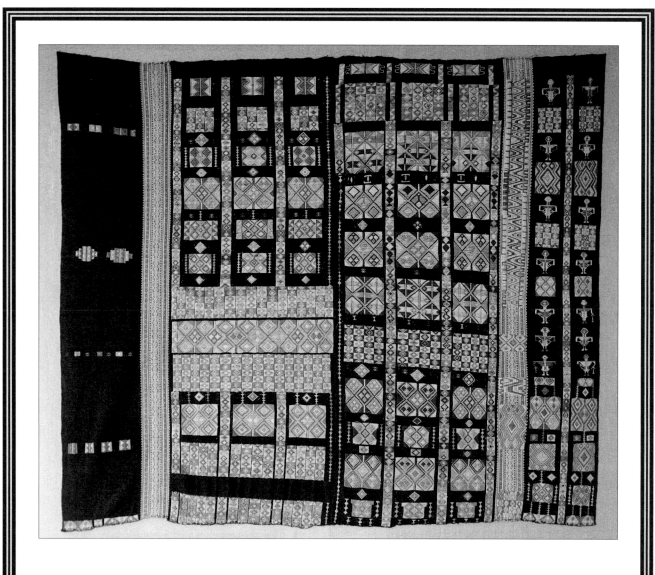

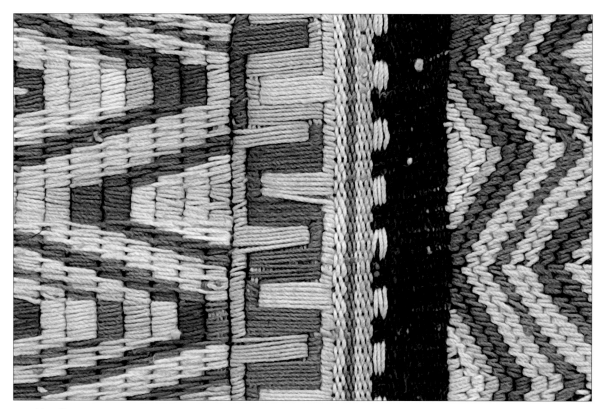

4.15 (detail)

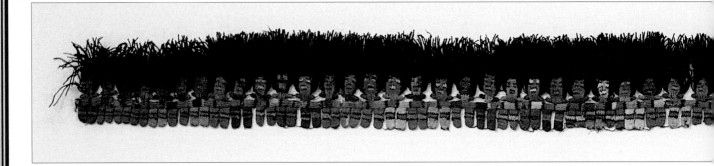

4.16 Mantle border
Nazca Valley, Peru
100 BCE–400 CE
alpaca, cotton; single-needle knitting
on cotton foundation
5 × 53 in.

This wild-haired community of hand-holding individuals had the audacity to appear at my studio a few months after I completed the interactive game *Whoosh*. I couldn't believe my eyes when I saw this lineup of individuals that could easily be considered prototypes for my own representations of art critics sitting side by side in anticipation of making their insightful pronouncements about my work! Their attentiveness, their gaze, their frontality, their faces and hair all echoed my own choices. I had to own this textile!

The most incredible fact about this find and its coincidental relationship to my work was that it was made in Peru 2,000 years ago! While I have always been fascinated by currents of inspiration that flow through history, this one landed quite by surprise.

This needle-knitted community of figures originally was connected as a border embellishment to a large plain-weave fabric. The fabric formed a mantle, a body covering probably made for the purpose of clothing a mummy bundle for burial. The tradition of burying dignitaries in the Nazca society with quantities of their very best textiles, many of them newly made for this purpose, has resulted in a legacy of textile masterpieces that speak of the medium as a dominant art form of their civilization rarely surpassed in history.

The greatest pleasure comes from speculating about what is represented by these figures that stand like a row of birds on a high wire. Are they entertainers? Are they relatives? Perhaps they exist as a gesture of communal relationship with the deceased, an illustration expressing a lasting connection with the community. Not a bad way to go!

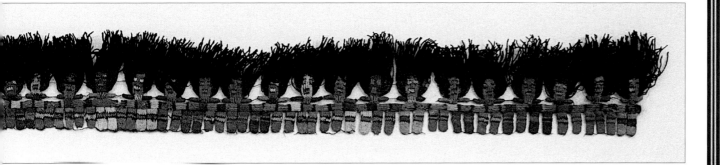

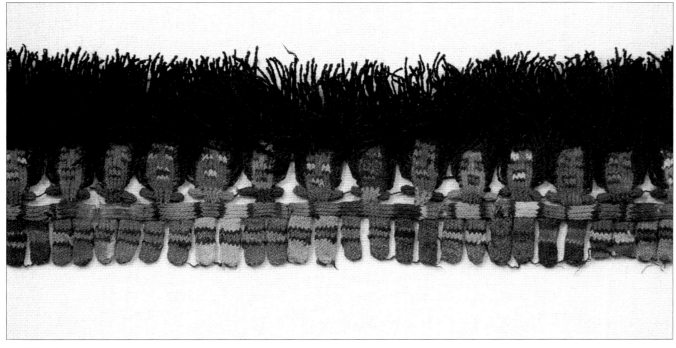

4.16 (detail)

4.17 *Tapis, woman's ceremonial skirt*
Lampung, South Sumatra, Paminggir people
17th century (?)
cotton, metallic thread, silk,
mirrored lead, embroidery
$49\frac{1}{2} \times 50\frac{1}{2}$ *in.*

In the mid-twentieth century, Indonesia was hardly a dot in the conscious awareness of most Americans. But that door was pried open with an abundance of extraordinary textiles that suddenly appeared on the market in the United States and Europe. As had been the case with nineteenth-century African sculpture or Japanese art as it emerged in European markets, Indonesian textiles opened eyes and minds with innovative imagery, great craftsmanship, and mystery.

This textile, a tapis worn by women for ritual occasions such as weddings or other life changing moments, was among my earliest purchases in a collection of Sumatran textiles that now totals forty pieces. I was completely impressed with the quality of images and composition that seemed only to have counterparts in ancient Peruvian textiles, European tapestries, and ecclesiastical embroideries. I was very attracted to the "serial" character of compositions that revealed related episodes in comic book style, adjacent interdependent vignettes, and systems of organization clearly rooted in pattern-based sensibility. Especially capturing my attention was the implication of precise narratives, which, if deciphered, could reveal insights into life and traditions long gone.

Explore the space of the embroidered panels showing figures organized in some kind of exotic architectural spaces. The figures are positioned frontally, facing the viewer. They wear dynamic headdresses, or perhaps auras that surround their heads. The bodies of several seem strangely articulated, like marionettes, or perhaps shadow puppets, and they clearly represent two sexes. Their posture is vivid, electrically charged, as if something of great intensity is happening, and that intensity is heightened with a fantastic environment of swirling patterns.

Eventually, I came to see a flotilla of watercraft...grand decorated sailing vessels transporting idealized reflections of humans to places beyond, not unlike the Egyptian notions of afterlife accessed by boats sailing through the sea of eternity.

And what about the contrast of the brilliantly colored and mirrored panels that surround the embroidery? From another tradition? Perhaps an inspiration initiated by exotic cloths appearing in Sumatra from India? Whatever their source, the exquisite craft and fine proportions complement the narrative panels as they suggest a star-filled firmament to be worn for a special occasion.

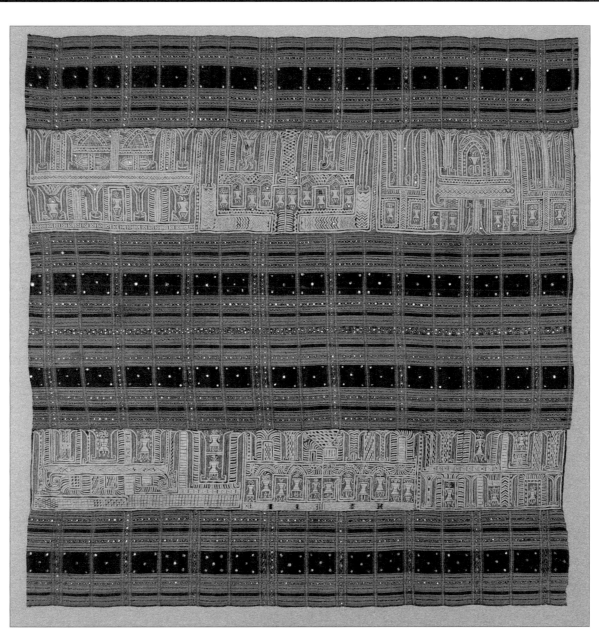

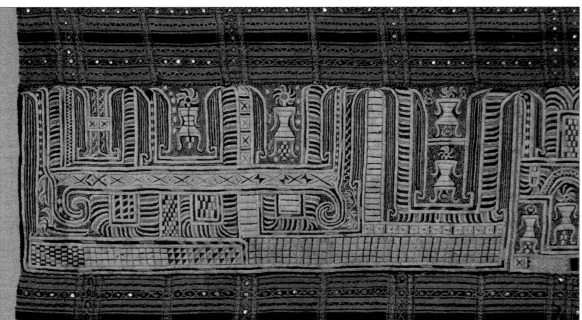

4.17 (detail)

4.18 Tapis, woman's ceremonial skirt
Lampung, South Sumatra, Indonesia
17th century (?)
cotton, silk
47 × 53½ in.

Four very large ships sail across the surface of this tapis, each with a single occupant—a stylized figure standing within a compartment—surrounded by abstractions representing a vigorous tree of life at the center, and a heavily ornamented prow and stern of the ship at the sides. Subtle shifts of ikat-dyed warp threads and the consequent blurring of contours is used to great advantage in creating a sense of movement in the textile.

As is the case with many important Sumatran textiles, sexual references are strongly implied in many of these skirts that accompany ceremonies honoring major transitions in life. Here those references are reflected in the band of silk embroidery moving horizontally across the width of the textile.

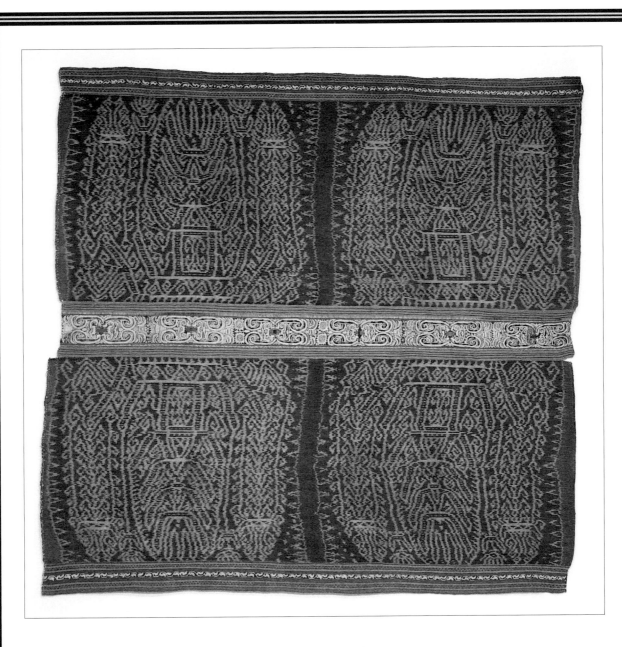

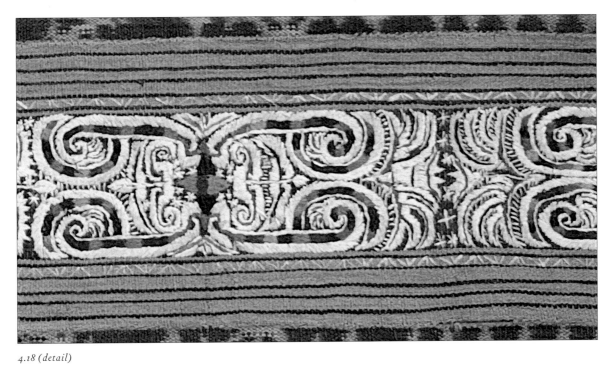

4.18 (detail)

4.19 *Aksu, woman's ceremonial overskirt*
Jalq'a, Department of Chuquisaca, Bolivia
1930–1960
alpaca wool; complementary warp weave
25 × 29 in.

Beware of the night when powerful energies coalesce to become visible, and darkness stimulates imagination for locating the unseen forces that accompany our lives.

A matrix of parallel warp threads stretched tightly on a frame is a three-dimensional place that plays host to the appearance of those images. The weaver is like a shaman that conjures them to reveal themselves with every pass of her weft thread. Her plan is not simply invented from nothingness in the moment of making, but has been culturally nurtured in her small village in Bolivia with family and friends who also experience the presence of those spirits and support one another in confronting the powers that they embody.

Subjects emerge from the textile like the sounds of dogs barking at the moon. A procession of them, standing tall, wings spread, staring ahead. They interlock with the space around them, forming reflections of themselves. Some are pregnant with offspring that radiate a promise of continuity in time and space. Two humans are trapped within those confines. A reflection of our inadequacy in relation to the spirits?

Traditionally, this ceremonial aksu is worn as a partial overskirt held to the waist with a belt. This panel is one of two that compose the aksu; the relatively simple second half is doubled over this panel and worn so that the menagerie of animals may be covered, not seen by others. The embodiment of spirits in this textile is a private matter, and an empowering one like the potency of tattoos hidden from view, a personal means for establishing equilibrium within the complexities of unseen forces that affect our lives.

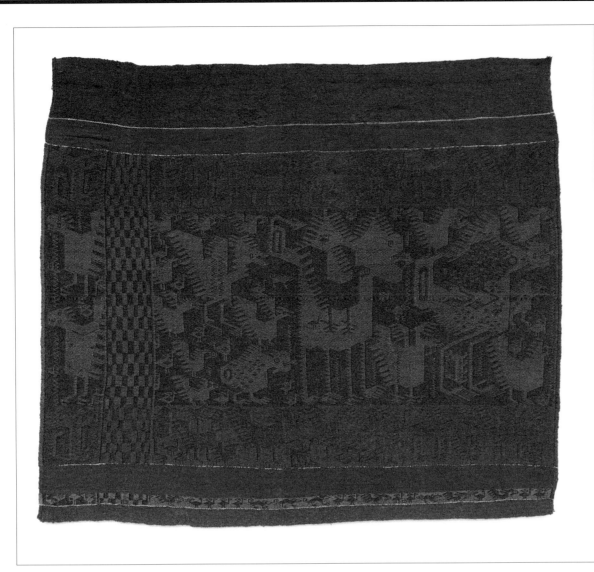

4.19 (detail)

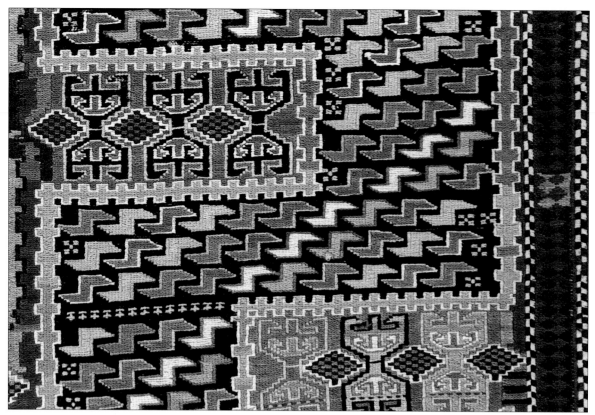

4.20 (detail)

4.20 *Sileh dragon carpet*
Southeastern Caucasus
1880
wool in all-over Soumak brocading
126 × 39 in.

The Chinese dragon invades the imagination with such an immense presence that we only catch glimpses of it. Attempts to fully represent it are futile. It is always present, and not. Its greatest effect on humans is psychological rather than physical.

Fragments of the dragon have surfaced across the globe for centuries, igniting reactions in a wide variety of forms. Among the most compelling is from the region of the Caucasus in the Middle East where the dragon became a dominant subject of carpet weaving.

I had the good fortune of coming upon a brilliant example from the Caucasus developed during one of the last phases of invention in its carpet making, a flat woven carpet of handspun yarns dyed in the most glorious range of natural colors. Highly abstracted dragon images dominate the weaving. Within the Z-shaped figure are lurking eyes and whip-like tails. And are those last vestiges of legs? Dominating the carpet is a rich pattern of scales, and within the angular abstraction of the body, a representation of figures that have been captured or trapped in the aura of the beast.

No jewel box could contain color more vivid and arresting. Through the weaver's skill, I am another victim of the dragon's powerful presence.

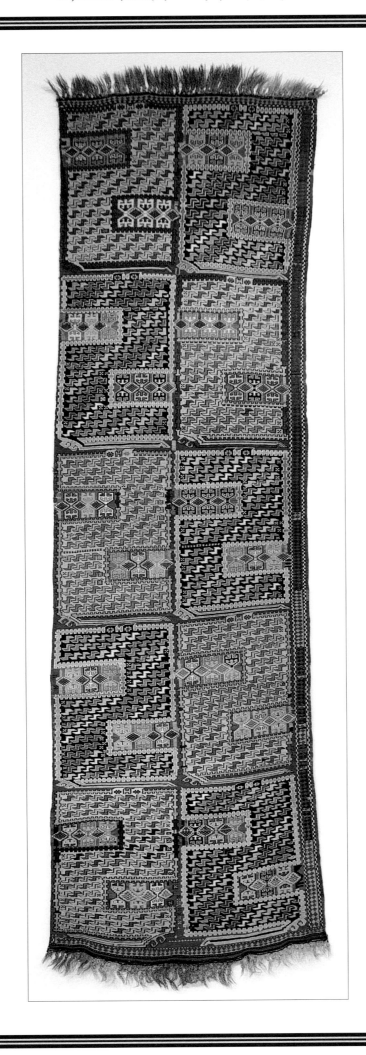

5.
Nothing Comes from Nothing: A Biography

FEBRUARY 21, 1940

Gerhardt Gunther Knodel is born on his father's birthday in Milwaukee, Wisconsin, to Herbert and Lilly Knodel, German-born parents who emigrated from Berlin to Los Angeles in 1927 and 1928, respectively, and met there in a German social club. As a young immigrant, Herbert works for a hosiery factory where he masters operation of complex knitting machines. The company transfers him to Wisconsin in 1935, and he immediately addresses a letter to Lilly, inviting her to take the next Santa Fe train east, where they will be married on her arrival. She agrees. Gerhardt is born five years later. Kindergarten begins at the age of 4, and Gerhardt awkwardly participates. The fact that he primarily speaks German is not an advantage in 1944; and to assimilate, the family decides to focus on English. This includes shortening "Gerhardt" to "Gery," the name he consistently uses until 1978.

JULY 16, 1942

Sister Gerda is born.

SUMMER 1944

The family of four packs the Buick and heads to Southern California. Thirteen re-tread tires later, the family arrives into the welcoming arms of Lilly's mother, Emma, and stepfather, Carl Jaeger, at their Middleton Place home in Los Angeles. Emma is a dressmaker who generously shares

with Gery her love of making clothes, quilts, and rugs, and for covering clothes hangers with fabric so that jackets won't slide. Carl is the head pastry chef at the Cocoanut Grove nightclub of the Ambassador Hotel, where his skills at spritzing roses and doves and decorating huge confections for the Hollywood film studios result in fascinating family albums of photographs documenting his creations presented to film stars.

The family purchases a home on 48th Street with an apricot tree for climbing, and a tree house. In the spirit of wartime conservation, the family's backyard Victory Garden is an inspiration to neighbors.

FALL 1945

Knodel attends 42nd Street School and lives and thrives in the secure environment of his post–World War II nuclear family and their mostly German friends and relatives.

1948

Disenchanted with the knitting business and wanting to enjoy the open air of Southern California, Gerhardt's father learns the carpenter's trade from his uncle, and within a few years is supervising his own projects. He builds a new family home in Inglewood, where the family lives for two years, followed by a third move in 1950 into a newly purchased home at 1946 West 78th Street that will anchor the family for years to come, and will offer an environment in which Gerhardt's interest in art develops.

1950

Lilly Knodel answers the front door of her home and greets an insurance salesman who, before leaving, offers to introduce Gerhardt and Gerda to Sunday school at St. Mark's Methodist Church on 82nd Street. Gerhardt, a boy soprano, is encouraged to join the children's choir, where he becomes a soloist (mainly for baptisms, where his rendition of Brahms' Lullaby is in great demand!). Within a year the choir is recruited by the Los Angeles Opera Conservatory to perform in *Carmen* and *La Boheme*, where numerous backstage adventures inspire adaptations in Gerhardt's marionette theater, established in the behind-the-garage playroom of his parents' home.

1951

Across-the-street neighbor Colby Billings suggests taking bikes to 74th Street School, where changes are being made in the auditorium. They benefit with one half of the old grand drape, a half-mile of maroon velveteen, transported home piled high on two bicycles. This is Gerhardt's first experience with luxury fabric on a very large scale.

1952

Knodel takes his first art class at Horace Mann Junior High School with Darcy Hayman, who allows students to let colors meander in their Prang paint boxes. Purpose: to make colors that have not even been named. She plays guitar as students work on her experimental projects. Knodel's work earns him his first award, a Gold Key from the Scholastic Art organization, including an afternoon at the posh Biltmore Hotel, and an appetite for more! He benefits from the untethered optimism of other young art teachers, including William Paul Baker, who has an insatiable appetite for extravagance and over-the-top fantasy. Home life includes cutting the front lawn on Saturdays, practicing piano for one hour every day, and Sunday dinners with the family. Even at the age of twelve he likes to slip off of his chair at his grandparents' dinner table, to be in the intimate world beneath the table—a tent defined by lace tablecloth and legs.

1954-1957

George Washington High School offers fine academic courses, perfectly balanced with the arts. He is a foreign language major in Spanish (has lead role in *Don Quixote de La Mancha*!), blames the teacher for his dislike of algebra,

and enrolls in as many art classes as possible, with special interest in art production, where he has a first taste of theater design. For him, good teachers hold the potential for creating magic with their students.

He sings in the choir at school and at the church, performs in the high school stage productions of *The Mikado* and *My Fair Lady,* designs and paints sets, attends every production of musicals at the Los Angeles Civic Light Opera, and dances as often as possible. Saturdays he works for $1.00 per hour at Desmond's clothing store warehouse, counting and sending merchandise to various stores. In June 1957, he delivers the commencement address before his class of 425 students. His favorite art teacher advises: "Do anything except teach. Don't waste your creative talent."

1957-1959

Knodel enrolls in Los Angeles City College, where he studies art with another talented instructor, Mary Jane Leland, who introduces him to textile design through Bauhaus methodology, tempered with 1950s design inspiration of Charles and Ray Eames, Alexander Girard, and others. Classes are small and intense, and the textile processes are seductive as is the notion of the pliability of the medium and its ease in transport. After his first year, he wins the

first prize of $100 at the California State Fair for a screen-printed textile. His parents are especially impressed, and for the first time his father has a notion that art might be a lucrative practice.

SUMMER 1958

Selected to be a member of a pre–Peace Corps work team, Knodel joins sixteen high school seniors and college freshmen, assigned to jungles of Panama for six weeks of "building bridges of friendship" on behalf of the Methodist Church. The opportunity to visit the San Blas Islands provides his first experience with exotic natives, albinos, witch doctors, and unique native dress. Then he continues on to Colombia, Jamaica, the Dominican Republic, and Haiti, and finally to Havana, Cuba, just at the time that Batista is being overthrown by Fidel Castro. The experience plants a hunger for world travel and diverse cultures.

1959–1961

Knodel studies art, art history, music, and education at UCLA. He explores diverse subjects but gravitates toward design, ceramics, and textiles. His interest in theater design is set aside because of heavy requirements in primary areas of study. At the close of the last semester of practice teaching, he takes a four-part qualifying examination for teaching positions within the Los Angeles City Schools, scores high, and is offered a position at Westchester High School, a model school of the city.

SUMMER 1961

Knodel spends summer at Camp Paivika in Crestline, California, as art director for the Easter Seal Societies program for severely handicapped children and adults. He has his first inspiring experience as a one-man leader.

FALL 1961

Knodel begins a six-year commitment to high school students at the height of California's exemplary record of achievement in education. He teaches five subjects and 150 students per day, opening worlds of possibilities for himself as well as for the students. He volunteers to collaborate with Robert Wood, the vocal music director, and with other faculty in drama, dance, and instrumental music, as visual designer and coordinator for all the school productions of plays and musicals, and designs twenty-four shows.

1962

Knodel experiences his first three-month, $5-per-day trip to Europe, going from LA to New York's Idlewild Airport, arriving at Eero Saarinen's new TWA terminal, where walls transition to ceilings with no line of demarcation separating them. He travels on to Iceland, Luxembourg, Germany, Austria, Italy, France, and England. He makes connections with German relatives and lives the pages of his art history notes. With $80 from his grandmother's sister Ida, he buys a Picasso ceramic vase in Valoris, France, and his first old textile, a Kashmir shawl in Carcassonne, France.

1963

Knodel purchases his first loom, a Bexell, and installs it in his Playa del Rey apartment. He joins the Southern California Designer-Craftsmen organization and participates in their exhibitions. SCDC provides the opportunity to meet outstanding practitioners in the field of crafts; Knodel is especially inspired by the innovative concepts and history of guest lecturer Anni Albers.

1964

Knodel takes a second three-month European trip, beginning at the New York World's Fair, where he experiences Moshe Safdie's Habatat and Buckminster Fuller's Geodesic dome for the U.S. Pavilion, containing enormous installations by Warhol, Oldenberg, and others. He is impressed by world statistics, especially predictions of population growth and its influence on world economies. He continues on to Portugal, Spain, Italy, Turkey, Austria, Germany, Denmark, and England. In Istanbul he has his first taste of the exotic east, and finds the gateway to interest in so much that is outside the domain of the West.

1968

Knodel decides to leave his high school teaching position to pursue graduate work with Mary Jane Leland at California State University at Long Beach. His focus is on exploring the potential of shaping living environments with textiles.

1969

Two of Knodel's works are accepted into the *Young Americans* exhibition sponsored by the American Crafts Council, and he attends the opening during their national conference in Albuquerque, New Mexico. The experience reveals the exciting potential for national recognition and inspires ambitious projects to follow.

In the summer he begins a one-year teaching assistantship in the Textile Department at California State University at Long Beach.

1970

Knodel completes the requirements for a master of arts degree, including a master's exhibition *Enclosures: An Exhibition of Environments* at the campus gallery. The exhibition is seen by Eudorah Moore, director of California Design at the Pasadena Museum, who subsequently invites him to include the majority of his graduate works in the upcoming 1971 exhibition.

Early summer brings a phone call from Mary Jane Leland, with news that she had been contacted by Cranbrook Academy of Art in Michigan (her alma mater) regarding its search for a new leader of the Fabric Design department. She suggests that Gerhardt would be the right person for the position. Knowing that many of his teachers/artists had attended Cranbrook, he is immediately suspicious about a 30-year-old emerging artist being able to carry on the dignified history of Cranbrook. She insists. A portfolio is sent, and within one week an invitation arrives: "Please come for interview, ASAP!" Five days later Gerhardt wings his way to Michigan.

Cranbrook midsummer is quite perfect. One walk through the woods, one look at the summer exhibition, one breath of creative air, along with the promise of support that will be provided, generate excitement about unexpected opportunity. The final few hours of the visit are spent at the airport with Wallace Mitchell, president of the Academy, who assures him that all governors feel he is perfectly suited. Then Mitchell offers him the position, and one week to decide.

Two weeks later he packs two suitcases with clothes, and two boxes with slides and yarns, into his Karmann Ghia, and proceeds to Michigan, arriving a month before classes begin.

FALL 1970

The year is one of transition at the Academy. Only four of the eight artists-in-residence survive the previous year of revolution, with the four new faculty members selected from outside both Michigan and the institution's history (George Ortman, painting; Michael Hall, sculpture; Robert

Evermon, printmaking; Gerhardt Knodel, textiles). All are given a license to reinvent.

Eager and talented students bolster Knodel's courage to aim high. When student assistants and a couple of the faculty wives indicate that they are there to assist in his studio work, he immediately involves them in constructing *Something to Do with Trees*, a major work shown at his first one-man exhibition at the Cranbrook Art Museum in December, along with a majority of the work from his graduate exhibition. The event is especially effective in introducing him via his work to key members of the Bloomfield Hills community.

(Approached by Melvin Maxwell Smith, who puffs that he is the owner of a Frank Lloyd Wright home down the street and needs new coverings for his cushioned banquets, Knodel responds, "Unlike my predecessor, I don't do upholstery.")

1971

Knodel welcomes students to his studio, but makes it a point to keep his work separate from theirs. Ambitious projects and long hours are intended to serve as a model of what he believes to be basic to any degree of success. As a stranger to Michigan, he regards generating sources of support as important. Nancy Yaw (Yaw Gallery, in nearby Birmingham) presents his first exhibition in a private gallery and becomes a loyal advocate for his work; ceramist Richard DeVore becomes a mentor in navigating the machinations of the academy; Knodel visits artists, designers, and craftsmen in New York and Chicago, including Jack Lenor Larsen, Sherri Smith, and Lenore Tawney, and invites them to interact with his students.

In mid-summer he enrolls at Haystack School of Crafts in Maine for the session with architect Paolo Soleri, and meets Kenneth Gross, assistant director. It is the beginning of a lifelong relationship.

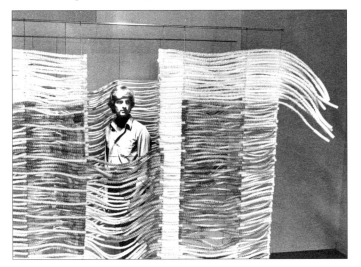

1972

Technical experiments for binding dyed strips of china silk onto lightweight Ethafoam rods evolve into a new body of work; *Eleven Aerial Acts* are presented at the Yaw Gallery, then shown in group exhibitions at the Kansas City Art Institute and the Worcester Art Museum.

Attracted by a spectacular opportunity to build a major environmental piece, Knodel accepts an invitation from the Women's Committee to transform the Cranbrook Art Museum with 9,000 square feet of stretch fabric and projected light for their Beaux Arts Ball.

1973

In search of exotic tent architecture in exotic lands, Knodel and Ken Gross travel to India, where Knodel acquires extraordinary experiences and bags full of antique textiles that become the foundation for his collection.

1974

Deliberate Entanglements opens at UCLA along with a conference that includes outstanding European artists Magdalena Abakanowicz and Jagoda Buic, and Olga de Amaral from Colombia. Abakanowicz and Buic are gracious, enthused, and willing to come to Cranbrook at Knodel's invitation, following the LA events.

Knodel meets Sheila Hicks at collector Paul Hirschler's home in Pasadena, and she proceeds to explain the hoops through which artists must pass in Switzerland in order to be legitimized at the most important and prestigious exhibition in the field of textiles, the Lausanne Biennial of Tapestry. Excited by the challenge, in late summer Knodel sends a proposal to Lausanne, Switzerland. Months later, he is accepted.

In celebration of the bicentennial, Knodel is in attendance as the largest flag in the US is dramatically unfurled (for the last time) over the facade of Hudson's Department Store in downtown Detroit, to accompaniment by the Detroit Symphony Orchestra.

1975

The opening events at Lausanne's 7th Biennial of Tapestry happen in May. Knodel's *Parhelic Path* spans the main gallery's forty feet of width, with a bold new presence. It is well received. Lunchtime conversations with other artists provide him fuel for ambition, and a first-time sense of being internationally relevant. A concurrent exhibition of Uzbek textiles from Afghanistan, and discussions with collectors in Lausanne, open thoughts of traveling for firsthand experiences with nomadic textile-based architecture.

1976

Knodel receives an artist grant from the National Endowment for the Arts, making possible a round-the-world five-month trip, January to May, to identify and study fabric architecture, especially focused on India, Iran, Afghanistan, Vienna, and London. The research is to lead to a major exhibition at the Detroit Institute of Arts, but on return, those plans are foiled as architect John Portman and Henry Ford II commission a major work for the new Renaissance Center, Detroit. In turn, the requirements of the work Knodel designs spark interest in a visit to Churchill Weavers in Berea, Kentucky, and initial experiments with weaving of Mylar and wool fabrics for the project in their facility. A successful collaboration is initiated, one which will continue in years to follow.

1977

Two suspended fabric sculptures, *Free Fall* at Renaissance Center, Detroit, and *Gulf Stream* at the University of Houston, are installed.

Roy Slade, Director of Corcoran Gallery, Washington, DC, is appointed President of Cranbrook Academy of Art. This initiates, for the first time, a period of institutional self-consciousness regarding Cranbrook's heritage and international significance. Opportunities for national and international events and exhibits, including the work of artists-in-residence, are initiated over the coming seventeen years.

Knodel participates in a summer residency at Anderson Ranch with ceramists Paul Soldner and Robert Turner and furniture makers Sam Maloof and Wendall Castle.

In mid-summer, Knodel travels to Switzerland for participation in the 8th Biennial of Tapestry, exhibiting *Arroyo Seco*.

1978

Fabric In Motion, a runway performance that animates textiles in the traveling exhibition *The Dyer's Art* in the Cranbrook Art Museum, is initiated by Knodel.

Knodel travels to the Murrah Federal Building in Oklahoma City for installation of *Sky Ribbons: An Oklahoma Tribute,* commissioned by the thriving art-in-architecture program of the National Endownment for the Arts. The project is dedicated in June by Joan Mondale, the wife of the US vice president and a strong arts advocate.

Sky Court, a woven sculpture, is installed at Xerox World Headquarters, Stamford, Connecticut.

Knodel participates in the first of a series of fabric miniature exhibitions at the British Crafts Centre, London, an international project developed in reaction to the large size requirements of works for the Lausanne Biennial, an idea that generated a new genre of fiberworks.

For the first time, Knodel incorporates photographic imagery accomplished by screen printing on cotton tapes before weaving. Using photographs taken during a visit to gardens at Schoenbrunn palace in Vienna, the suspended weavings surround the visitor in the gallery in the spirit of poetic tapestry environments such as *Lady and the Unicorn,* seen by Knodel two years earlier at the Cluny Museum in Paris.

Participation in four panel discussions at Fiberworks conference at Merritt College, Oakland, California, provides an opportunity to join one of the first high-level events uniting the dominant players in the field of textiles.

1979

Inspired by textiles and tales generated by Mary Kahlenberg's travels in Indonesia (for the Los Angeles Museum of Art, where she is Curator of Textiles), Knodel travels for five weeks in Java, Bali, and Sumatra. He adds significant works to his growing collection, and pursues a new interest in narrative textiles, textiles that "speak."

New photo-weavings are exhibited at UCLA, Wight Art Gallery, and in *Art in Architecture* at the Kemper Gallery, Kansas City Art Institute.

Architect Daniel Libeskind joins the faculty at the Cranbrook Academy of Art, and becomes a major resource for historic models of inspiration that unite textiles with other art traditions.

1980

Knodel's first New York City exhibition at Hadler Rodriguez Gallery is scheduled to open the first week of February. Installation is just complete when he receives news that his mother is critically ill. He leaves immediately for LA and arrives in time to spend a day with her before her passing on February 2.

Knodel negotiates a two-year leave from teaching responsibilities. The goal is to live for two years as an independent artist, exploring for the first time the consequence of full-time studio involvement. Freedom begins as students depart in May.

Anticipating studio space off campus, he explores the town of Pontiac, ten minutes north of Cranbrook, identifies potential in the old and empty Rogers Sporting Goods shop on Lawrence Street, and purchases the building with dean of students Barbara Price. An intense four-month renovation follows, and the studio is finally occupied in late September.

The first public screening takes place on PBS of *Gerhardt Knodel: An Artist and His Work* by filmmaker Sue Marks. The film surveys his interest in architectural projects with visits to several sites where key installations reside; it also includes the Churchill Weavers in Berea, Kentucky, where new work is in progress, and Knodel's Pontiac studio.

1981

Working full time in his new Pontiac studio and free of Cranbrook responsibilities, Knodel initiates a period of extraordinary productivity.

The first of four major installations in the entry atria of Lincoln Centre, Dallas, is completed. Knodel explores a sky-related metaphor in each project, reflecting associations with three constellations aligned with the zodiac.

Knodel is invited to produce a gallery installation for Philadelphia College of Art; the result is *Inside/Out,* a work intended to provoke questions about the location of the art experience. The project is the first one to be conceived as a stage for stimulating interaction explored in performances by artists in dance, music, and poetry.

Plans for potential architectural commissions are developed and presented in Cincinnati, Ohio (Cincinnati Bell), Washington, DC (International Square), Orlando, Florida, Houston, Texas (United Energy Resources), and San Diego, California.

Jack Lenor Larsen and Mildred Constantine's exhibition and publication *The Art Fabric: Mainstreams* is presented at the San Francisco Museum of Art. Knodel's *Act 8* receives significant attention.

Inside/Out, a woven work, is presented at the 4th Textile Triennial, Lodz, Poland.

Knodel discovers that by using Xerox color transfer paper, he can apply a more complex image to the cotton tapes he had been using for weft in his woven pieces. He leases a color machine with Carl Toth (artist-in-residence and head of photography at Cranbrook), and develops the first four weavings incorporating the process: *Riverfront, Billboard, Facade, Processional.*

A proposal by Sheri Simons to become his first full-time studio apprentice, co-sponsored by the Michigan Council for the Arts, is accepted.

During travel to Italy in September and October, Knodel makes an important discovery: the facade of the brilliantly patterned cathedral in Orvieto illuminated with warm, brilliant afternoon sun. The presence of two men sitting on its steps provokes thoughts that will lead to major works in 1982.

At the Arena Chapel in Padua, with painting by Giotto, Knodel comments: "This is a place 'beyond,' a spiritual place where human beings are together with evidence of the best that can be. In the presence of that environment, we are all more, individually and collectively."

On returning to the Pontiac studio, Knodel writes: "Just now I'm also feeling torn with regard to a lot of opportunity. Received letters—an invitation to participate in Polish Triennial of Textiles in Lodz, and an exhibition of new research in fiber to be shown in conjunction with the Documenta in Kassel next year. Then there are upcoming university exhibitions—and Nancy Yaw has asked me to do a show with her gallery in the fall. I'd best get busy!"

Alice Marcoux, head of textiles as RISD, initiates the Jacquard Project, with invitation to explore creative potential of their loom. Knodel generates plans for fourteen weavings.

1982

In January, the Super Bowl is held at the Silverdome in Pontiac, with a parade held downtown in sixteen-degree weather. Near the studio Knodel photographs visitors standing in empty store windows, an inspiration for producing *The Pontiac Curtain*, a 36-foot woven portrait of main street Pontiac.

Roy Slade, director of CAM, invites Knodel to exhibit work produced during his two-year leave. The exhibition in the museum's main galleries, *Gerhardt Knodel Makes Places to Be,* includes a major theatrical installation, architectural models and drawings, *The Pontiac Curtain,* and numerous additional weavings. The installation/environment becomes the setting for interventions and inventions by performing artists, musicians, and poets, and plays host to a fashion show produced by Academy students, all initiated by Knodel. The project inspires a new approach to his participation in the 11th Tapestry Biennial the following year.

The mayor of Pontiac declares "Gerhardt Knodel Day" with a city reception in the galleries of the Cranbrook Art Museum.

Following the museum opening at Cranbrook, the Yaw Gallery in Birmingham, Michigan, presents *Gerhardt Knodel: The Jacquard Project*, a suite of fourteen Jacquard weavings, mounted and framed to provoke thoughts on the relationships between weavings and paintings.

The Yaw Gallery assists in producing an exhibition catalog: *Gerhardt Knodel Makes Places to Be.*

1983

A conference on architecture and human values of Rudolph Steiner is presented at the Cranbrook Art Museum, opening significant doors of understanding relative to theories of form in space generated by the human body.

11th Biennial of Tapestry, Lausanne, Switzerland, features *Entr'acte* by Knodel, providing him an entire gallery for the installation of his work that merges associations of theater with art gallery, and provokes questions about the role of the audience as actors or observers.

Grand Exchange at Cincinnati Bell is recognized by *Time* magazine as one of ten outstanding works in design of the previous year.

Knodel presents the keynote address at the American Crafts Council national conference in Winston-Salem, North Carolina.

Design in America: The Cranbrook Vision opens at the Detroit Institute of Arts. An event of international significance, it recognizes the ongoing contributions of the Academy, and inspires new levels of appreciation for the legacy of the institution. To create a contemporary counterpart, Knodel curates *New Images in Fabric,* presented at the Detroit Artists Market, including the video "Fabric in Motion," a dramatization of fabric produced by the fiber department at Cranbrook, and filmed by Booth Cable Company, Birmingham, Michigan.

1984

Design in America: The Cranbrook Vision opens at the Metropolitan Museum of Art, New York, with subsidiary exhibitions presenting contemporary work at other city-based venues. C.D.S. Gallery presents *Cranbrook Contemporary,* featuring work of artists-in-residence.

Elements Gallery in New York hosts *New Woven Work by Gerhardt Knodel,* including *Theodora's Wrath* based in Byzantine textile traditions.

In July, Knodel travels to China as a member of the United States Arts and Culture of China Study Delegation, a group of twenty-three artists and teachers, including leader Cynthia Schira, Joan Livingstone, Anne Wilson, and Lia Cook. Influences of Chinese gardens in relation to architecture and decorative arts become an important resource in future work.

Chinese bushes, ink, and books on calligraphy inspire first experiments with images for commission in Minneapolis at Opus Corporation.

Knodel is selected as one of four artists to receive the United States/Japan Friendship Fellowship Commission award, allowing him to live in Japan for up to one year. The award supports his interest in researching the subject of space in Japanese architecture as manifested in theater and annual festivals. He departs for Kyoto on December 28.

1985

Tokyo and Kyoto become Knodel's primary home base, from which he travels extensively during the seven-month stay. His experiences with artists, craftsmen, and architects are extensively documented in drawings, journal entries, and photographs. He visits living treasures of Japan, and he lectures frequently. The Eastern/Western split in Japanese identity becomes a primary source of interest, and one that will fuel future work.

Gathering on a Distant Sea, a reflection on migration of influences that define Japanese culture, is commissioned by Hughes Corporation for its headquarters in Los Angeles.

Three Different Worlds, for Opus Corporation, Minneapolis, inspired by travels in China, is installed. For the first time, Knodel combines colored neon lighting with woven and printed textiles. The location of the work provides many levels for viewing, and unusual opportunity for the audience to pass through the work on escalators.

1986

New weavings that incorporate influences from travels in Japan and China become the focus of studio work. Reflections on nature in the contemporary world are visualized in *Second Nature,* commissioned for the Minneapolis Institute of Art.

Enormous guardian figures protecting the entry gates of many Buddhist monasteries suggest a new series of weavings. Cranbrook colleagues are photographed and incorporated in the weavings, becoming symbolic guardians of fundamental, nature-based conditions on which humans depend. (*Guardians of Second, Third and Fourth Corner; Guardians of the New Day.*)

Knodel purchases a second Pontiac studio building adjacent to #24 East Lawrence, and develops plans and procedures for a major renovation. The result is a space with 28-foot ceilings and opportunity to see large works develop.

The opening exhibition of the new Museum of American Craft in New York, *Poetry of the Physical,* includes *The Pontiac Curtain* hung adjacent to the grand staircase.

New York artist Robert Kushner visits the academy and inspires the notion of a Cranbrook/Kashmir collaboration in which designs for shawls, created by Knodel and his students, are sent to Kashmir for interpretation in embroidery on wool by local craftsmen.

1987

Cranbrook/Kashmir: A Collaboration opens at the Cranbrook Art Museum.

The *Guardian* series of weavings is first presented at the Miller/Brown Gallery, San Francisco.

The US Ambassador to Romania, Roger Kirk, and his wife Betty provide hospitality and support for Knodel to experience the rich history of painted church architecture in the north of the country. Knodel is inspired by the scope of imagery on the exterior of buildings, which rivals the tapestry tradition in the West as it becomes clothing for the architecture's exterior.

A proposal for a new work, *Guardians of the New Life,* is accepted, built, and presented in an international exhibition of contemporary fiber work at Kyoto Conference Center, Japan. The work is Knodel's reflection on mutations of nature seen in the history of decorative arts in relation to current scientific research on genetic engineering and cloning.

For the same occasion, Knodel is invited to collaborate with Japanese artist Akihiko Izukura on another project for the Kyoto Conference Center. Following Knodel's arrival in Japan, a massive work based on interaction between mythological forces, *Reflections of a Fox and a Bear,* is built in one week in a Buddhist temple with 15 assistants.

1988

Two wall works are commissioned for the boardroom of the new State of Michigan Library/Museum, in Lansing, designed by architect William Kessler (*View Over North, View Over South*).

Knodel and Gross purchase a modernist home by William Kessler on Lower Long Lake as "a retreat up north" (seven minutes north of Cranbrook) and a new subject of their attention.

Interest in the theater as subject is supported with a new work for the foyer of the Singletary Center For The Arts, University of Kentucky. *Garden of the Muses* spans one hundred feet and provides the audience with an onstage experience before entering the auditorium. A new technical approach allows for all components to be produced in the Pontiac studio with the assistance of fifteen graduate students and Susie Rubenstein, artistic collaborator.

Knodel is invited to participate as juror for the controversial 12th Lausanne Biennial of Tapestry, Switzerland.

Travel to Mexico in December with students inspires weavings *Lola's Garden 1* and *2,* based on the garden of Frida Kahlo's home and studio, where the group is hosted by Diego Rivera's close friend and patron Dolores Olmedo. Rivera's close ties with Detroit open doors of opportunity for all.

1989

Frontiers in Fiber: The Americans, curated by Mildred Constantine and Laurel Reuter, travels internationally, including three venues in China. *Guardians of the New Day* is included.

A new approach involving construction of a fabric plane by interlacing strips of printed and dyed fabric into a commercially produced fabric net, suggests ideas for building semi-permeable walls in which the fabric undulates, revealing aspects of both front and back. The process also exposes images of birds that appear simultaneously free, and not. *Bird Suite* is first presented at the Yaw Gallery, Birmingham, Michigan.

Two nephews arrive in June for a three week trip to Egypt and Paris, the first escorted trip for six unsuspecting children of sister Gerda and her husband Donald Bishop. The goal is to go where Southern Californians seldom go, and to generate exotic memories along the way. For Knodel, the travel provides opportunity to see the world through fresh, impressionable, young eyes.

Birdwall, a free-standing fabric wall of interlaced layers, is first exhibited at the University Art Gallery, State University at Stony Brook, New York. It becomes the core idea for an exhibition entitled *Shared Boundaries* at the Craft Alliance Center for the Visual Arts, St. Louis, Missouri.

1990

A sabbatical leave, January to September, welcomes a new year of work in the Pontiac studio. Harry Boom, Dutch artist from Amsterdam, comes to lead the program in fibers and provide fresh insights and challenges.

Knodel's surprise fiftieth birthday party with 175 guests includes his father from Los Angeles, who shares the same birthday, and friends and family from around the US.

Thomas Ferrera, chair of the Art Department at California State University at Long Beach, informs Knodel that he will be recognized as "outstanding alumnus" by the Fine Arts Department. The award parallels recognition of his 20th year at Cranbrook.

Knodel's new approach to building the fabric plane of interlaced strips of fabric is integrated with loom-woven fabric. Nineteen works are generated and exhibited at Textile Arts International, Minneapolis, Minnesota. Relationships between rocks (weight) and birds (flight) are at the core of the work.

The Fuqua School of Business at Duke University offers the opportunity to design a sequence of five woven tapestries and to reinterpret the traditional cloth canopy with an invention made of hundreds of moving metal parts that are alive with reflected light and color.

In August the circus comes to downtown Pontiac with every spine-tingling amenity, including a village of red and white striped tents. The vast environment is a model of sensations that Knodel aspires to evoke in his architectural work.

Once again, Knodel accompanies the members of the Fiber Department to Mexico City and Oaxaca to encourage their appetite for discovery.

1991

Boston architect Michael McKinnell visits the Pontiac studio to discuss an ambitious, collaborative project in Reading, Pennsylvania, that will inspire Knodel's investigation of the inner space of textiles as a gathering place for light.

Knodel designs and produces *Walls*, an installation filling the gallery space at Seattle Pacific University, Washington. The work becomes a metaphor for experiencing art in a gallery setting, examining the question: "Where is the art?"

1992

A major installation work at Sonje Museum of Contemporary Art, in Kyong-ju, Korea, is presented with lectures at the National Museum of Contemporary Art and Hongik University in Seoul. Knodel has the opportunity to interact with outstanding Korean artists and connect with potential students.

Rafael Moneo, Spanish architect, is chosen to design a new studios building for Cranbrook Academy. Discussion with him promotes interest in future expansion and development of the Academy.

1993

Dawn's Promise is installed in the vast atrium of Arrow International, Reading, Pennsylvania.

Down by the Riverside, a multi-layered woven wall, is commissioned by Susquehanna University in Selingsgrove, Pennsylvania, for the entrance to the Degenstein Performing Arts Center.

Challenged to examine the state of craft in the context of the contemporary art world, Knodel explores theme "Crafting Truth with Confidence," delivered at the midsummer symposium of Haystack School of Crafts, Deer Isle, Maine.

Knodel is awarded "Fellow of the American Crafts Council" at the Council's national conference in Chicago.

Thirteen Studies of Reciprocal Space, a series of small objects interacting with textiles, is included with wall-size

works in an exhibition at the Sybaris Gallery, Royal Oak, Michigan. The entire body of work is a reaction to Knodel's realization that the word "space" is traditionally absent from texts that analyze or instruct textile making, yet is an essential component of textiles' identity.

The history of the Dennos Museum of Art in Traverse City, Michigan, reflects tension between preserving the natural environment and destroying that environment for new architecture. Knodel reflects on the value juxtaposition and for the first time, in his installation in the atrium, incorporates a major historic textile from his collection.

1994

Knodel initiates a symposium at Cranbrook generated by grad students from Cranbrook, School of the Art Institute of Chicago, and Concordia University in Montreal, who vigorously investigate contemporary issues overlooked in the earlier presentations in Chicago and contribute to an expanded scope of subjects appropriate to the fiber medium.

Knodel is invited as visiting artist to SUNY, Cortland, where an exhibition of Indonesian textiles from his collection entitled *Through New Eyes* is presented. The goal is to examine the relationship of ethnic textiles with contemporary viewpoints.

Roy Slade retires, and Susanna Torre begins as new director of Cranbrook Academy of Art.

1995

To shift student work into a broader community, Knodel joins fellow Cranbrook Artists in Residence Gary Griffin and Tony Hepburn in generating *Intersections and Interstices* at the defunct Burlington Building in Pontiac, Michigan. Grad students work in teams, building a response to specific locations, as do Knodel, Griffin, and Hepburn, who collaborate to produce a major installation.

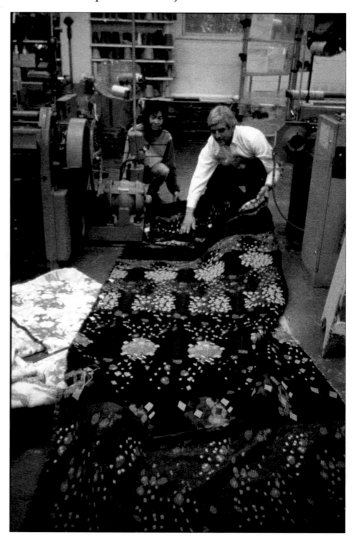

As a means for increasing interest in the computerized loom for making contemporary art, Bhakti Ziek, weaving instructor at Philadelphia College of Textiles, invites Knodel and others to explore computer-based Jacquard weaving. Working with student assistants, he produces *bedTime,* a series of woven bed furnishings and wall works.

Knodel curates the exhibition *Mysterious Voids at the Heart of Historic Textiles* for The Textile Museum, Washington, DC. The exhibition pairs selected textiles with photographs of architectural situations that express the theme of creating space by occupying it.

The Detroit Institute of Arts invites area artists to consider complementing or replacing works in the galleries of the museum with their own interventions. Knodel submits plans to reorient Islamic objects by covering them with fabric enclosures that define a new way to view the objects. *Night Shade* addresses the depletion of meaning that often accompanies objects removed from their original context.

Congregation Shaarey Zedek in West Bloomfield, Michigan, invites Knodel to design and produce a series of weavings that ultimately wrap three upper walls of the main sanctuary with imagery meaningful to the religion. *Gates of Righteousness* is received with a generous ceremony of dedication and appreciation.

Congregation Shir Shalom provides the opportunity to create *Song of Songs,* an architectural stained-glass window above the bima, and a suspended curtain of gold metallic thread containing shards of glass with fragments of Hebrew text from the Psalms.

In mid-summer, Berlin, Germany, plays host to Christo, who wraps the Reichtag with 13+ football fields of fabric, and a million+ feet of blue rope. Knodel revels in the expressive power of the Reichstag project, the process of its making, and the pleasure of being with Christo and Jeanne Claude in a place made familiar to Knodel with family stories originating in Berlin.

Marianne Strengell, influential head of the weaving program at Cranbrook for 25 years, first meets Gerhardt Knodel on the 25th anniversary of his leadership in the studio used by both of them during their time at the Academy.

Knodel accompanies 15 graduate students on a trip to England and Scotland, with special emphasis on the village of Cranbrook, located in Kent County, ancestral home of the Booth family at Cranbrook in Michigan.

He and students produce works that explore the coincidence of two places with the same name and related histories.

1996

Following a series of unexpected events, Gerhardt is appointed interim Director of the Academy, and continues to head the Fiber Department as well. Immediately he sets to work remediating aspects of the physical facilities and the program. In mid-summer, he is chosen to become full-time director, and in the fall transfers his teaching responsibilities to Margo Mensing.

Noting that no other local institution had laid claim on the title "Millenium Project," he proposes a program of international travel for each of the departments of the

Academy over the last four years of the twentieth century, a move that will support the international relevance of the institution.

Knodel establishes a new gallery presence in Pontiac, "Network: A Project of Cranbrook Academy of Art," to present work of recent graduates.

Renovation of the American Center in Southfield, Michigan, provides Knodel the opportunity to create *16 Provinces of Natur,* an installation of suspended elements and a coordinated carpet that centers a vast architectural space at the building's entrance.

Lifelines, an eighteen-month project, is installed in a three-story atrium of Beaumont Hospital. A translucent wall of twenty-eight suspended screens, containing text reflecting traditional healing practices in various locations in the world, is positioned so that each screen affords privacy for the rooms that face the atrium.

Knodel's presentation at the close of the Textile Society of America's conference, presented in the old Chicago Stock Exchange room at the Art Institute of Chicago, is intended to stimulate interest and support for contemporary textiles by people who are positioned at the core of the field.

1997

The language of shadow projections is explored with an invitation to create a gallery installation for the Charles. S. Mott College. Panels of fragmented text build an environment, *Relatively Yours,* in which visitors are invited to don white T-shirts upon entering the gallery, then walk between walls of projected text shadows that paint both their front and back sides with related, but opposing, subjects. Knodel equates the space for shadows as being equivalent to the functional space in and around fibers in any textile construction.

1998

Knodel's commencement address at Kansas City Art Institute is focused on appreciation for the subtle insights shared by people who teach one another.

A commissioned work for the central atrium of the Northville Public Library provides the opportunity to further explore the potential relationships of image and shadow. A secret language of fragmented text that surrounds the viewer is intended to evoke the origins of language.

Skywalking, a collection of miniature tabletop "screens" made of panels of polycarbonate with thousands of hand-drilled holes, is presented at the Sybaris Gallery, Royal Oak, Michigan. The works intensify the language of pattern, shadow, and reflection with an overlay of diverse subjects derived from objects collected in Knodel's travels.

Knodel presents "The Academy in Transition: Is a Creative Utopia Possible at the End of the 20th Century?" at the University of the Arts, Seoul, South Korea, and Tokyo Design Center, Japan.

2000–2007

Knodel's full-time work as director of Cranbrook Academy of Art and Vice President of the Cranbrook Educational Community dominates his professional life. Inspired by diverse and unexpected opportunities, he decides not to

compromise the studio work and instead, channels creative energy on the matters of operating and building the academy.

The following excerpts from his journals offer a few glimpses of the unpredictable and varied conditions that channeled his creative resources into the field of administration.

"If there is essential meaning in the birth of the twenty-first century, it must exist within a concept of time as a container requiring twenty-four midnights to become filled. We can now move from self-definition relative to a fixed moment in time to the self that lives 24 hours simultaneously. Our 'befores' and our 'afters' may now be constantly with us, expanding each moment of our days and our nights from local to global. The earth has moved from 'object' to 'sensation' as media of communication have erased boundaries and distance. The new world will have no impenetrable walls."

"Following months of planning, today I'm finally off with thirty-six 'guests' as I lead a tour to Europe for an 'Islands in the Stream' adventure in Russia, Finland and Sweden."

"Attempting to interject some studio time, I eventually found myself at the loom threading warp #3 for the stripe project, and weaving off several yards. Working in the studio is like returning to dreamtime, or a state of altered consciousness that is simultaneously real and not. And what will come of the stripes? Will anyone consider them as statements of my passing time so carefully set aside to allow for the activity?"

"Today, at last, I have the greatest pleasure in reporting the completion of negotiations to construct the New Studios Building. Following what seems like a short lifetime of attention to this project, it is a great relief to know that construction is imminent."

"Welcomed 120 alumni at the Cooper Hewitt Museum in New York."

"We've now raised 13 million dollars for construction of the New Studios Building. Still, many more to go!"

"At one point of the groundbreaking ceremony I sat looking out onto the audience and the most extraordinary sense of well-being washed over me—the sense of a moment of perfection when a goal is realized and simultaneously discovered—quite like the moment after removing a weaving from the loom, hanging it, walking away, and then turning to see if anything is there. At that moment the labor drops away—along with the good intentions—and one discovers the new life in the work, if it exists."

"My father, Herbert Knodel, passes away in Los Angeles, at age of 93. I am with him. I return to Michigan on November 4, arriving in time to host the annual and final Guy Fawkes Ball, a Cranbrook fundraising event, and then return to California on November 12 for my father's burial at sea."

"At a meeting at Virginia Commonwealth University I was delighted to hear many colleagues refer so respectfully, and even reverentially, to the Academy and our facilities, and I realize again the uniqueness which we must sustain and vigorously support for continued success."

"Decembers are notoriously busy months, always complicated by celebrations, closures, and commitments to dealing with issues that seem to have accumulated, waiting for resolution before year's end. Thoughts of family and commitments to others come into focus, and the

inevitable survey of contacts that culminates with Christmas cards—this year numbering around 600."

"Last night, leaving my office at Cranbrook at 7 p.m., which seems to be the earliest I am able to leave on most days, I was overwhelmed by a strange new sensation. It occurred to me that my leadership role is now solidified and mature; that the past years as Academy Director have served as training ground for another level of action with significant consequences. I have the sense of full responsibility for what may happen in the near future and excitement about how the fullness of feeling about my position may be useful to others."

"Last night I was honored to be awarded the Distinguished Educator Award by the Renwick Gallery, Washington, DC."

"A major flood in my Pontiac studio on Super Bowl Sunday results in significant renovation, and elimination of artwork and architectural models destroyed by water cascading from second floor."

"On the occasion for honoring the memory of Ed Rossbach and a collection of his work given by his wife Kathryn Westphal, I presented a lecture on his work, accompanied by seventy textiles from my own collection as examples of resources that would have inspired Rossbach. Being in the presence of the textiles I've collected is like standing within a visualized aura of my own beliefs. The associations are powerfully rewarding."

2003

A significant influence on Knodel's decision to return to full-time studio work occurred as a consequence of a simple inquiry in 2003 about his interest in considering involvement with a second project for Beaumont Hospital. A competition had already occurred, and finalists were presenting their solutions to the committee that included a donor who wished to honor her parents by giving a work to be strategically located in a new wing of the hospital under construction. The extent of Knodel's involvement and responsibilities had led committee members to conclude that he would not have time for the project, but one of the members decided to take initiative and make the contact. One look at the architectural model and Knodel was inspired not just to solve the project as outlined, but to extend it far beyond what was originally planned. Within three weeks a model was produced and presented to overwhelmingly enthusiastic response, by the committee and the donor, initiating a two-year period of development and production of *The Echo of Flora Exotica,* a work unlike anything Knodel had produced previously, and one that encouraged thoughts for returning to privately developed creative work.

2007

As a culmination to Knodel's thirty-seven years at the Academy, Greg Wittkopp, director of the Cranbrook Art Museum, suggests an exhibition featuring work of Knodel and the head of Fibers, Jane Lackey, and their students. The result: *Hothouse: The Field of Fiber at Cranbrook, 1970–1996,* an exhibition, catalog, and grand ceremony. Knodel exhibits *Guardians of the New Day, Guardians of the New Life, Act 8,* and *bedTime.* In the lower floor galleries of the museum, he presents eighty historic textiles from his collection, all connected with his course in the history of textiles offered over the years. A grand reunion accompanies and celebrates the occasion.

Knodel retires from Cranbrook Educational Community on June 1.

"Materiality," Knodel's keynote address for International Fiber Symposium, University of the Arts, Philadelphia, Pennsylvania, is inspired by the craft of Fred Astaire and Ginger Rogers and a lightweight plastic bag caught in the wind in the Hollywood film *American Beauty.*

In the process of discovering new subjects for future works, Knodel produces a series of nine drawings, *Recovery Games: Strange Encounters,* based on dualities observed in a pre-Columbian ceramic vessel recently added to his collection.

In December, two months of travel in Japan, Thailand, Cambodia, Laos, India, and Korea is initiated as a necessary interval and means to reconnect Knodel to essential components of his own work.

2008

Knodel returns to the studio with renewed energy and expectations. He determines that directions for exploration are to be discovered in the process of work. No new materials are to be used, and old projects are considered fair game for revision. In the process of working, he uncovers the notion that new strategies parallel those of game playing, and the metaphor begins to evolve and inspire.

The first large-scale work, *Recovery Games: Skeeball,* is exhibited in the Fiber Biennial at Snyderman Works Gallery, Philadelphia, Pennsylvania.

Renovation of *All the World's a Stage,* a work made in 1980 for the Midland Center for the Arts, suggests to the museum director the idea of offering Knodel a one-person exhibition at the time of reinstallation of the weaving.

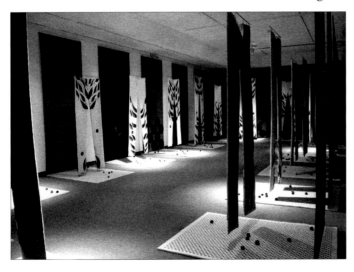

The first survey exhibition of new work is presented at the Midland Arts Museum, Midland, Michigan, including *Strange Encounter* drawings and newly repurposed projects: *Recovery Games: Skeeball, Bingo, The Accelerator,* and *Shoot the Rapids.* Also shown are the first pair of recently invented dexterity games, *Feeding Frenzy-Red/Black.* Two

galleries of historic textiles from Knodel's collection complement the new work.

Hothouse is received with great enthusiasm at the Reading Public Museum, Reading, Pennsylvania. The museum acquires *bedTime,* the Jacquard project.

2009

Uninterrupted days in the studio stimulate reflections on contemporary conditions affecting people's lives, especially the downturn of the economy and situations in which expectations of positive outcomes are soured by unavoidable circumstances. Experimentation with adjusting pattern fields of old Japanese kimono fabrics generates an expanded view of qualities, both positive and negative, embodied in what is commonly considered "decorative." The *Laughter: After Laughter* series is begun.

For the first time, old textiles are incorporated in Knodel's work, and a set of Victorian stencils enters his field of attention with subjects that inspire associations. Like the development of characters in a novel, the identity, needs, and actions of these subjects evolve.

With interest in allowing new technologies to interact with established practices in the realm of textiles, Knodel incorporates digital photography and billboard-sized printing into *Embraced.*

Laser-cutting technology first enters the working process in *Learning to Act,* a four-panel dexterity game. This development reinforces the notion that textiles may legitimately exist at the root of the works and be read through the lens of textile associations without having to be constructed of fiber-based materials.

Knodel's keynote address, "Off the Grid," to the International Surface Design Conference, Kansas City, Missouri, outlines his thinking on diverse extensions into art making that is rooted in characteristics of textiles.

Knodel delivers commencement address at Oregon College of Arts and Crafts, Portland, Oregon.

2010

WARP, a multi-faceted exhibition leaning on the identity of intersecting threads as the common denominator for diverse works, includes Knodel's dexterity game, *Left, Right, Left-Right-Left,* at Gallery Project, Ann Arbor, Michigan.

An opportunity to experiment with new ideas for expanding the inherited language of historic textiles into the twenty-first century is explored with students at Haystack School, Deer Isle, Maine.

Lecture presentation at collector's weekend, Quilt and Textile Museum, San Jose, California.

2011

Interviews with writer T'ai Smith result in publication of "Architectonic Thought on the Loom" for *The Journal of Modern Craft,* including reflections on loom weaving and its relationship to architectural projects.

The first of four large shadow curtains are developed as spatial extensions of subjects from Victorian stencils.

Knodel's interest in combining new technologies into the work leads to the invention of *Whoosh,* an interactive artwork and game that unites recorded voices of art critics with the work they are appraising.

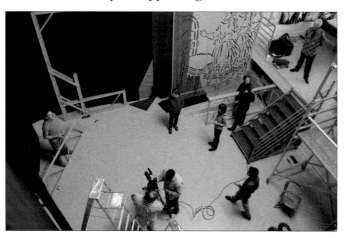

Whoosh inspires a video dramatization to be shown side-by-side with the actual game. Knodel assembles and directs a cast of character actors for filming by Jim Mencotti and associates in the Pontiac studio.

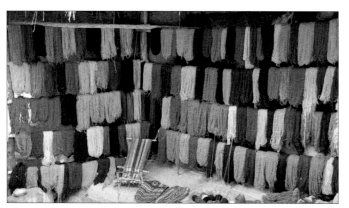

Mid-year, travel to Bolivia, Peru, and Guatemala presents new experiences with time and space, reinforces the importance of weaving tradition, and inspires a return to loom weaving in the following year.

Twelve panels of screen-printed and flocked silk organza produced in 1969 are included in the *Golden State of Craft: California 1960–1985* exhibition, Craft and Folk Art Museum, Los Angeles, linking Knodel's development with the evolution of the craft movement in California.

A "Distinguished Educators" exhibition at the Crane Arts Building in Philadelphia presents *Whoosh,* the only interactive work in a milestone survey of contemporary fiber-based art.

2012

Innovations & Legends, a two-year national traveling exhibition of contemporary fiber work initiated by the Muskegon Museum of Art, includes *Do You See What I See?* Knodel is speaker and panel moderator for opening symposium.

Guardian of the Third Corner is installed at the residence of the Consul General to Jerusalem, part of the Art in Embassies Program of the US Department of State.

Happily Ever After is commissioned for the Lillian and Donald Bauder residence, Columbia, Maryland.

In conjunction with the reopening of the renovated Cranbrook Art Museum, Knodel presents a lecture with artist Ann Hamilton, redefining Marianne Strengell's contributions as head of textiles during her tenure at Cranbrook.

Knodel attends the symposium on Kuba textiles at The Textile Museum, Washington, DC, and contributes to discussions on the future of the venerated museum as it moves onto the campus of George Washington University.

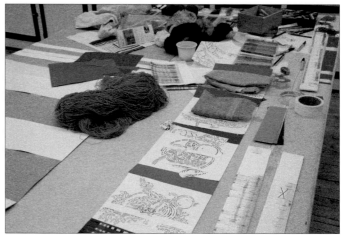

The shadow curtains of 2011 generate ideas for a large-scale work to develop their potential. An episode in Italo Calvino's novel *Baron in the Trees* offers the point of departure for a multi-panel, track-suspended work that demands studio attention for most of the year.

A series of eleven video interviews focusing on new work

is recorded in Knodel's Pontiac studio and produced and directed by Jim Mencotti.

The Trustees of The Textile Museum, Washington, DC, invite Knodel to join the board with the specific goal of encouraging collecting of contemporary work.

The primacy of textiles in the world of art is reinforced by the Metropolitan Museum's exhibition *Interwoven Globe: The Worldwide Textile Trade 1500–1800*. Knodel's responses to the exhibition are recorded in a review published by the Textile Society of America.

2014

The year begins with a response to a *New York Times* article regarding consequences of a typhoon disaster in the Philippines. Knodel's *Start All Over Again*, a two-panel dexterity game, is accompanied by twenty-two smaller games that channel the issues of the disaster into the hands of the player.

Knodel participates in panel "The Male Mystique" at the biennial conference of the Textile Society of America at UCLA.

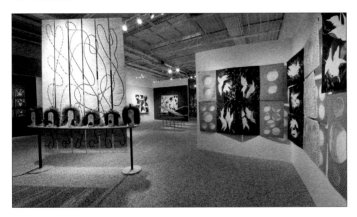

Let the Games Begin!, a survey of work produced in the previous six years, is presented at Wasserman Projects, Birmingham, Michigan.

Knodel is honored with the position of Director Emeritus of Cranbrook Academy of Art, the first emeritus award given by the institution.

6.
Chronology
of Work
1969–2014

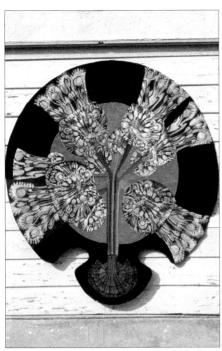

001
Tree of Life

1969
wool, silk, nylon, screen printed, batiked,
and flocked
72 × 84 in.
col. Robert Pfannebecker

Light conveys energy. Designed to change under a variety of different lighting conditions, this multi-layered work comprised of fabrics of various densities becomes luminous when back-lighted.

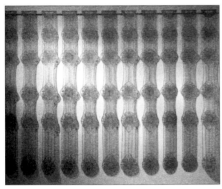

002
Flexible "Wallpaper"

1969
Silk organza, screen printed and flocked
each panel 96 × 12 in.

In response to the static condition of traditional wallpaper, these interchangeable units of silk in various colors, suspended with Velcro, offer many possibilities for rearrangement, including complete removal for an appropriate occasion. Rich shadows complement the translucent silk panels, hung a few inches from a wall.

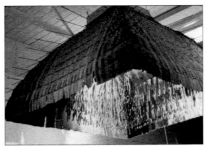

003
Woven Canopy

1969
linen, cotton, nylon, leather, glass, with
in-woven aluminum rods
36 × 72 × 72 in.
col. Deanne Sellers

Exotic intimacy and romantic reflection on Middle Eastern lore are sources of inspiration for this collapsible woven canopy. Metal rods in four woven panels interlace to form a suspended enclosure lined with hundreds of fringe-like elements that move and reflect light.

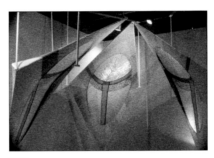

004
Sails: A Space Enclosure

1969
nylon stretch fabric and silk, screen printed
and flocked, on articulated tubular steel
frame
four units, each 120 × 72 × 24 in.

Four movable units on ceiling-suspended tracks are adjustable, creating a flexible space-defining system within walls of rigid architecture. Each unit rotates 360 degrees to become a ceiling canopy or an enclosure. Light modulates and transforms each sail, creating a luminous environment.

005
Sculptured Wall Panels

1970
nylon stretch fabric, screen printed, on
metal frame
two units, each 96 × 30 × 12 in.

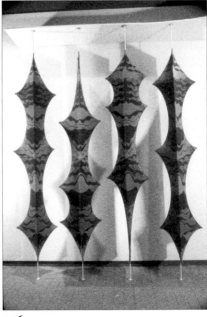

006
Act II

1970
nylon stretch fabric, screen printed, on
metal frame, 8 revolving panels supported
on 8 spring tension pole frames, each 96 ×
18 in.
col. Robert Pfannebecker

Ten revolving units may be arranged to form a wall, or swiveled a quarter-turn to reveal a curvilinear contour. By rearranging opposite sides of warm and cool color, and by rotating the units, various patterns and degrees of color temperature result. The spring tension pole also allows for easy repositioning and flexible arrangement.

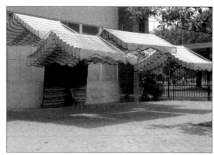

008
Sunshades

1970
cotton canvas and nylon marquisette,
screen printed and flocked, vinyl, on
tubular steel framework support
six units, various sizes—24 × 48 × 72 to
24 × 96 × 120 in.
curtain enclosure: 84 × 72 in.

As the suspended sunshades sway in open air, sunlight from above penetrates openings in the canvas, dappling the space and occupants beneath the canopies with projected light patterns. Movement is enhanced as sheer fins of fabric respond to air currents. Transparent vinyl covers each unit making for easy maintenance.

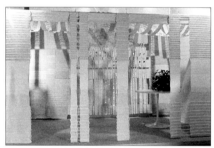

009
Dining Environment

1971
handwoven and knotted cotton, linen,
nylon, glass mirrors, wood support
96 × 144 × 96 in.

Inspired by mirrored cloths of northwest India, this white environment of restrained elegance waits for dinner guests, whose images and color are reflected in a multitude of mirrors. Colored silk curtains hanging in a recess at the front are raised to announce dinner, or lowered to enhance the sense of enclosure. When not in use, the entire unit can be collapsed adjacent to the back wall to become a wall screen.

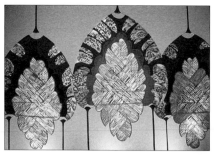

010
Something to Do with Trees

1971
wool, silk, nylon, polyester, screen printed,
batiked, flocked
four units, each 204 × 72 in.

Inspiration was generated by exposure to fall color in Northern Michigan, where light transforms old-growth groves into chapels of luminous sensations. Visual variety is achieved by choreographing light sources.

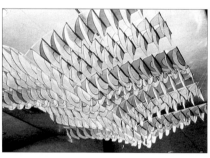

011
Flying Canopy

1971
cotton canvas and nylon marquisette,
screen printed and flocked, vinyl, steel and
acrylic rod support
144 × 216 × 48 in.

In the spirit of Leonardo da Vinci's bird-like flying machine, the individual sections of this canopy rock against the air like bird wings. Activated by air-movement in interior spaces, the moving wings reveal invisible activity of the environment. Opaque, transparent and reflective surfaces and pattern repetition likewise generate sensations of movement.

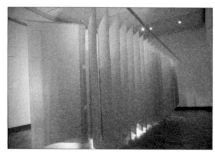

012
44 Panel Channel

1973
china silk, painted and dyed, suspended
from tension structure of steel, cord and
cable
108 × 72 × 264 in.

Twenty-two pairs of silk panels hung in chevron formation convey, from the outside, qualities of softness in texture and color, which tend to suggest all there is to know about "touch." At the front end of the channel a sign invites the viewer to pass through, hands at one's sides, and indicates that *44 Panel Channel* is about that which is experienced along the way. One assumes that the experience will provide sensations of a lingerie department, but in fact, when moving forward the onrush of air causes pairs of panels to open. One can move through the entire channel without touching anything! The inner channel, pleated and dyed brilliant yellow-orange, is visually dominant, and the chromatic sequence moving from warm to cool is experienced only in the periphery of one's vision, creating the sensation that someone is manipulating the quality of the light in the gallery.

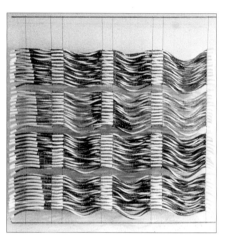

013
Moon Viewing

1973
resist-dyed silk, Ethafoam, nylon
monofilament
84 × 108 × 6 in.

Early in the 1970's Knodel discovered the product called Ethafoam, a continuous rod of extruded synthetic used primarily for upholstery work. Because the rods were resistant to dyeing, he explored altering the character of the Ethafoam with strips of china silk bound with monofilament onto the rods. By patterning the silk with resist dyeing techniques before wrapping, color could be introduced into a sequence of linear elements which, when assembled onto metal rods, could suggest complex textile structures. The relatively weightless products suggested movement in space, and in turn, the notion of energetic but elegant "aerial acts."

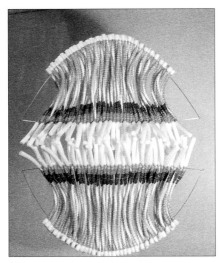

014
Aerial Act

1973
resist-dyed silk, Ethafoam, nylon
monofilament

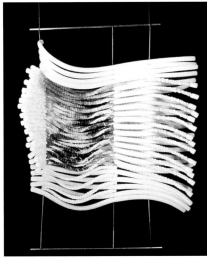

015
Bahama Deep

1973
resist-dyed silk, Ethafoam, nylon
monofilament

016
Santa Fe

1973
resist-dyed silk, Ethafoam, nylon
monofilament, metal
84 × 84 × 3 in.

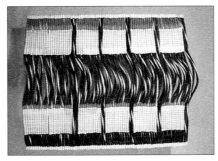

017
March

1973
resist-dyed silk, Ethafoam, nylon
monofilament, metal

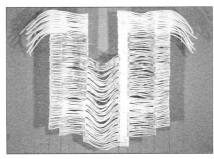

018
Airflo 1

1973
resist-dyed silk, Ethafoam, nylon
monofilament, metal
84 × 84 × 6 in.

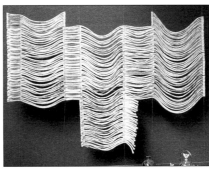

019
Airflo 2

1973
resist-dyed silk, Ethafoam, nylon
monofilament, metal
84 × 108 × 6 in.

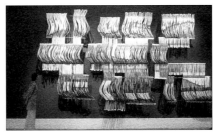

020
Brigantine

1973
resist-dyed silk, Ethafoam, nylon
monofilament, metal

020A, 020B, 020C
Throughscape for One, Two and
Three

1974
resist-dyed silk, nylon cord, mounted on
acrylic
each panel 50 × 40 in.

In the process of exploring how a fabric plane might be supported horizontally in space, Knodel came upon the idea for suspending the fabric with multiple cords attached to lines traversing space. One application of the technique results in draped fabric that reminds one of window curtains; instead of framing the view seen through the window, the fabric becomes the subject as it carries the view in its folds.

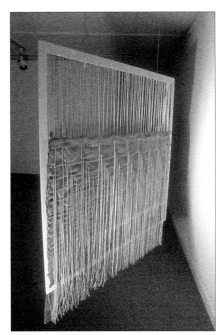

021
Pacifica

1974
resist-dyed silk, nylon cord, wood

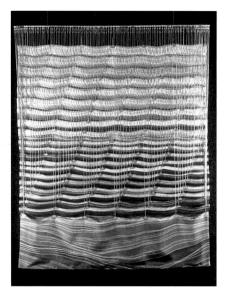

022
Seascape II

1974
resist-dyed silk, nylon cord, metal
50 × 40 × 12 in.
col. Mr. & Mrs. Phillip Berman

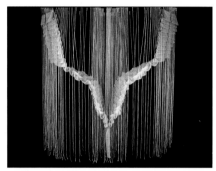

023
Up and Away

1974
resist-dyed silk, nylon cord
84 × 18 × 24 to 96 in. (variable width)

The flexibility of fabric can be a dynamic component of sculpture. This form was the first to accommodate simple manipulation resulting in a variety of configurations created by the viewer. The sculpture becomes flexible clothing for space. A myriad of configurations exists as potential within the essence of the sculpture; all exist to be discovered.

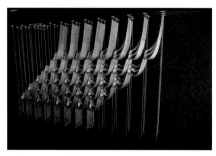

024
Flank Right (proposal for a movable fabric wall)

1974
silk, nylon cords
48 × 60 × 72 in.

As a system for achieving visual interest and functional changes within architecture, this expandable fabric wall can vary the size, color, and texture of a room as it marches into space. Manipulation of the wall can be controlled electrically or with a system of pulleys and cords. By interrupting the expansion or contraction of the wall, variations of pattern density and color are produced. The effect is like drawing in space.

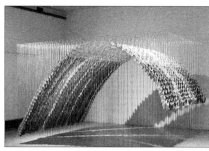

025
Act 8: A Manipulable Canopy

1974
resist-dyed silk, nylon cord, steel cable supports
96 × 120 × 168 in.
col. Cranbrook Art Museum, Bloomfield Hills, Michigan

Three panels of china silk suspended from nylon cords are attached to tension cables between opposing walls. When closed the fabric construction is a "wall hanging" on either of the opposing walls, or it can be opened to form a variety of configurations that define a semi-enclosed environment. The interior provides space for cocktails for six, or a bed for two (or more!). The canopy can easily move over furniture, but is an ideal accompaniment to floor-based entertaining. According to the needs of the moment one can change the space. The canopy is very responsive to air movement. It breathes! The colored cords define an atmosphere and transform the quality of light within and around the structure. Zones of color likewise affect one's sense of space.

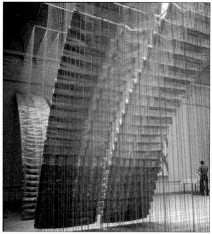

026
Parhelic Path

1975
Mylar, cotton and synthetic yarns, plastic, rayon cord
240 × 100 × 96 in.
Presented at the 10th Biennial of Tapestry, Museum of Fine Art, Lausanne, Switzerland

Four handwoven reflective fabric planes are suspended from hundreds of nylon cords attached to steel cables spanning a 40-foot-wide gallery. The fabrics appear to originate high on opposite walls and descend in two arcs forming an intimate passage for viewers. In doing so, the fabric (tapestry) leaves the wall to take on an architectural function by reconfiguring space and introducing dynamics of visual and physical movement and color. Walking between the descending arcs carries sensations of bodily extension, of physical expansion not unlike that which is sensed by winged creatures.

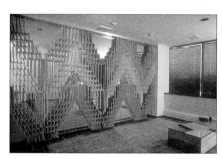

027
Sounding

1976
Indian tussah silk, silk screen printed, and nylon cords suspended from a ceiling-mounted track
96 × 168 × 96 in.
col. Cranbrook Art Museum; gift of Maurice Cohen

A movable fabric wall in six sections that invites participation through rearrangement. By opening or closing the six units of suspended fabric hanging against a mirrored wall, visual space and light of the office expands or contracts. The owner becomes an active agent in relation to the work.

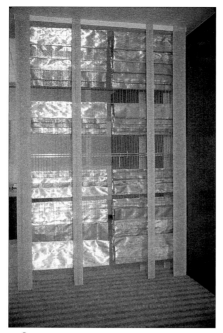

A point of departure was an analogy between the endless resources of the university library and the flow of the resource-rich gulf stream. The undulating fabric elements, held under tension from opposite ends of the building, are reflected in mirrored surfaces that visually extend the gesture far beyond the physical limits of the building. At the same time they shelter lounge areas of the library's entry with a ceiling of glowing color.

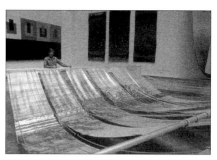

028
Ford's Throughscape

1976
wool, Mylar, metallic gimp
108 × 78 × 8 in.
Office of Henry Ford II, Ford Motor Company World Headquarters, Dearborn, Michigan

In a reception room of an office designed by Skidmore, Owings, and Merrill, the unit functions as a space divider. The lighting is dim, the surface of the fabric is subtly active. The striped composition suggests spaces beyond; a strong horizon line near viewing height when one is seated is intended to inspire contemplation.

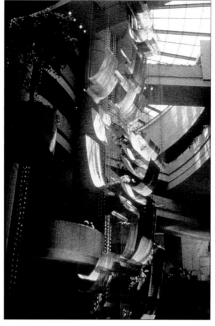

029
Free Fall

1977
Mylar, wool, rayon, metallic gimp, acrylic tubes, nylon cord, steel cable
840 × 180 × 96 in.
Atrium of Plaza Hotel, Renaissance Center, Detroit, Michigan

A vertical passage defined by fabric, light and color. Forty fabric planes create an animated sequence making transition from the skylight above to the reflecting pool at its base. The work responds to the impulses of unseen forces/air initiated by the architecture. Fabrics billow, ripple, and sway with air currents. Their reflective qualities change in response to skylight illumination. Form and density variations also occur with every viewpoint that the spectator discovers in the active architecture of suspended skyways, bridges, escalators, and viewing platforms.

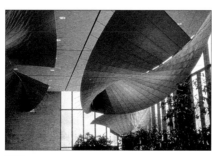

030
Gulf Stream

1977
wool, Mylar, aluminum, steel
240 × 1,200 × 360 in.
D. Anderson Library, University of Houston, Texas

"Like a glass of water to a lake, or a breath of fresh air to the sky, the elements which compose this work embody the essence of that which they are a part, but they are also aspects of something larger."
—*GK 1977*

031
Arroyo Seco

1977
silk and Mylar fabric, screen printed, nylon monofilament, nylon rope, aluminum framework
47 × 192 × 192 in.
Presented at the 11th Biennial of Tapestry, Museum of Fine Art, Lausanne, Switzerland

"Arroyo Seco (a dry river bed) winds through Pasadena, California, a concave space that cradled my attention and reminded me of certain feelings about fabric. The wet/dry aspect of the river bed became a counterpart to wet/dry mirage-like aspects of the Mylar and silk fabric with which I had been experimenting. Also, the experience of penetrating the layered space of the Arroyo from a bridge above it, suggested a response. What resulted is a 'tapestry' viewed horizontally, with overtones of other associations: beds, hammocks, and deck chairs. On approach, the viewer is first barred from space beyond his reach, but moving around the work, the sense of space opens and expands until finally, like a bird flying over it, one is within it. Layers of cords define an intangible atmosphere."
—*GK*

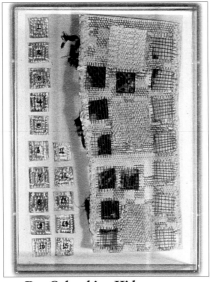

032 Pre-Columbian Hideaway

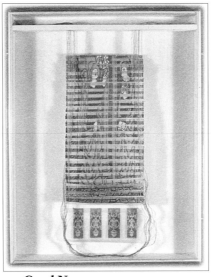

035 Good News

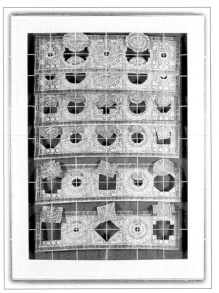

038 Extensions

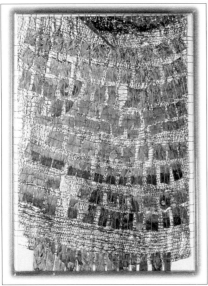

033 Feathered Fragment

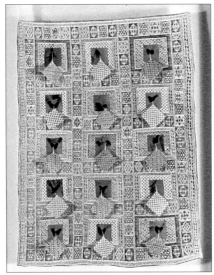

036 Second Guess

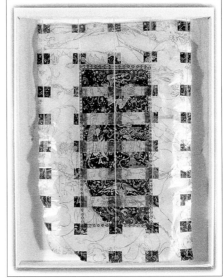

039 Persian Flight

034 Kelim Extended

037 Passing Through

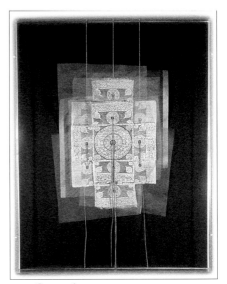

040 Centering

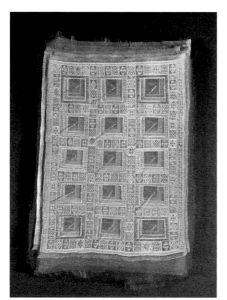

041 Allah Extended

042 24 Fragments AB

043 Fallen Angels

032–043
Historic Fabric Reconstructions

1975–1977
photographs and mixed media
in Plexiglas boxes
various sizes: 9 × 6 in. to 18 × 12 in.

Textile research and conservation are adventurous games. The attention given by conservators in the process of restoring textile fragments from the past may be considered living extensions of those objects.

Old textiles are often enhanced in the process of conservation, so why not explore a similar approach by manipulating photographs? Each of the reconstructions is built on careful consideration of the original intention of the fabric. Each intervention is intended to take the viewer to a place that may have been ignored or overlooked. Humor is not avoided.

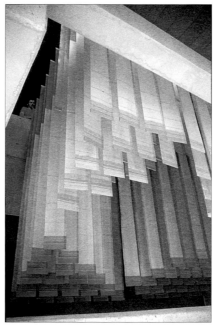

044
Sky Ribbons: An Oklahoma Tribute

1978
wool, Mylar, metallic gimp, metal supports
168 × 144 × 240 in.
Alfred P. Murrah Federal Building,
Oklahoma City

"Ribbons are a means to visual joy. Native American Indians celebrated their lives by decorating their clothing with ribbons. Nineteenth-century settlers came with ribbons that served as symbols of refinement and elegance in a dusty place. Blue ribbons became signs of ultimate victory or reward for the rancher, the bronc buster, and the farmer. The military decorated their best with strips of colored cloth.

"*Sky Ribbons* is a landscape and a sky scape which celebrates all of the best that we have been. Like the American flag it symbolizes and commemorates our origins and history, and in its color, light, life, and order, it recognizes elements which are fundamental to all people."

—*GK, 1978*

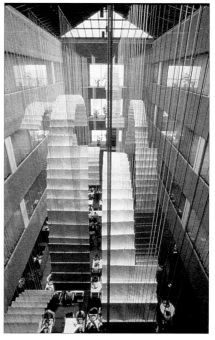

045
Sky Court

1978
wool, Mylar, nylon
Xerox World Headquarters, Stamford,
Connecticut

"While studying the atrium space at Xerox Headquarters, I discovered opportunity generated by floor-to-ceiling windows facing into the courtyard on three levels, allowing the audience to come close to the work that I was designing for that space. The situation provoked my memory of a roller coaster ride, the quiet ascent, and the intense journey that followed. What about experiencing fabric that originates near one's body, and that carries the imagination of the viewer as it extends out on a dramatic and energetic journey into space? Simultaneously, I realized that the structure could also become an intimate and colorful shelter for occupants of the dining facility beneath it."

—*GK, 1978*

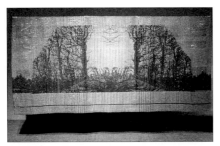

046
Schoenbrunn Suite (6 panels)

1978
cotton twill tape screen printed and dyed
before weaving, Mylar, linen
047: 51 × 109 in. 049: 51 × 110 in.
048: 51 × 90 in. #5 51 × 132 in.
#3 51 × 93 in. #6 51 × 143 in.

The *Suite* was inspired by a springtime visit to the gardens of Schoenbrunn near Vienna, where the spaces through which one walks are like outdoor rooms defined by severely trimmed trees and plants.

A suite of six weavings, each with symmetrically centered photographic images, were ceiling-suspended in the gallery, forming a floating rectangle, a suspended garden. Lighting was arranged so that reflection on the Mylar warp intensified as the viewer moved from standing to seated position on benches located in the center of the gallery. Unlike traditional wool tapestries that absorb light, these weavings became a source of illumination in the gallery, defining a contemplative space reflecting the garden experience.

050
Abyss

12 × 40 in.

Many cultures of the world have developed associations with landscape in their textiles. No doubt this is inspired by the lowest common denominator of the vertical against the horizontal in the structure of weaving which is as expressively powerful as the human being that stands vertically against the horizon. A woven textile offers potential of locating oneself in space in a way that is not unlike locating oneself in the natural environment.

051
Dawn

12 × 40 in.

052
Skypass

12 × 40 in.

053
Southern Lights

12 × 40 in

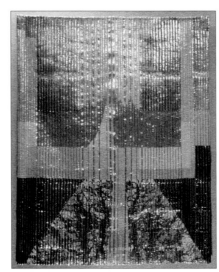

054
View Over East

39 × 26 in.

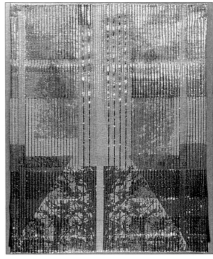

055
View Over West

39 × 26 in.

056
View Over North

39 × 50 in.

057
View Over South

39 × 48 in.

All 1979
cotton twill tape screen printed and dyed
before weaving, Mylar, linen, soutache
braid

058
Schoenbrunn Cadence: East to West

1979
cotton twill tape, Mylar
51 × 120 in.

059
All the World's a Stage

1980
cotton twill tape screen printed and dyed,
before weaving, Mylar, linen
90 × 204 in.
Entrance lobby, Midland Center
for the Arts, Midland, Michigan

Shakespeare's "all the world's a stage" inspired this work as a prelude to a theatrical event, offering an invitation for audience members to be a players on stage.

Miniature textile projects

In the late 1970s curators in Europe and the United States generated exhibits of miniature textile projects to counteract the super-sized projects required by the Lausanne Tapestry Biennial, the world's premiere exhibition of new work in the fiber medium. For Knodel, the invitation provided both opportunity and stimulus for exploring the architectural adventure of a single rectangle of loom-woven fabric as it traversed and defined the space of a small plane of transparent acrylic.

060
Field with 28 Columns

1978
Mylar, silk, acrylic
8 × 8 × 4 in.

061
Field with 70 Columns

1978
Mylar, silk, acrylic
8 × 8 × 3 in.

062
Field with Triangulation

1978
Mylar, silk, acrylic
8 × 8 × 3 in.

063
The King's Storage (Room 7): A Tapestry of World History

1980
Mylar, silk, acrylic
8 × 8 × 6 in.

Royalty amassed vast collections of tapestries as a means to impress others. This miniature work presents transparent "tapestries" linked by a single warp that passes through space in a manner suggestive of production weaving on a mechanized loom. In one hand a viewer can hold references to a huge collection of monumental moments of history.

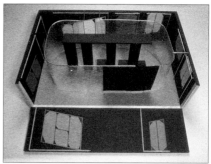

064
Inside/Out, An Installation Project

1981
cotton canvas, wood, paint, PVC
Art Gallery, Philadelphia College of Art
(University of the Arts), Pennsylvania

Inside/Out functions in middle-ground between painting, architecture and theater. It bridges the space between art as a still image and art that invites interaction with audiences. An accompanying text asks the following:

> "Is it true that the artist gives and the audience receives?
>
> "Is it true that the audience gives and art receives?
>
> "Is the audience always on the outside of art?"
>
> —GK

"The viewer enters the gallery with anticipation of an art experience. Visual sensitivity is heightened. The viewer sees—approaches—thinks—and at some point realizes that he may be on stage and that his physical presence may be an active part of the piece. But he can also return to the role of observer recipient of visual stimulus/sensation. The option exists of being audience or player, or of functioning in a space somewhere between the two. There is opportunity for indulging in a visual experience which may trigger intellectual response, but there is also opportunity to be stimulated to a physical response. The environment suggests that there is a space for active response from the viewer, wherein the viewer becomes performer, thereby fulfilling the potential of the work."

> —Betty Park, catalog essay, Gerhardt
> Knodel Makes Places to Be, *1982*

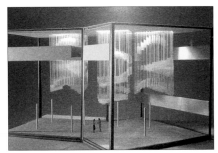

066
Model for Grand Exchange

1980
steel, Formica, acrylic, miniature
weavings, cord

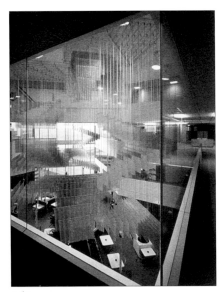

067
Grand Exchange

1981
wool, Mylar, metal, nylon
Height: 624 in.
Cincinnati Bell of Ohio

The installation was conceived to be an imaginary architectural environment suspended in space that invited viewers to transcend the physical limits of the offices in which they work. At every level the viewer is invited to visually extend into the open space of the atrium, where suspended fabric planes suggest stairs, steps, planes of landscape, clouds, or geometric constructions reflecting impulses of electronic communications. These spatial structures are intended as places for the imagination, places for both conscious and the subconscious inhabitation.

Three collages based on atrium plan at Cincinnati Bell of Ohio

1981
Photographs and digital transfer prints, gouache, illustration board

068
Three Different Worlds

50 × 36 in.

All Went up To See Apollo

50 × 36 in.

069
Picnic

50 × 36 in.

070
Model for International Square

1981
Mylar, wool, cotton, acrylic, paper
Washington, DC

Designed to occupy the twelve-story atrium of an office space near the White House in Washington, DC, the goal was to take occupants of the building to places where they did not intend to be: up, down, in or through—lead them to consider what's up *there*, or if they are up *there*, lead them to consider what's *down*. Throughout the work are familiar elements that diagram activity, but do not lead to where one is expecting to go. The atrium functions as a transitional core surrounded by corporate offices that it serves, an open introductory place that can play host to one's imagination.

12 Constellations for Texas

1981–1983

A sculpture in four parts, occupying the four buildings that comprise the Lincoln Centre, Dallas. Parts 1, 3, and 4 each occupy a large, mirrored entry atrium with a supported glass ceiling. Part 2 is located in the central reception area of the Lincoln Radisson Hotel.

The sky has always inspired earthbound humans. To some it has appeared as an endless void through which passes a pageant of images suggested by the stars. In each of the atriums of Lincoln Centre, one sees architectural space extended by mirrored surfaces, expanding the space, like the sky, to places beyond. Each atrium becomes a signature home for imaginary constellations that identify the location, just as is done in the night sky.

071 Constellation 1: Aries, Taurus, Gemini (model)

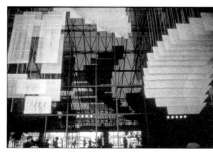

072 Constellation 1: Aries, Taurus, Gemini

1981
wool, PVC, metallic gimp, nylon

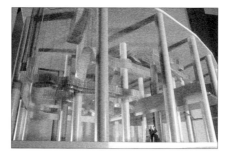

073 Constellation 2: Capricorn, Aquarius, Pisces (model)

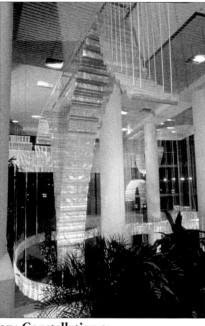

074 Constellation 2: Capricorn, Aquarius, Pisces

1982
wool, PVC, metallic gimp, nylon

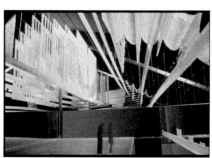

075 Constellation 3: Cancer, Leo, Virgo (model)

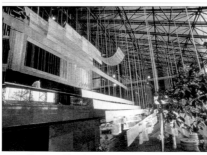

076 Constellation 3: Cancer, Leo, Virgo

1982
wool, PVC, metallic gimp, nylon

The space is viewed as one entity from the front, with the main doorway functioning as a proscenium through which the audience moves onto the stage. Long, thin horizontal panels of fabric stretch between opposite walls, defining a substance that may be seen as a sky above or water below, depending where the view stands. By walking up to the mezzanine one stands between earth and sky as if flying between cloud layers. In that place viewers are standing at the core, spotlit at center stage.

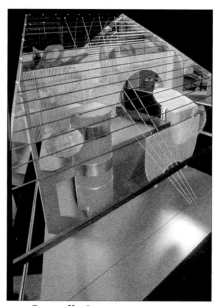

077 Constellation 4: Libra, Scorpio, Sagittarius (model)

078 Constellation 4: Libra, Scorpio, Sagittarius

1983
wool, PVC, metallic gimp, nylon

Seven weavings on the theme "Gerhardt Knodel Makes Places to Be"

All composed of cotton twill tape painted and printed before weaving, Mylar, metallic gimp, linen, and lined with cotton fabric.

"I discovered that by using the Xerox color transfer paper, I could apply a more complex image to the cotton tapes which I have used for flat weavings. The linear complexity of the photo images form a nice relationship with the woven lines (warp and weft), and that unity suggests a good means to creating richer surfaces with more levels of significance than those which are purely geometric and abstract."

—*GK journal, 24 September 1981*

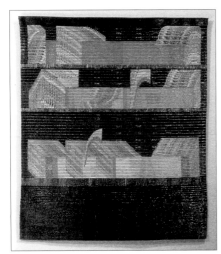

079
Riverfront

1981
51 × 60 in.

080
Billboard

1981
36 × 50 in.

081
Santa Cruz

1981
28 × 50 in.
col. Robert Pfannebecker

082
Facade

1981
53 × 102 in.
col. Herman Miller, Zeeland, Michigan

Processional

1981
46 × 52 in.
col. TRW, Cleveland

083
Lydia's Room

1982
52 × 60 in.
col. Peter Robinson

"Lydia Winstron Malbin was a major collector of Futurist art. Once, she showed to me a photo of Giacomo Balla's home interior that was as vibrant with activity as was the spirit of the movement of which he was a part. That photo was amplified to become something akin to visual music and is the source for this response to the spirit of Lydia's room."

—GK

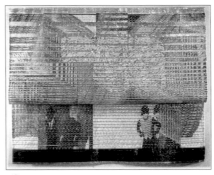

084
Souvenir

1982
col. Milwaukee Museum of Art

The first appearance of human subjects in the weavings.

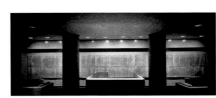

085
Three Islands Beyond

1982
52 × 425 in.
United Energy Resources, Houston, Texas

A visual cushion between the entry lobby and the corporate meeting room beyond. It references places that are quiet and timeless. Places to remember.

086
Islands Remembered

1982 (In memory of Lilly Knodel)
512 × 252 in.

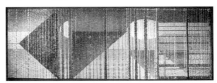

087
Inside/Out

Hotel, San Antonio, Texas (via Miller/ Brown Gallery, S.F.)

Jacquard Suite

088 #1

089 #2

090 #3

093 #6

096 #9

091 #4

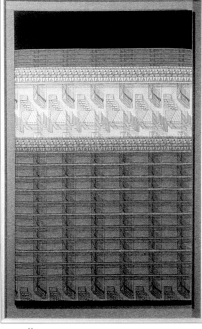

094 #7

097 #10

092 #5

095 #8

098 #11

099 #12

088–099
Jacquard Suite
1982
cotton, rayon, metallic gimp
woven on the Jacquard loom at R.I.S.D.

Twelve framed Jacquard-woven compositions made on a continuous warp.

"I first saw the Jacquard loom at RISD on Monday morning, October 24, 1981. On the left side of the loom hung hundreds of punched cards strung together and arranged like so many rows of soldiers ready for battle. The firing line was above, a place to which each card was advanced in rotation for the purpose of activating hooks and cords which in turn activated the weaving web below. A sequence of 400 punched holes or blank spaces in each card corresponded exactly to the elaborate system of red marks which I had drawn on gridded point paper a month ago, yet by looking at the cards alone there was no clue to the language content, like looking at the surface of a phonograph record.

"From the beginning I regarded my programmed image as raw material, like good basic foodstuff that can be modified with endless variety. The image of overlapping planes had been suggested by some of my recent three-dimensional architectural works which appear as volumes suspended in space, volumes related by the proximity of parallel planes of fabric. (Books are that way; parallel pages of information, bound together.) Within my design I attempted to assign to groups of pages a variety of surface patterns, which I thought of as images in a pattern book. I anticipated that the weaving process would allow for enlarging or expanding those pattern fragments by interrupting the loom, backing it up, then running it forward, backing it up again, and running it forward again, thereby repeating small horizontal slices of the overall design to evolve new patterns.

"In each of the pieces I felt like a bricklayer starting at the bottom of a house knowing that the foundation would support a wall which would eventually make way for windows and support a roof. A building system or design was not predetermined for each panel."
—*GK, Gerhardt Knodel Makes Places to Be*

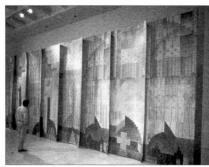

100
The Pontiac Curtain
1982
cotton twill tape painted and printed with dyes before weaving, cotton, Mylar, linen, metallic gimp
168 × 432 × 13 in.

The *Pontiac Curtain* is a grand response to the Cathedral at Orvieto, Italy, where two old men sat talking in the afternoon sun before the vast carved marble and mosaic facade, probably expecting that all old people everywhere had such an enjoyable place to be. Back in the studio in Pontiac, Michigan, the experience was channeled into thoughts for a vast "tapestry" in line with major figurative tapestries of the past, but now incorporating images of local people embedded in a rich and complex composition. Patrons of a local Pontiac restaurant were invited to become part of an artwork by having themselves photographed in a back room. The photos were combined with abstracted views of the buildings along Saginaw Street, the main street of the town that played host to that year's American Super Bowl. The morning of the big game the city staged a parade along the main street. Local people huddled away from snow and cold in the windows of empty buildings, where they stood waiting for the parade to begin, looking not like mannequins, but also not like humans. They embodied the spirit of facades of buildings that had optimistically anticipated lucrative business in the city, but were now empty or abandoned, simply waiting for something to happen, not unlike the founding fathers of the church, portrayed in stone relief on the cathedral facade.

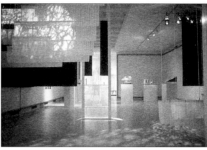

101
A Place to Be
1983
An installation at the Cranbrook Art Museum in conjunction with the exhibition *Gerhardt Knodel Makes Places to Be.*

Scrims and handwoven curtains combined to create the sense of a theater space with the viewer on stage. Viewers entered the exhibition through this space. During the course of the exhibition, various individuals activated the space with dance, song, mime, poetry, and fashion, with audience participation, each response especially created to extend the expressive qualities of the space with the interaction.

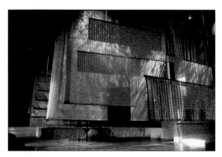

102
Entre'acte
1983
cotton scrim, velour, nylon, Mylar, cotton twill tape, linen
An installation at the 13th Biennial of Tapestry, Museum of Fine Art, Lausanne, Switzerland.

Entre'acte, the pause or interlude in a theatrical experience, metaphorically relates to the time between high points of one's life. Two stages for actors face each other, divided with a scrim curtain suspended exactly in the center of the room. The audience enters and exits through archways opposite one another in the long walls of the rectangular gallery. Immediately on entry, each member of the audience must decide whether to be to the left or right of the dividing curtain. Then comes the realization that they are standing in the space of a stage without room for an audience! In this situation, all visitors become actors. Their presence on one side becomes the subject of attention by audiences standing opposite.

Both stages are composed of parallel panels of handwoven fabric suspended from the ceiling with cords that allow the panels to move. These planes of fabric were conceived as being tapestry-like, but not

confined to the traditional wall presentation. They march off of opposite walls in the rectangular gallery, toward the center. During the course of the exhibition, dancers and other performers were invited to participate, interpret and extend the implications of the work. The following text was written on an adjacent wall:

> "We knew what had been.
> We knew what was to come.
> We believed in that which
> was on both sides,
> but were without either.
> A closet held two party
> dresses which she had worn.
> She stood before them
> and remembered.
> Meanwhile, Icarus put on
> his wings and the
> conductor lifted his baton.
> We were the space between."
>
> —*GK*

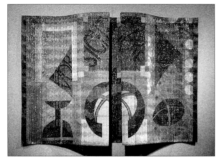

103
Another Day

1983 cotton twill tape painted and printed with dyes before weaving, cotton linen, Mylar
48 × 66 × 5 in.

104
Theodora's Wrath

1984
cotton twill tape painted and printed with dyes, Mylar, metallic gimp, linen, cotton, on metal framework
each panel 48 × 54 × 6½ in.
6 panels:
#1 col Joyce & Myron LaBan;
#2 col. Joan & Armando Ortiz;
#5 col. Dr. & Mrs. Howard Parven;
#6 col. Virginia Friend

"While the Byzantine world was dazzled by the regal and religious trappings of Justinian and Theodora, I've always been fascinated by thoughts of their personal conversations, the contentious and confrontational ones that occurred behind closed doors. This weaving is one of a series that converts a design device seen in the most elegant Byzantine silks, a repeated roundel of pearls framing powerful subjects of the period, into a game of roulette. Pearls have become balls set into motion in a never-ending cycle of chance, a metaphor for the multifaceted character of powerful leaders whose images are enshrined in art."

—*GK*

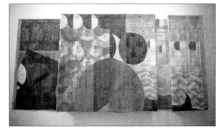

105
Finders Keep

1984
cotton twill tape painted and printed with dyes, Mylar, rayon, linen

106
Second Nature

1986
cotton twill tape painted and printed with dyes, Mylar, rayon, linen
50 × 223 × 7 in.
col. Minneapolis Institute of Art

107
While the World Slept On

1986
cotton twill tape painted and printed with dyes, Mylar, rayon, linen
50 × 144 × 7 in.
col. Mr & Mrs. William Weatherford

Three "Invitations" for Sinai Hospital, Detroit (now moved to Waterford, Michigan)

108
#1 Invitation to the First Spring

1984
52 × 144 × 3 in.

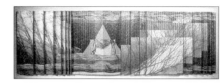

109
#2 Invitation to a Ritual Levitation

1984
52 × 177 × 3 in.

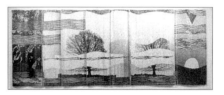

110
#3 Invitation to a Midsummer Night

1984
52 × 152 × 3 in.
cotton twill tape painted and printed with dyes, Mylar, rayon, linen

Three weavings commissioned for the main room at the hospital's entrance where anxious individuals gather and wait. Each "tapestry" presents a specific place in a continuous landscape, a place to become centered, a secure place alive with optimism.

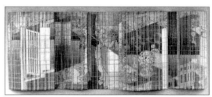

III
Gathering on a Distant Sea

1985
cotton twill tape painted and printed with dyes, Mylar, silk, rayon, linen; 5 panels on metal frames
60 × 177 × 8 in.
Hughes International Corporation,
Los Angeles, California.

"The subject deals with a gathering of special powers of inspiration, 'treasures' which become visible for a moment, like bright ideas. The treasures effect one's perception of reality, like *takarazukuchi*, Buddhist treasures that arrived in Japan from India. The lady gathering the treasures is a mythical figure with whom I relate. The project effectively summarized the benefits to me for living in Japan for seven months. It is a tribute to that extraordinary experience."

—*GK*

112
The Garden Game

1984
wool, linen, Mylar, metal supports
Lake Cook Office Center,
Deerfield, Illinois

113
Three Different Worlds

1985
wool, cotton, Mylar, nylon, metal supports,
neon lighting
240 × 540 × 240 in.
Opus Corporation,
Minneapolis, Minnesota

114, 115
Drawings for Three Different Worlds

1985
114. india ink on paper
ea. 11 x 8½ in.
115. india ink acrylic, colored pencil
24 x 36 in.

The *Guardian* series

Knodel's application to the United States/ Japan Friendship Fellowship organization was accepted in the fall of 1984. Consequently, he was able to spend the majority of 1985 living in Japan, where he absorbed Japanese culture specially focused in religious environments, traditional theater, and public festivals. On return to the studio he initiated a series of projects reflecting the powerful presence of enormous painted wood guardian figures that stand at the entrance to Buddhist temples as a threshold to enlightened experience. His "guardians" were generated from photographs taken in his studio of fellow artists-in-residence at Cranbrook Academy of Art. With Knodel's direction, each of the faculty took poses inside a circular con- figuration that distorted their normal posture and ultimately inspired the compositions and environments that he developed in the weavings.

The two-dimensional weavings attempt to show spaial sensations. The interaction of thread builds a matrix of atmosphere which surrounds photographic images in the weavings to create a place for the mind to enter freely, a comfortable and natural place to be. They are collaborations with living experience: land, water, air, and light, and the four corners, north, south, east, and west.

116
Guardian of the Second Corner

1986
cotton twill tape painted and printed with dye, Mylar, rayon, linen, metallic gimp, metal support
54 × 70 in.
col. Northwestern National Life Insurance Company, Minneapolis, Minnesota.

117
Guardian of the Third Corner

1986
cotton twill tape painted and printed with dye, Mylar, rayon, linen, metallic gimp, metal support
54 × 63 in.

118
Guardian of the Fourth Corner

1986
cotton twill tape painted and printed with dye, Mylar, rayon, linen, metallic gimp, metal support
60 × 54 × 3 in.
col. Guardian Industries, Troy, Michigan.

119
Hallway

1986 cotton twill tape painted and printed with dye, Mylar, rayon, linen, metallic gimp, metal support
50 × 70 × 6 in.
col. Saks Fifth Avenue, New York

120
Awaiting Room in the Moon

1986
cotton twill tape painted and printed with dye, Mylar, rayon, linen, metallic gimp
50 × 110 × 6 in.

121
Guardians of the New Day

1987
cotton twill tape painted and printed with dye, Mylar, rayon, linen, metallic gimp, foil, metal support
93 × 186 × 6 in.

"My recent works have been an attempt to find myself in the time in which we are living. The structure of woven cloth is the context, the environment. One by one, I have used the images of people I know to inhabit the space of the woven textile, finding a place for the human being in the textile which empowers the place with human attention, yet is respectful of the dominant natural conditions that will finally prevail."
—*GK, 1988*

122
Guardians of the Four Corners

1987
cotton twill tape painted and printed with dye, linen, Mylar, gold leaf, metal support
72 × 72 × 6 in.
col. Mr. & Mrs. Sam Shell

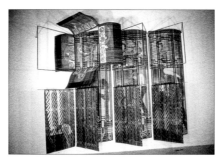

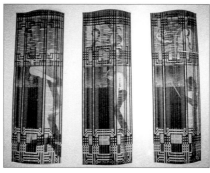

123, 124
Guardians of the New Life

1987
cotton twill tape painted and printed with dye, linen, rayon, Mylar, metallic gimp, metal support
156 × 192 × 24 in.

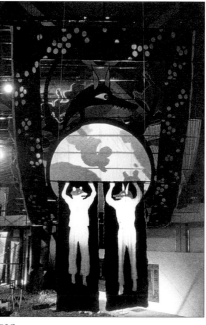

125
Reflections of a Fox and a Bear; a collaboration with Akhiko Izukura

1987
wool felt, washi paper, bamboo, silk, metal support
Kyoto, Japan;
International Textile Exhibition

Japanese weave master Akhiko Izukura invited Knodel to partner with him in producing an installation for an international exhibition in Kyoto. Knodel conceived a plan in which each of the artists would be represented as mythological characters significant in Japanese history, each suspended in a field of images synthesized from shadow portraits made of his students at Cranbrook and projected onto a large paper screen in the body shared by the Fox and the Bear. The project was inspired by traditional, candle lit paper floats used in the Tanabata festival. Illusive, fleeting images of gods illuminated in a night parade offered an exciting reference for this temporary meeting of two artists. Knodel arrived in Kyoto only ten days before the exhibition opening. A day was spent collecting materials (bamboo, silk, paper, and fleece for making wool felt), then work proceeded with fifteen assistants on the tatami-mat-covered floor of a large room in a Buddhist temple. The work was completed only hours before the opening.

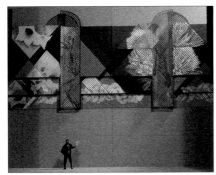

126
Garden of the Muses (model)

127
Garden of the Muses

1988
cotton, silk, nylon, polypropylene net,
wood, neon light, metal supports
216 × 1,200 × 300 in.
Singletary Center for the Arts,
University of Kentucky

The foyer of a major performing arts center provided opportunity to work side by side with theater activity that had offered inspiration for other projects. The solution was to transform a brick-covered entry hall with images suggestive of a garden inhabited by the spirits of inspiration, the muses of the theater. Most emerged as figures formed with collaged components of the natural world, subjects that are often used as decorative motifs in textile design. Each muse was caged, as if looking into the space from a place beyond, enlivening it in anticipation of the theatrical experience in the main auditorium. Installation of neon light behind translucent panels contributed an other-worldly glow. The work provided opportunity for rich collaboration with studio assistant Susie Rubenstein.

128
Lampung I

1988
cotton twill tape painted and printed with
dye, linen, rayon, Mylar, metal support
49 × 63 × 5 in.

129
Lampung II

1988
cotton twill tape painted and printed with
dye, linen, rayon, Mylar, metal support
49 × 63 × 5 in.

130
Lola's Garden 1

1988
cotton twill tape painted and printed with
dye, linen, rayon, Mylar, metal support
49 × 60 × 5 in.

131
Lola's Garden 2

1988
cotton twill tape painted and printed with
dye, linen, rayon, Mylar, metal support

49 × 47 × 6 in.
col. Nancy & Jim Yaw

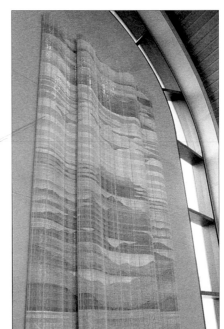

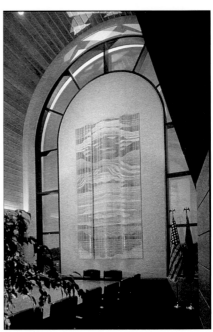

132, 133
North of Center
and South of Center

1988
cotton twill tape painted and printed with
dye, linen, rayon, Mylar, metal support
each 192 × 72 × 8 in.
State of Michigan Museum and Library,
Lansing, Michigan

With an invitation to develop a work for the boardroom of the new facility, thoughts immediately went to the minds of people making important decisions to benefit the people of Michigan. The architectural walls at either end of the room seemed to function as plugs that obscured the view of the state beyond, rather than windows to that environment. The weavings became remedies to that situation, suggesting imaginative extensions of essential characteristics of the state, land, water, and sky, and perhaps even offering places for wandering minds.

134
Make a Run for the Border:
A Project Model for Taco Bell
Boardroom, Irvine, California
1988
approx. 200 square feet

A dynamic confrontation of two subjects of movement, motorcycles and angels, playing in a field of geometric patterning composed of lines (as in a maze) leading to irresistible, magnetic centers.

Bird Suite
1989

Printed and painted cotton bonded to silk, polypropylene net, metal and wood support

A series of works were generated from a simple observation about a new method for constructing a textile. By painting and printing commercially woven cloth, then bonding silk to the back side of it for stability and contrast, the fabric could then be bias-cut into strips and rewoven, strip by strip, into a commercial polypropylene mesh. The process of weaving strips diagonally through the grid of net openings produced intervals between the strips that brought space into the textile image. The fabric that resulted was springy and pliable. By folding it back on itself it was possible to expose both the back and the front. Both surfaces of the fabric thus became active in forming images.

The subject of birds was inspired by the fact that the net was commercially produced for covering fruit trees and for protecting the fruit from birds. In the new approach, rather than keeping the birds away, the net gives birth to the images of the birds. The net in which the birds are interwoven is the means for visualizing them.

The birds were caged in stackable wooden frames, presented not as specimens of capture, but as living entities born out of a history of patterned textiles. The birds appear simultaneously free, and not.

135 #1
47 × 73 × 6 in.

136 #2
47 × 73 × 6 in.

137 #3
47 × 40 × 6 in.

138 #4
47 × 56 × 6 in.

139
47 × 56 × 6 in.

140

141

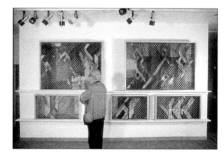

142
Birdsuite installation (detail),
Yaw Gallery, Birmingham, Michigan
1989

143, 144

Project Model for Duke University, Fuqua International Business Center

1990
metal canopy and woven wall reliefs in central reception room

The location in the university suggested a solution that merged references to various cultures. Five types of trees were abstracted into subjects for a canopy of painted metal components standing as a forest, symbols of unity and interdependence. Each of the metal trees would gently rock as air currents stirred the environment, and lighting above the canopy would project images of the trees onto the adjacent walls and floor, creating an inviting area of moving shadows below. The canopy would be accompanied in the dining hall with a series of weavings based on the abstracted trees, with one of the trees featured as the dominant element in each of the weavings.

Five Weavings

1990
cotton twill tape painted and printed with dye, cotton fabric painted and printed, silk, Mylar, linen, cotton, polypropylene net, metal support

The appearance of rocks as subject in the weavings became a surprising and unexpected development in Knodel's work. Not far from his Pontiac studio, a nineteenth-century home situated on a corner property had burned. The property was distinctive especially because of a huge, four-foot-diameter rock located on the corner of the property adjacent to the sidewalk where children on their way to school had walked for over 100 years. With grand ambition for developing the garden at his new home, Knodel noticed the boulder that now sat, as if abandoned, adjacent to the burned home. An idea came to mind: why not move the boulder to his own property? A neighbor even discussed the idea with Knodel, and plans were made for the move.

In the early morning, two days later, the day of the move, Knodel saw from the window of his lakeside home an enormous orange sun emerge over the horizon on the east end of the lake. For a moment it sat on the edge of the water with such presence as to remind him of the Pontiac boulder. But then, within a minute or two, the brilliant disc of light was swallowed up by a mass of purple low-hanging clouds.

An hour later, anticipation was high as Knodel drove to the site of the boulder. And then, approaching the property, a crushing disappointment: the boulder was gone, swallowed up, disappeared. (As were the burned remnants of the house—apparently all the victims of a front-end loader that moved all the debris, including the rock, into a void, the original basement of the home, and simply covered it all with topsoil.)

During that morning the clouds swallowed the sun, and the earth swallowed the rock. The rock became as buoyant as the sun with power to lift up off of the earth, a state of being parallel to investigation of birds escaping the confines of nets that are supposed to trap them. A bit of a miracle had happened.

145
Isola Bella

45 × 54 in.
col. Ginger and Marlin Miller, Reading, Pennsylvania

146
The Rock of San Marco; Midnight

46 × 54 in.
col. Mr. & Mrs. Starkels, Bloomfield Hills, Michigan

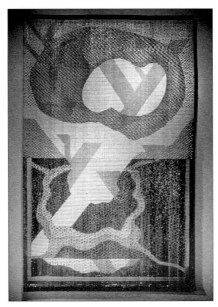

147
Miracle of St. Perry Street

85 × 54 in.

148
Stonebirds d'Napoli

57 × 54 in.
col. Nissan Research and Development Corporation

150
Basaltum Transfiguratum

38 × 54 in.

Fourteen Weavings

1990
cotton twill tape painted and printed with dye, cotton fabric painted and printed, silk, Mylar, linen, cotton, polypropylene net, mounted on linen-covered wood frame

A further expansion of the technical possibilities initially explored in the Bird Suite series was the inclusion of the pliable, net-bound imagery into a specific environment created by a two-dimensional handwoven fabric. This approach to constructing the fabric plane afforded more spontaneity and flexibility in building an image than was possible in the linear process of weaving. Still, qualities of thread and textile structure remain fundamentally important.

151
Earthbird

32 × 31 in.

152
Wings of Song

32 × 31 in.

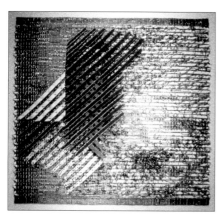

153
Awakening

32 × 31 in.

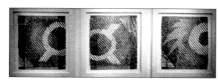

154
Nimbus Tropicus I

32 × 31 in.

Nimbus Tropicus II

32 × 31 in.

Nimbus Tropicus III

32 × 31 in.

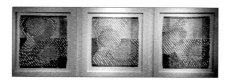

155
Pool Rock I

32 × 31 in.

Pool Rock II

32 × 31 in.

Pool Rock III

32 × 31 in.

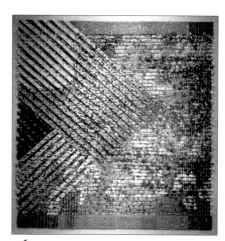

156
Transfiguratum

32 × 31 in.

157
Va-Room

34 × 31 in.

158
Lady Light

31 × 32 in.

159
Surrender to the Sky

31 × 32 in.

160
Six Step Tango

31 × 32 in.

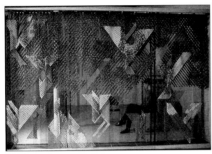

161
Birdwall

1989
screen-printed cotton bonded with silk,
polypropylene net, wood support
96 × 180 × 12 in.

"I have been puzzling the question of imagery for a new woven wall. Should its expressive 'position' be rooted in controversy?

"The wall as symbol and metaphor is appropriate in two specific political situations, Berlin and China. The revolutionary events in China having taken place during the past two weeks are especially potent. During this time, students have taken initiative to leave their 'nest'—to venture beyond the edge of that which was politically secure and out into the larger arena where freedom exists, but not without danger. Unfortunately, their will to fly was thwarted—and everyone seems uncertain about the future of the students. Can they return to the nest?

"Two weeks ago, outside the lake house, I saw a bird—a rather large infant—flopping around on the ground, apparently seeking security of something familiar, but now physically separated from that security. He could hear his mother's voice high on the branches above (perhaps chastising him, or encouraging him, I was not clear). In his confusion and with his will to get on with whatever was next, he turned his head up and back, over and over, to see where he had come from.

"There may be no way to go back. Still, we are indelibly imprinted by our past and must carry it into the future. It is the moment of awareness of the separation, the longing pause before the flight, that seems to be worthy of reflection in my work.

"Reflecting on the situation in China, and the subject of the bird, takes me back to rich symbolism seen in textiles and other objects during my travels there. In all cases the symbol was security, implying a place for the individual in a hierarchy of meaning/value. The symbol allowed one to belong and any use of it outside a predetermined mode of use isolated it, rendering it dysfunctional. Beautiful as it might be, it lost its power when experienced away from the structure that created its identity."

—GK journal notes, June 16, 1989

Birdwall was inspired by the notion of separation. It became a fabric wall, a physical space divider accessible from both sides, that would convey the subject by showing a field of pattern (referencing wallpaper) with gaps/holes interrupting the pattern, and bird-like shapes that seem to have escaped out of it. Both the wallpaper and the birds would be made of the same materials, same patterning and color, but the birds would be formed in folds of netting that appear to be freer than the flat planes of the patterned wall. The gesture of the birds was also carefully considered as they acknowledge the source from which they have emerged. The form is a semi-permeable membrane/screen to function as a wall, a physical space divider that simultaneously allowed for visual access, one side to the other.

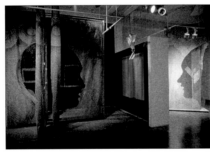

162
Walls, a gallery installation

1991
cotton, silk, polypropylene net,
wood and metal support
Seattle Pacific University, Washington

Can a wall be the embodiment of the architectural idea and also be art that is normally thought to hang on it?

Two enormous human heads are delineated as negative shapes in the fabric substance of intersecting walls. The heads face each other, separated by an opaque art wall containing rectangular "canvases" coordinated in color with the heads that are oriented toward it, as if looking at it. The red head is empty, except for the depiction of frames for art that are drawn with silk thread into the transparent net of which the walls are made. The subjects of the art seem to have left their home in those frames. Depictions of flying birds traverse the space to a place adjacent to the heads and here they hover in darkness above floor patterns descriptive of buildings/walls that once occupied the site. The image of a huge serpent undulates across a black curtain wall at the back.

Finally, a few birds congregate in the space in front of the second "green" head in a gesture of reconciliation.

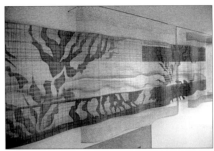

163
Down by the Riverside

1993
cotton, linen, Mylar,
metallic gimp, metal support
84 × 600 × 12 in.
Degenstein Performing Arts Center,
Susquehanna University,
Selingsgrove, Pennsylvania

164
Truth or Consequences

1992
cotton printed and painted
with dyes, silk, polypropylene net
156 × 180 × 24 in.
Oakland County Computer Center,
Pontiac, Michigan

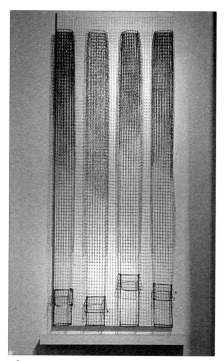

165
Summer Reign

1992
metallic gimp, linen, cotton, polypropylene
net, painted aluminum
72 × 30 × 5 in.
col. Freda Sacks

"I am looking at my new work as a series of bags that structure a place for reflection, for contrasting memories and impressions of my past with new realities. The commercial netting which forms the basic structure for these works is appealing for its ability to simultaneously filter and entrap, to release and to hold, to be all, or nothing. The bag is a metaphor for that which we would hold on to. It is also defining the space or place wherein that holding happens." —*GK, 1993*

Thirteen Studies of Reciprocal Space

1993
mixed media

"All fabrics comprise fibers and the spaces between them. The space is vital to the pliability of the textile plane, space between fibers allow them to flex, bend or be compressed, interstices allow air to penetrate and temperature to be controlled, spaces also allow for light penetration or transfer resulting in translucency or transparency of the textile plane. The semi-permeable nature of many fabrics created through their structure of open and closed space results in a man-made product that is the closest substance to skin, and many of the criteria for evaluating the quality of fabrics are born deep within human experiences of the sensual realm—especially the sense of touch—experienced through skin. It could be argued that whereas other media for human expression, such as stone metal, glass or clay, are discovered outside the body, and

primarily formed through the intellect, fiber is our body, its existence is all of us, and knowledge about it is acknowledgement of what we are—chambered being existing only because of a flow of air, water and food through the spaces of our bodies, through the interstices of our being.

"In the past months, I have worked with some means to manifest the essential conditions of inner space as it is expressed through textiles. In each case, form is presented as an action frozen for study or captured in suspended time before one inhales, exhales, or vice-versa. Who knows if the action of the mechanism is initiated by being empty or full. the works in the exhibition are verbs, works of action, but not necessarily a progressive action leading forward. In fact, questions about stages of movement enhance the moment, like a watch stopped at 5:05, that moment carries the residue of its moment. Five o' five is linked expressly with five o' six and five o' four—just as every thought or every breath is linked to adjacent thoughts or breaths. This tangency of action and time so central to our being, gives rise to various forms of communication in art.

"Most time arts (music, literature, theater, film) are experienced as a forward drive—a push through space moving from point to point in a progression that is ultimately defined by beginning and ending.

"One night, a few months ago, I reconsidered a basic weaving text, *The Art and Craft of Handweaving*. By simple manipulation of the book as an object, I discovered that the linear description of history and process documented in the book lacked subjective soul, space, and interval for which I am searching. The reader is given information in a familiar form, but there is not expression about the conditions that inspire that form. One inhales but there is no room for the exhale. Quite literally, the text, with all its careful exposition, forgets to breathe. In response, I physically cut and drilled the book, and discovered a provocative result. My action physically recreated this familiar text—the space introduced seems true to the content—something is liberated that formerly seemed captive: information. Words and images as signs and symbols now function/breathe. The structure of communication through a didactic logic is now liberated to become action that is simultaneously complete and incomplete, defined and open. Importantly, the 'text' no longer suffers associations with most How-To craft books, still it might be read as one. The one, lone surviving word stamped on the cover seems to reveal the essence of it all—INCLUDING—neither an action forward or in reverse. Space/openness seems to have entered the lateral progression of text as perpendicular intrusion. I can now breathe through the physical openings in the book, and in doing so, I (the reader) am acknowledged.

"How to make works that include rather than exclude? How to make works that exist on the periphery, defining space, rather than occupying or filling the space? The search for answers to these question is at the core of the work comprising this exhibition."

Notes on new work in 1993 exhibition at Sybaris Gallery, Royal Oak, Michigan

166
ECHO-OH

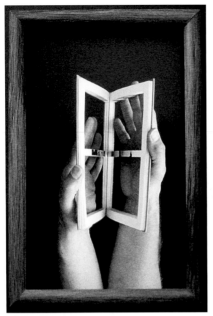

**167, 168, 169
INCLUDING**

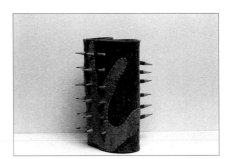

**173
ICKLE-TICK**

**177
SLIPPER**

**170
HUSH-HSUH**

**174
PALM-MLAP**

**178
RIN/GER**

**171
AB-BA**

**172
REVO-OVER**

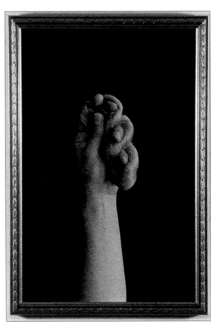

**175
PATER-RETAP**

**176
N-FOLD-N**

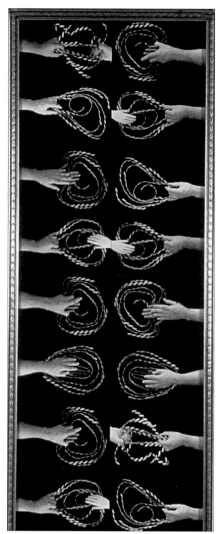

179
ALIGN-ALLEIN

180
INSIGHT

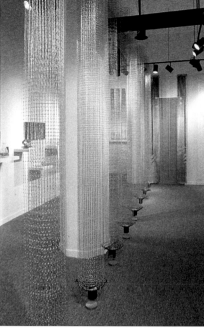

181
**Eight Columns for
Framing a Place of Anticipation**

*1993
polypropylene net, metallic gimp, brass
ea. 124 × 12 × 12 in.*

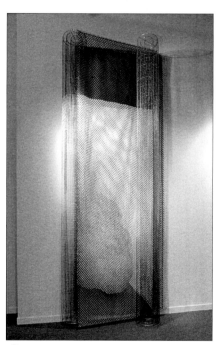

182
Entrance to Mount Illume

*1993
silk, cotton, polypropylene net, brass
130 × 57 × 20 in.*

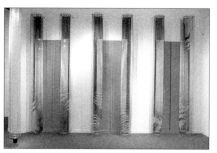

183
**Three Places of
Possibility at Journey's End:
XINGU-UGNIX
YAZOO-OOZAY
ZAMA-AMAZ**

*silk, cotton, polypropylene net
120 × 36 × 15 in.*

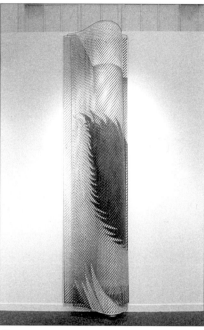

184
FIRST LEAF

*1993
silk, cotton, polypropylene net
120 × 32 × 13 in.
col. Wadsworth Atheneum*

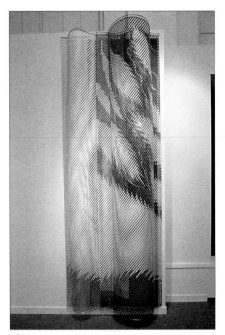

185
LEAVING FIRST

1993
silk, cotton, polypropylene net
120 × 46 × 15 in.

186
Dawn's Promise

1993
cotton, metallic gimp, polypropylene net
516 × 108 × 24 in.
col. Arrow International,
Reading, Pennsylvania

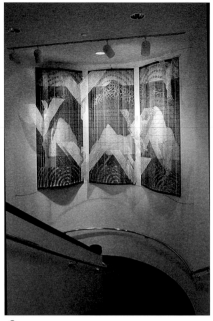

187
At Sieman's Well

1993
cotton twill tape painted and printed with
dyes, Mylar, linen, cotton fabric, silk,
metal supports
168 × 96 × 9 in.
col. Siemans Technology,
Troy, Michigan

188
American Chestnut, an installation

1993
mixed media, Indian tent wall
Dennos Museum of Art,
Traverse City, Michigan

"In a sense, the textile wall becomes the plane of art onto which experiences are projected and grow out of. It acts as a filter to our experience with nature. Once nature is internalized, then art is possible. Internalization can only bring about a greater understanding and more responsive action. The installation allows one to walk through the trees and enter the forest to inhabit the work and wear the environment."

—GK

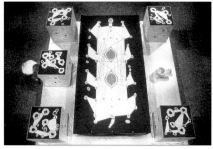

189
Night Shade, an installation for
***Interventions* exhibition at Detroit**
Institute of Arts

1995
mixed synthetics, photographic film
positives, Islamic ceramics, metalwork,
and textiles in the collection of the
Detroit Institute of Arts
60 × 192 × 192 in.

Night Shade addresses the depletion of meaning that art often suffers when placed in museums—especially those works whose cultural context is foreign to most visitors. This "intervention" did not displace any of the Islamic objects on view, the acrylic vitrines that covered them, or the central carpet on display. Instead, by covering everything with a soft metallic fabric tent, *Night Shade* evoked the temporary nomadic architecture of the Middle East. Openings pierced in the tent allowed viewers to become voyeurs, gazing at objects in the vitrines that were now surrounded with photo film positives showing images from contemporary Iranian life, and illuminated with patterns of light that penetrated the pierced fabric cover of each vitrine. The installation was an imaginative allusion to a tent seen at nightfall by a river on the Iranian plain.

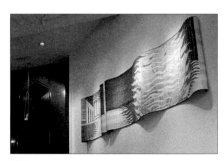

190
Gates of Righteousness

1995
cotton twill tapes painted
and printed with dyes, Mylar, linen, cotton,
metallic gimp, on metal support
3 woven panels on north, northeast,
and east walls of sanctuary
B'nai Israel Center (main sanctuary),
Congregation Shaarey Zedek,
West Bloomfield, Michigan

"A synagogue is a home, a center of one's life sustained in time. As various subjects for this work were explored, the image of gates emerged as a way to convey important points of entry into the faith. The gates

became a symbolic threshold, just as the doors of the ark are a threshold to the word of God contained in the Torah. The work culminates with a representation of life, light, and fire embodied in the form of a tree or bush that blossoms with flames, a reference to constant energy of the faith."

—from Knodel's comments at dedication, September 14, 1995

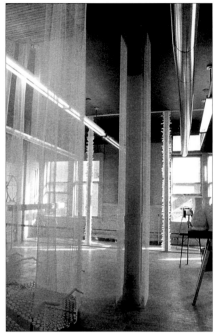

191
Pontiac Intersections + Interstices: Fiber, Metal, Clay, an installation with Gary Griffin and Tony Hepburn

1995
mixed media

This collaborative project in an abandoned office supply building in Pontiac, Michigan, generated the conceptual and physical penetration of an architectural "body" by a group of Cranbrook artists. In Knodel's corner, the gestures are not violent. Instead they respond to nuances of detail. Light enters the building, and it is gently captured and reflected. The vacated building is an arena in which one's location determines the center. The past welcomes interaction, but it is like a sieve that only momentarily holds our attention, a condition that will also slip away.

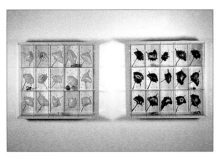

192
By Coincidence: Yellow/Black

1995
wood, glass, plastic, rubber foam, small objects

During a travel experience to Cranbrook, Kent County, England, with students from Cranbrook in Bloomfield Hills, Michigan, we discovered an uncanny relationship of two places that share similar characteristics. Contributing to the strangeness was the fact that Knodel had collected a bag of leaves from his favorite ginko tree at Cranbrook, and discovered that there were exactly the right number of those leaves to place one in each of the prayer books on the shelf at the entrance to St. Dunstan's Church. In turn, he picked a group of holly leaves to be removed to St. Dunstan's church on the campus of Cranbrook, in Michigan, and placed in prayer books there. Would those leaves inspire curiosity about their origin? Would something strange and unexpected result from the displacement? Would anyone be led to ask "where is the real Cranbook?"

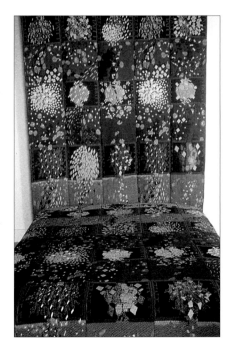

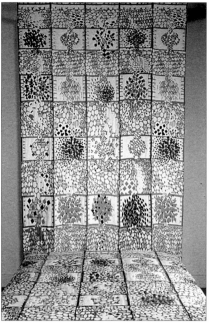

193, 194
bedTime

1995
cotton, metallic gimp, wood support
Jacquard fabric woven at
Philadelphia College of Textiles

The fabric evolved in response to invitation by Bhakti Ziek to explore the potential of Jacquard weaving at Philadelphia College of Textiles. Along with the notion of producing a functional bed covering, a series of collages were made that express fleeting time within a compositional structure derived from the covers of *Time* magazine. Four eight-foot images were designed, and each was woven, then cut and mixed with other panels to produce a mattress cover, bed cover, and a wall hanging suspended from the canopy frame above the bed. The fabric is reversible (summer/winter).

195
Time After Time

1995
Jacquard woven cotton, and metallic gimp
108 × 144 in.
col. Reading Museum of Art, Pennsylvania

Replaces the usual portraits seen on *Time* magazine covers with an abstract visualization of time in space.

196
Song of Songs

1995
architectural stained glass window
and curtain of metallic gimp and
polypropylene nylon, containing panels
of printed fused glass
144 × 240 × 96 in.
Congregation Shir Shalom synagogue,
West Bloomfield, Michigan

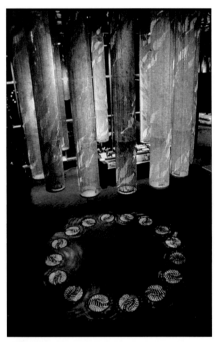

197
16 Provinces of Natur

1996
fiberglass, acrylic, stainless steel,
metal supports, nylon carpet
ceiling height 336 in.,
carpet diameter 192 in.
American Center, Southfield, Michigan.

A circular grove of tree-like columns, ceiling-suspended against a mirrored surface, was created as means for centering audiences in a vast commercial entry lobby.

Leaf-related patterns were projected through the bottom panels of each column by lights installed within each of sixteen columns. On the floor below, light projections coming from the columns corresponded to a patterned carpet set into a vast slate lobby floor. Visitors could stand within the installation and center themselves in that circular space at the core of the entire architectural project.

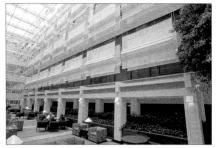

198
Lifelines

1996
PVC-coated fiberglass, wool felt,
polypropylene net, metal armature
540 × 1,200 × 36 in.
Beaumont Hospital, Royal Oak, Michigan

Lifelines is a fabric wall comprised of twenty-eight screens that capture changes in daylight or night light for patients whose rooms face the atrium. Fragments of text on the subject of healing from diverse cultures in history are accessible from each room, but the complete text is not. A legend allows each patient to see how the fragment of text adjacent to their window is related to others, a subtle means for contradicting the sense of isolation that patients often experience. The piece metaphorically relates to the desire for good health as constantly pursued, but over which no one has absolute control.

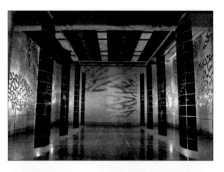

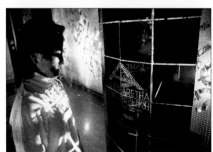

199, 200
Relatively Yours,
a gallery installation at
Mott Community College,
Flint, Michigan

1997
polycarbonate, vinyl,
metallic foil, Mylar, light
108 × 240 × 480 in.

A viewer enters the gallery and is welcomed

with a request to put on a white T-shirt that hangs on an entry rack. Walking along an open channel of space in the center of the gallery, the viewer is stenciled with light and shadow formed by pairs of panels that line the central space. Names of people are projected onto the viewer, names that form interesting coincidences (Benjamin Franklin and Aretha Franklin, Darth Vader and Ralph Nadar, Pluto 1 and Pluto 2). The viewer's body becomes the site of linkage. Only when in perfect alignment is meaning formed, but front and back side projections can never be viewed simultaneously. Behind the polycarbonate walls are panels of fragmented ancient text to be used in the Northville Library project, *Skydance at the Western Gate*, another work that explores gaps in communication.

Skywalking, an exhibition for the Sybaris Gallery, Royal Oak, Michigan.

"In the past months, I've made embroideries without thread. Substituting a drill bit for the needle, and polycarbonate plastic for the fabric, I've drilled with the rhythm of the embroiderer—considering each penetration embroidered with the drill press—punctuating repeatedly until pattern emerges from holes of light clustered into lines, forms and surface. The process is subtractive—taking away to reveal. The image is built with light—like drawing with white chalk on black paper. Each hole exposes more light, until an image appears.

"The subject of this work is the relationship between external and internal intervals—the space between two 'things' and the space between two 'breaths.' The consequence of noticing any subject is the reverberation set in motion. Although the essence of a tennis game may be represented as a single image of a player in motion, racquet poised for contact with the ball, I am more interested in the image of the ball volleyed repeatedly in time and space, each volley existing only as a fragment of pattern that is the play.

"Images are generated by objects that sit on a shelf of my library. The hands and feet are mine."

—GK, *Footnotes, December 1998*

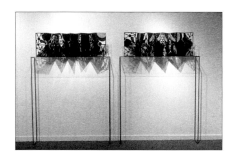

201, 202
The Lorena Twins
and Their Offspring #1

1998
polycarbonate
7 × 40 × 6 in.

203
The Lorena Twins
and Their Offspring #2

1988
polycarbonate
7 × 40 × 6 in.

204
Skywalking

1998
polycarbonate
7 × 38 × 6 in.

205
The Fishman Triplets

1998
polycarbonate
7 × 38 × 6 in.

206
The Eight Bobs and Their Alteregos

1998
polycarbonate
14 × 60 × 6 in.

207, 208, 209, 210
Devil Music #1
Devil Music #2
Devil Music #3
Devil Music #4

1998
polycarbonate
ea. 14 × 28 × 6 in.

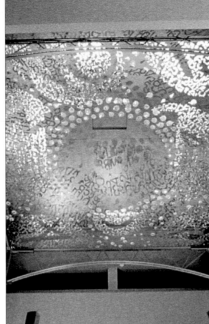

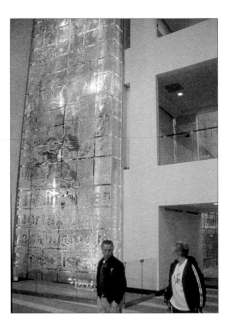

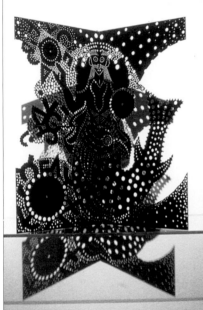

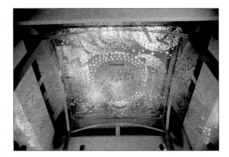

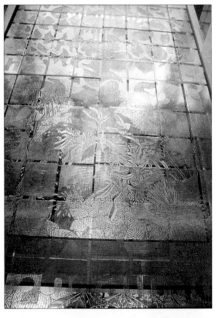

211, 212, 213, 214
The Jonah Brothers #1
The Jonah Brothers #2
The Jonah Brothers #3
The Jonah Brothers #4

1998
polycarbonate
ea. 14 × 10 × 5 in.

215
Skydance at the Western Gate

1998
metallic foil, polypropylene net,
metallic gimp
180 × 240 × 240 in.
Northville Public Library,
Northville, Michigan

Skydance at the Western Gate represents the intersections of thoughts past, present, and future. The origin of the idea is the ancient Silk Road, along which material goods and ideas from civilizations as far apart as China in the East and Rome in the West passed each other en route to destinations so far away that once arrived they were regarded as "other-worldly." The place where strangers meet, or where their products come together, inspires the work. The entire work is composed of fragmented letter forms of ancient origin.

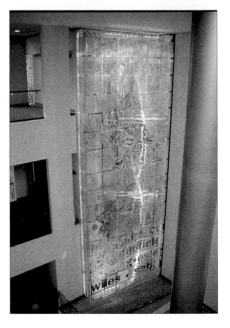

216, 217, 218
The Echo of Flora Exotica

2005
Polyester fabric, digitally printed,
with fabric appliqué, Mylar grid, printed
acrylic, colored fluorescent light.
Installation includes eleven original block
prints by Jacques Hnizdovsky
(1915–1985) that were inspiration
for the floral curtains.
Three sections, each 168 × 480 × 36 in.
William Beaumont Hospital,
Royal Oak, Michigan

"From the beginning, I wanted to counteract the hard and efficient surfaces that characterize the hospital's architecture with a condition that referenced the softer, subjective side of health care. Simultaneously, I wanted to make reference to individuals in medical history who have devoted themselves to research from which current medical sciences benefit. I imagined something like a wall of engraved names, such as one might find in a museum or government building, a wall that would be penetrated to allow visual access to that which normally is not seen. I determined that a fantastic garden with nurturing and poetic qualities would be a wonderful goal. Just as doctors work with living beings to find solutions to health problems, I imagined the artwork to be generated in relationship to another artist. The images of plants created thirty-three years ago by Jacques Hnizdovsky became the link. As I planted a garden with his woodcut images, I discovered that a collaborative relationship developed—a connection that metaphorically expressed the doctor/patient relationship at the source of true healing." —*GK, 2005*

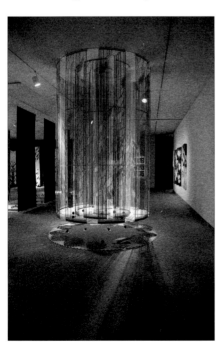

219
Recovery Games: The Accelerator

2008
dyed fiberglass fabric, cotton, acrylic,
stainless steel, gator board, wood
168 × 96 × 84 in.

Twenty fiberglass panels from an architectural installation (see *16 Provinces of Natur*, 1998) have been reconfigured into a three-dimensional spiraled channel. As the viewer walks around the perimeter of the piece, his visual attention and movement activate a sensation of flickering light as thin slices of warm and cool colored panels play against one another. The floor of the spiral configuration is cut with a series of circular holes to trap and interrupt the movement of balls racing along the channel toward the protective safe zone at the center. The unlucky balls fall to the lower level activating gauges of measurement. However, contrary to expectation, nothing happens. *The Accelerator* is only active in the presence of one's perception as one moves around the piece. The viewer's eyes activate *The Accelerator*.

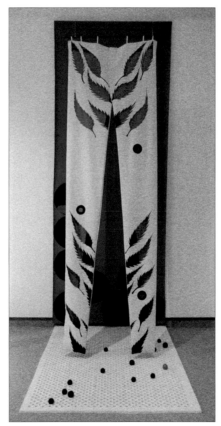

220
Big Pants

2008
silk noil, china silk, nylon
two sizes: 98 × 30 in., 120 × 30 in.

Big Pants was inspired by components of an earlier installation (see *American Chestnut*, 1996). Its new identity is bigger than life and flirts with implications generated by pierced patterns and carefully positioned dots.

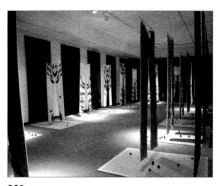

221
Recovery Games: Bingo

2008
silk noil, nylon, cotton, felt, plastic, wood
144 × 240 × 600 in.

Can polka dots become weapons? Can the decorative association of the dot pattern be retrofitted into a scene of tension and conflict? This installation was conceived as a place of tension and confrontation, like the moment of a ceasefire in a battle, a moment of pause and reflection before the action continues. The viewer is invited to enter the playing field at the center of the room by passing between pairs of the suspended pants that are dramatically spotlighted, leaving the center dark. Something has happened in this space where time and action are suspended. Who makes the next move?

222
Recovery Games: Shoot the Rapids

2008
silk, Mylar, nylon, wood, paper, metal
43 × 49 × 1¾ in.

Reconstruction using components (see maquette, *Arroyo Seco*, 1977) created to emulate the character of an arroyo seco, or dry riverbed. By isolating each of the six panels and hanging them vertically, the feeling of a downward rush is enhanced. At the top of each panel are implications of a game in which balls drop through apertures, into and onto the idea of light reflection and movement. The arroyo is now far from dry.

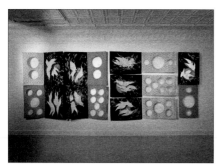

223
Recovery Games: Skeeball

2007
silk, cotton, polyester, metal supports
72 × 180 × 6 in.

A box of leaf-shaped silk fragments (a byproduct of *American Chestnut*, 1996) inspired an inspection of their potential in forming subjects for a new work. Birds emerged, and with them the notion of relating them in pairs, playful pairs enjoying diverse relationships.

The birds required a home, so a large fabric panel was cut with a circular aperture reminiscent of the hole through which wrens enter their wood houses, and through which they see a framed view of the world outside. The transitional nature of the circular hole as a point of entrance and departure was a perfect metaphor for the transitional state experienced by Knodel on returning to the studio after years as director of Cranbrook Academy of Art.

A further observation was that the action mirrored the throw of a bean bag into a clown's mouth in a carnival game. In turn, that suggested companion pieces for each of the seven bird panels. Those patterned fabric panels now echo the presence of the birds with finely stitched silk contours drawn onto translucent fabric across each of their circular openings.

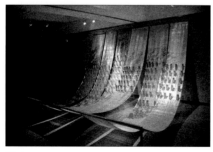

224
Recovery Games: At the Ready

2008
handwoven silk and Mylar, screen printed, digitally printed polyester, wire, lead
206 × 206 × 96 in.

Playing games with huge pairs of pants (see *Recovery Games: Bingo*) required a response at a contrasting scale. What if the pants were part of a legion standing ready for battle, like pawns in a game of chess?

Huge handwoven panels of silk and Mylar from the earlier landscape-oriented project

(see *Arroyo Seco*, 1977) offered to play host to the legions, and also to another idea regarding approach to patterned textiles where pattern is always integrated into the plane of cloth. What if the patterned subjects were able to stand erect on the textile, perpendicular to it, and to move independently, activated by air movement?

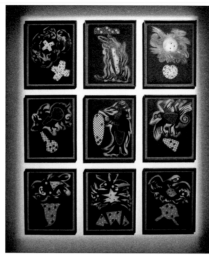

225–233
Recovery Games: Strange Encounters

2007
illustration board, Prismacolor pencil, oil pastel, plastic, wood
nine units: each 16 × 13 × 1¼ in.
#4, 6, 7 col. Sandra Seligman
#8 col. Genie and George Lanthorne
#9 col. Gretchen Davidson

Inside vs. outside conditions of identity and behavior affect all people. A popular question: "How much should I reveal about that which is me?" That dichotomy is wonderfully illustrated in a pre-Columbian Colima vessel and headrest in the artist's collection. One side shows a three-dimensional dog, sitting on his haunches, and barking at the moon (his open mouth is where liquor is loaded into the vessel.) The back side is a flat slab, cut flat to provide a resting place in the grave for the head of a deceased person who becomes appropriately supplied for the journey into the afterlife. What is most curious is that the contour of the flat back side is a series of three birds! Although they are part of one another, the dog can't see the birds, nor can the birds see the dog; still they define a single, functional, three-dimensional object.

Strange Encounters is a group of drawing/ constructions showing subjects that have been hybridized, mutated to share single bodies with a common core. The interior forms that unite them also exist outside each pair as game boards, places where new strategies happen.

234
Textile Traces

2008
Japanese silk ikat, plastic spools of cotton thread, plastic discs, clamshell box
16 × 24 × 3 in.
Photograph by Bruce M. White 2015
Lloyd Cotsen Box Project Collection

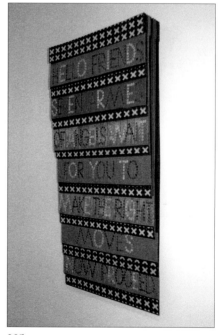

235
Now Proceed

2008
Japanese silk ikat, cotton, polyester printed with photo images, plastic discs, glass beads, mat board; mounted on linen-covered wood frame
42 × 20½ in.
col. Gary Wasserman

Textiles are usually connected with utility or function. This work is first in a series made from a traditional Japanese kimono, deconstructed, then applied to a new form. The model for the work was another old

textile, a Sumatran striped wedding skirt containing language representative of the owner. In this response, the striping has been assigned a different function in a three-dimensional form reminiscent of a carpet sampler. Each stripe can be lifted and separated from the others, revealing something more about itself, but the labeling on the ends of each sample is coordinated to offer an introduction to the entire series of works that followed this one. "Seven armies of angels wait for you to make the right moves, now proceed."

236
Laughter/After Laughter #1

2009
Japanese silk ikat, linen, plastic discs,
nylon net
12 × 66 in. and 5½ × 66 in.
col. Detroit Institute of Arts

237
Laughter/After Laughter #2

2009
printed silk, linen, plastic discs, nylon net
12 × 66 in. and 5½ × 66 in.
col. Barbara Bloom

238
Laughter/After Laughter #3

pieced quilt-top fragment,
linen, plastic discs, nylon net
12 × 66 in. and 5½ × 66 in.
col. Debbie Bragman

Laughter affects the environment, just as a downturn in the economy affects the psyche of a society. These works set out to explore the degree to which text rendered with pattern elements (plastic discs) could interact with the textile pattern that played host. The intensity of the laughter is different in each panel of the series, just as is the echo or sensation that follows (the "after" laughter).

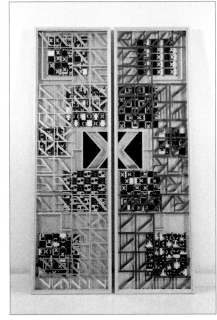

239
Left, Right, Left-Right-Left
(Dexterity Game)

2010
Japanese silk ikat, acrylic,
mat board, plastic discs, stainless steel
balls, wood, mica
2 panels, each 60¾ × 18 × 1¾ in.

240
Let's Dance
(A mended reconstruction)

2009
Japanese silk ikat, cotton, linen, plastic
discs, Prismacolor pencil
47½ × 28 in.

Just as an archaeologist assembles scrap fragments from ancient textiles and attempts to reassemble them to understand the whole, this work organizes the leftovers from a series of eight pieces produced from the fabric of a single kimono, realigning them in the original kimono fabric width, and combining them with a checkerboard-printed

textile of similar proportions as the original. Here, reconstruction is associated with the movement of mending a woven textile, specifically the action of the needle that passes in direction of warp, then weft. Language that suggests directions for a Fred Astaire dance routine was used as a substitute for thread.

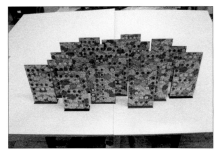

241
P/R/O/L/I/F/E/R/O/U/S P/O/S/S/
E/S/S/I/O/N/S

2010
stencil-printed Japanese silk,
linen, plastic discs
22 units, marked A–V; each 9 × 5 × 1½ in.
cols. Judy Vine, Gretchen Davidson,
Julie Rothstein, Andrea Dickson,
Molly Valade, Jean Schuler, Rick Carmody

A series of works made from deconstructed Japanese kimonos extended the meaning of the textile with patterning and text. The original textile was part of a Girl's Day kimono, used for an occasion on which parents of a young girl enhanced her image with traditional kimono, hair style, jewelry, and makeup. In fact, one might consider the parents to be possessing their daughter's image, similar to the way material possessions empower an owner. Here, the goal is to objectify the text by allowing each letter to stand on its own, turning it into an independent object available for distribution.

242
Proliferous Possessions Possessed

2010
antique stencil printed Japanese silk, linen,
plastic discs
16 × 144 in.

A second response to the potential of the Japanese Girl's Day kimono fabric, subversively superimposing the words "proliferous possessions" onto the fabric in a way that integrates the language of text with the language of pattern.

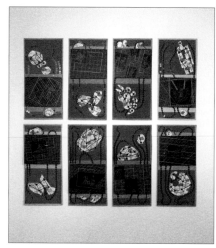

243
Embrace

2009
Japanese silk, plastic sequins, mat board,
Prismacolor pencil
8 panels, each 31 × 15½ × 1¼ in.

Embrace refers to the beautiful potential of finding meaningful relationships among unsuspecting elements. Discovery of a collection of innocent Victorian stencils inspired their integration with fabric panels in which antique kimono fabric was formed into objects being reached for by a series of blue tentacles. The first impression of the drawings is one of play, but closer consideration reveals the suggestion of potential hazard or tension among the subjects depicted. The unusual relationships are ultimately no more strange than some of the unanticipated conditions that generated the fiscal emergency in the United States at the time that this work was made.

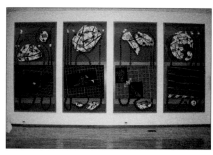

244
Embraced

2009
mixed media quilts with
digital prints and acrylic
4 units, each 120 × 60 × 5 in.

The aspect of tension is further developed (from the work *Embrace*) as handmade quilts containing images derived from the stencils are juxtaposed with huge photo enlargements reminiscent of commercial advertising. Bits of the original Japanese kimono fabrics, the departure point for the series, are now used in critically expressive locations within the quilted gaming fields.

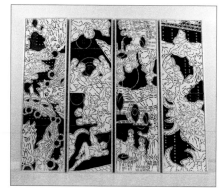

245
Learning to Act/Acting to Learn:
Six Times Eight (A Dexterity Game)
The Other Side of Cold
(A Dexterity Game)
Risk (A Dexterity Game)
Gaze (A Dexterity Game)

2010
wood, acrylic, polycarbonate plastic,
plastic discs, paper, photocopies of stencil
print Japanese silk, stainless steel balls
4 panels, each 60¾ × 18 × 1¾ in.

This set of dexterity games was developed from Victorian stencil images referenced in other works (e.g., *Embrace*), with the intention of extending insight into those subjects and their relationships. A collage of laser-cut figures floats above a dark playing field where hundreds of stainless balls are set into action. A storyline is suggested, involving a search or quest generated by each of the subjects. The viewer is invited to participate in a search that is never won, in a patterned field suggested by eighteenth-century French lace.

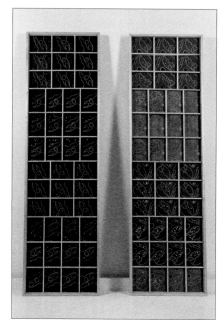

246
Feeding Frenzy-Black

247
Feeding Frenzy-Red

2008
black panel: wood, paper, plastic discs,
Prismacolor pencil, copper balls, acrylic
red panel: wood, Japanese paper, Egyptian
papyrus, copper balls, acrylic
each panel 61½ × 18¼ × 1½ in.

This, the first of the unwinnable dexterity game series, was generated by thoughts about pattern design in which the potential of an image, explored through repetition in a variety of ways, is endless. Every piece of cloth consumed today is part of something larger. One may buy three yards from a bolt, but there is always the four yards that came before, or the five yards that follow. We never see the whole. Unlike a painting in which contents are composed to be complete within its confines, textiles are expansive and connected. It is impossible for the consumers in *Feeding Frenzy* to ingest all of their targets, but they are wonderful to watch in the process of their pursuit.

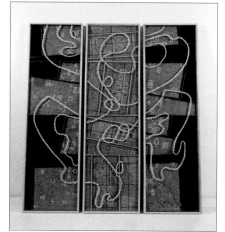

248
Hopscotch

2010
paper, plastic, shell sequins, newspaper,
acrylic paint, chalk, oil pastel, pencil,
stainless steel balls, wood, acrylic
3 panels, each 61 × 18 × 1¾ in.

Thoughts of playing the traditional game of hopscotch as a child became a vivid source of inspiration for this recollection of images and sensations associated with the game, from marking coarse pavement with chalk that leaves traces as time passes, to the activity generated by the game. Traditionally the game of hopscotch helps a child to find a place for himself/herself in the world. In this case, the world is geometrically diagrammed and numbered, with rules that allow one to explore it in a systematic way. The players internalize the experience, and ultimately, wherever they are, they may never be completely lost. The game never ends.

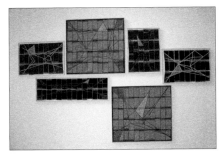

249
Reconstruction

2010
antique Japanese ikat-dyed silk, paper,
nylon net, printed polyester netting
7 panels. Overall 72 × 126 × 1¾ in.
(Purple: 29½ × 22 × 1¾ in.;
pink and blue: 36½ × 40 × 1¾ in.;
brown and blue: 22½ × 32½ × 1¾ in.;
black: 15½ × 50 × 1¾ in.)

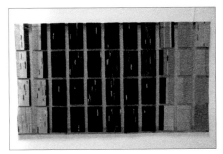

250
Kesa

2010
wool, cotton,
metallic printed nylon netting
48 × 86 in.

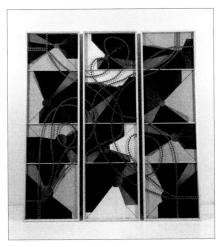

251
Gathering Four Corners of the Sky
(A Dexterity Game)

2011
digital photo prints, acrylic,
wood, steel balls
3 panels, each 60 × 18 × 1¾ in.
col. Erica and Ralph Gerson

This dexterity game is based on the form of a Japanese *kesa*, a Buddhist monk's robe, which contains references to cardinal directions in the four corners, and a pattern field of collaged elements that surrounds

the body in a gesture of wearing the environment. The game involves directing the balls in each section to the circular form at the center, then moving them to each of the four corners. This game is never won. Strategies to arrange the rolling stainless balls in one section upset the arranged balls in the adjacent part. Endlessness is a strategy similar to that of repetitive textile patterning.

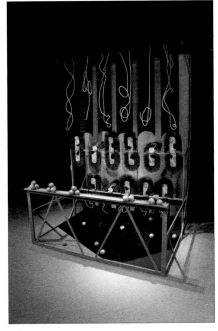

252
Whoosh

2011
mixed media; electronic components
132 × 96 × 84 in.

Whoosh is an interactive game and an expressive metaphor regarding the influence of art critics. Inspired by a carnival game, the audience is invited to toss balls containing text from the magazine *Art in America* at wooden heads representing a group of critics who are pondering the textile panels that hang above and below them. When knocked back, each head releases the voice of the critic, describing what the work is NOT. The succession of descriptions referencing important artists of the past leave the player no recourse but to make up their own mind about the work. The work is accompanied by video depicting a costumed cast at a carnival sideshow interacting with *Whoosh*.

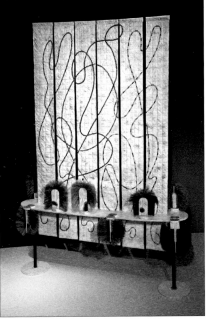

253
Dinner Talk

2011
mixed media; electronic components
120 × 90 × 24 in.

Twelve art critics are positioned around an oval dinner table. As each hinged head (based on carnival knock-downs) is lowered, it activates an LED light under the table, and also the voice of the critic. In their "up" positions, critics face away from the artwork, but their critique begins when they meet and converse under the table, looking only at the tail ends of the artwork, leaving the work unobstructed and accessible to the audience. Voices accumulate as one head after another is lowered, until there is nothing but garbled cacophony.

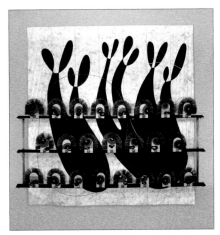

254
Do You See What I See?

2011
Tyvek, wood, horsehair,
plastic, paint, metal
86 × 91 × 13 in.

Each of the heads, representing the audience for art, can be lowered individually into a position where it is now looking at the artwork behind. Lowering it opens the

hinged space at the base of each head, where fragments of drawings transferred from Victorian stencils are seen, white on black. The drawn fragments, showing familiar subjects, reflect the enormous range of ways that different individuals regard/see/interpret the same subject. The audience completes the cycle of art-making in individual ways.

Stencil Drawings in Space

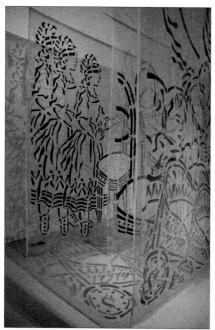

255 #1
Hide and Seek
(Falling Is Not a Problem)

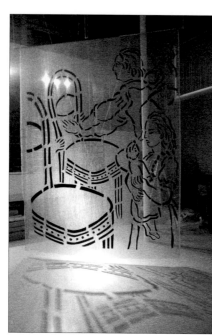

256 #2
You've Got to Be Taught
(Otherwise)

257 #3
Nap Time
(Don't Be Afraid to Sleep)

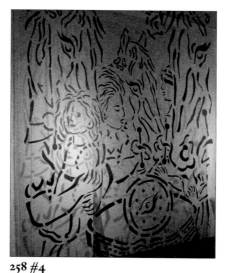

258 #4
Collision
(Something Good Will Come of It)

2011
polyester
each panel 144 × 112 in.

259, 260, 261
Caught in the Act:
(Waiting, Watching, Wondering)

3 moving shadow curtains
2012–2013
polyester, cotton
each curtain 120 × 96 × 4 in.

The images derived from a set of Victorian stencils are further explored in this series of shadow curtains in which the negative shapes seen in the stencils are now rendered as positive forms attached to a large transparent fabric. Now it is possible for light to project the stencil images onto the surrounding environment or even the viewing audience. The subjects still come from the stencils, but they are now freely recombined into new images. Hybridized humans and birds suggest a transitional state of being,

and become metaphors for the contemporary drift away from essentially body-based activity such as cursive handwriting and textile making skills. An image of a falling child ignored by other subjects enhances the sense of inevitable change and its consequences. The movable curtains are a vehicle for contemporary mythology, and the viewer has the choice of revealing or concealing the story by simple manipulation of the curtain.

262
Interlude: Red

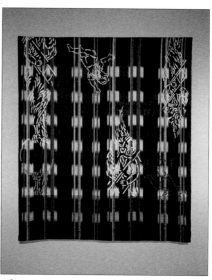

263
Interlude: Purple

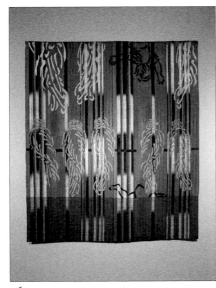

264
Interlude: Green

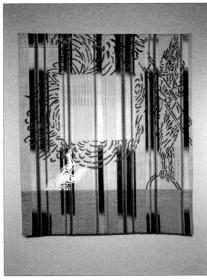

265
Interlude: Yellow

4 weavings
2012–2013
cotton, rayon, polyester, on wood support
each panel 68 × 60 × 2 in.

Each of the weavings was inspired by a 2012 visit to Guatemala, one of the world's richest resources for the traditions of hand-weaving, where significant ideas/images are integrated into woven textiles of daily or ceremonial use. The intensity of color and pattern in those textiles generated four companion pieces for the shadow curtains in which the consequences of ignoring important issues of our time continue to be explored. The striped field of hand-dyed, hand-woven cloth is now regarded as an elegant field of space that plays host to the action of the subjects. The textiles intend to intersect the best associations of decorative arts, with a degree of probing inquiry, generating a hesitation at the place that the beautiful and the meaningful meet.

266
Endgame

2013
Tyvek, wood, cotton, horsehair,
plastic, paint, metal
wall, 52 × 168 × 6 in.;
turnstiles, 48 × 12 × 12 in.

The final game in the series presents an integration of portraits of the critics into the handwoven textiles that were their subject for critique in *Whoosh* and *Dinner Talk*. The composition is theatrical with side curtains open to watch the active game at center stage. Three additional "critics" join the audience for the artwork from the position of the viewer.

267
Calvino's Curtain:
Invitation to a Future

2014
cotton, rayon, linen, polyester, Mylar
120 × 480 × 14 in.
6 woven panels, each 120 × 30 in.;
5 shadow curtains, each 120 × 96 in.;
6 polyester fleece panels; 5 Mylar panels

This forty-foot expandable curtain contains a loose narrative inspired by Italo Calvino's book *The Baron in the Trees*. In first position the curtain is "closed," revealing only the series of woven panels that suggest the wall of a dining room interior, the setting for the act that triggers the intriguing events to follow. By pulling the left curtain, the space between the first two panels is opened to reveal a shadow curtain with figurative images suggesting the beginning of a voyage. Additional movement opens subsequent panels, developing the sense of adventure. The curtain is intended as a parallel to the discoveries and the awakening suggested in the book. The moving curtains provide many options for reconfiguring components; manipulation of the curtain encourages participation in the narrative.

268
Start All Over Again

2014
wood, paper, digital prints, steel balls,
acrylic
2 units, each 60 × 18 × 1¾ in.

269–291
Start All Over Again

2014
wood, paper, digital prints, steel balls,
acrylic
22 units, marked A–V; each 12 × 13 × 1½ in.
"F": col. Daniel Pados

Constructing a new reality from broken pieces. In November 2013 the *New York Times* showed a single, powerful photograph capturing the impact of a typhoon that destroyed the city of Tacloban in the Philippines. The image showed a woman and her daughter walking past a debris-filled street of shards of what had once been neighborhood. Surrounded by the broken environment, the woman walked with an arm around her daughter, carrying what little she could save; a statue of the Madonna, a rosary, a half-filled glass jar containing a goldfish. Even the clothing she wore took on significance in relation to the disaster: a Calvin Klein T-shirt, a jacket with pop imagery, and a cowboy-style bandanna covering her nose and mouth. The image inspired thoughts on how humans instinctively work with remains of disaster to build anew. From the source photo, background images of ruined homes were isolated, cut, pasted, and reconstructed, a process allowing the artist opportunity to interact with the remnants of one's life. The interactive device of a dexterity game was incorporated to represent the intellectual human response in the process of building something new. Now, even the audience can interact in that process. The memory of song lyrics by Dorothy Fields offered the title: "Pick yourself up, Dust yourself off, Start all over again."

Acknowledgments

This book is a lasting record of an original, singular evolution of a body of work that will not be repeated, and a tribute to many friends who contributed to its development.

The inspiration for this publication was generated with a gift of longtime friendship, interest, and support by former colleague Robert Wood. The book is dedicated to his memory.

The genesis of this book is also the result of a constellation of opportunities: the decision to present the work at American University Museum, by its director Jack Rasmussen; the enthusiasm for the work generated by Rebecca A. T. Stevens and Giselle Huberman in Washington, DC, and Gary Wasserman and Wasserman Projects in Birmingham, Michigan; and especially the interest of publishers Nancy and Peter Schiffer, who carefully considered the potential of the publication and encouraged its development.

The project was given special impetus by those who contributed to its contents. Janet Koplos, Shelley Selim, Douglas Dawson, and Rebecca A. T. Stevens have become important collaborators via their attention to various aspects of the artwork, presented by them with careful consideration and patience. Their work is enhanced with the talents of Schiffer editor Sandra Korinchak, and Judy Dyki at the Cranbrook Academy of Art Library. Graphic designer Elliott Earls has enthusiastically approached the project as an opportunity to exercise his own skill and imagination, patiently coordinated with the needs of others.

Careful photographic documentation is essential, and over the years the body of work has benefited from the skill and creative insight of distinguished photographers, including Balthazar Korab, Robert Hensleigh, and most recently, PD Rearick. Michael Thomas has been endlessly patient in assisting with the essential conversion of slides and transparencies into digital format.

Studio assistants over the years were often recruited from the ranks of interested, talented, and dedicated graduate students, many of whom rallied to last-minute emergency calls for assistance. Some worked for a few hours, others became longterm colleagues. All probably retain a few memories of our hours together. Add to this list steadfast supporters of the work in the community, including George and Eugenia Lanthorne and Lillian Zonars, who could be relied on for their support.

Bright ideas occasionally occur without the technical background to accomplish them. This is especially true with regard to realizing digital-based additions in recent works, and in-studio documentation, none of which would exist without the technical expertise of Jack Butler, Butler Graphics, Inc; Edward Martincic, NuVision Technologies, Inc; Jim Mencotti, JJMencotti, LLC; and Michael Paradise.

Assistance with other aspects of the work has come from expert metalsmith Dan Majewski and woodworker Matt Michalec.

Finally, it is appropriate to acknowledge a few individuals who have contributed to the appetite for a life lived within the field of art and documented in this publication. William Paul Baker opened the doors at Horace Mann Junior High School in Los Angeles with boundless energy, enthusiasm, and joy. Mary Jane Leland and Bernard Kester established high ideals and standards for accomplishment; Wallace Mitchell and Roy Slade engendered a sense of trust that became a foundation for the pleasure of risk-taking within the academic environment; colleagues at Cranbrook and graduate students formed a great army of determined souls willing to establish meaningful positions in life via their work.

Through it all, Kenneth Gross has been a supportive partner whose willingness to contribute in every aspect of this very complicated career has been essential in nurturing an extraordinary life.

—*Gerhardt Knodel*

US $45.00

ISBN: 978-0-7643-4994-2

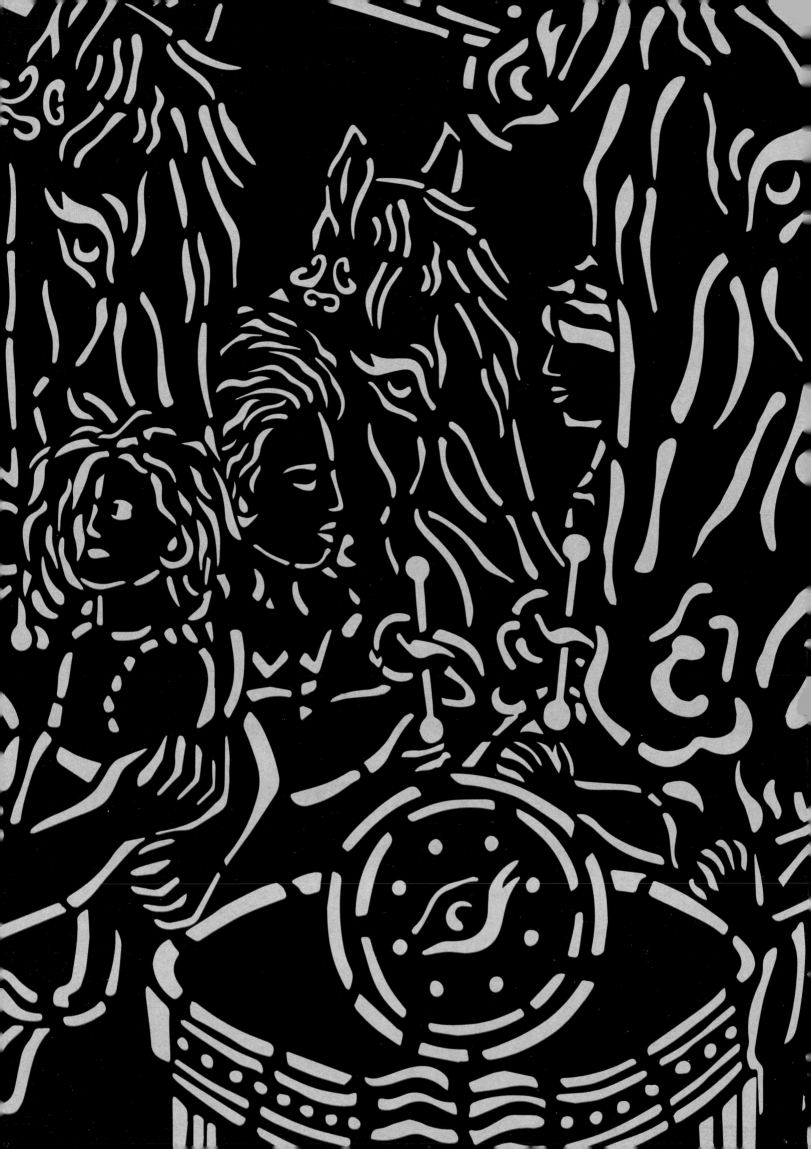